THE MONET COOKBOOK

Recipes from Giverny

Texts by Florence Gentner
Photographs by Francis Hammond
Styling by Garlone Bardel

PRESTEL

MUNICH · LONDON · NEW YORK

Summary

❖

Foreword

❖

While Claude Monet's paintings conjure up images of light and mesmerizing reflections, art historians of the period reveal the dogged determination that lay behind his Impressionist works. Furthermore, the artist's own letters disclose his tendency to worry. Those who sat down with him to enjoy a good meal, however, spoke only of his evident pleasure and delight in sharing. Monet spearheaded a movement in painting that turned contemporary ideas of art upside down and set passions raging, but during his life, at both the worst points and the best, he found sheer joy through food. Wherever he ate, be it at the family dinner table, in a country inn or in a renowned Parisian restaurant, he appreciated simple dishes made of fresh ingredients and prepared according to very basic yet authentic principles.

Monet's life was impacted by frequent upheavals but, fortunately, things stabilized when he moved to Giverny at the age of forty-two. The recipes prepared in his Giverny kitchen epitomize the ways of a social and welcoming middle-class family. Born into comfortable circumstances, Monet was probably brought up with the fine foods of Normandy. Certainly, this would explain how he developed an abiding taste for good food, a preference he maintained throughout his youth as he wandered the countryside in search of beautiful subjects alongside his friends who answered to the names of Renoir, Bazille and Sisley. Guy de Maupassant might well have been thinking of them when he described what he called "living the life of a dauber" in his novel *Miss Harriett*, published in 1883: "Roaming about with a pack on one's back from inn to inn, on the pretext of making landscape studies from nature […] stopping here and there when a stream takes one's fancy, or one catches a delightful whiff of potatoes frying at a hotelier's door."

The first years of Impressionism were by no means easy; its artists were scarcely in a position to indulge in extravagant dining. That said, many of the early works include beautiful still lifes of gleaming plates and glasses on a table at the Fournaise Restaurant or on a white cloth spread on a forest floor. Impressionist artists were drawn to festive occasions and holidays. Writing in the early 12th century, René Gimpel commented, "The Impressionists show their particular talent and attain the summit of their art when they paint our French Sundays." Later on, Monet especially loved the Sundays when he hosted in his yellow dining room at Giverny surrounded by people he truly enjoyed.

Monet did not prepare the steaming dishes that were brought to his table. Although he appreciated excellent food, he was not a cook himself, unlike his charismatic friend Alexandre Dumas, whom he valued as much for his culinary talents as for his friendship. Monet made sure that he ate well and that he could offer his guests the very best from his kitchen garden. He amassed a talented team of people, including meticulous cooks and diligent gardeners. When Monet was satisfied with his work and his company, he displayed a happiness that was infectious.

Monet's son-in-law, Jean-Pierre Hoschedé, was a part of Monet's everyday life and he left a detailed account of what went on at Giverny. The recipes used in the kitchen there suggest a carefully balanced lifestyle, which Monet deliberately maintained with his

second wife, Alice. Leaving him to get on with his painting, Alice took charge of the household, overseeing the staff, tending to the large family, huge house and enormous garden. In the second half of the nineteenth century, there was a proliferation of books on household management written for women. Alongside recipes, these books featured practical advice on everyday family life that often sounded like moral precepts.

Alice may well have read Madame Millet-Robinet's *Domestic Economy*, including a section called "The Duties, Tasks and Pleasures of Country Women." Published in 1853, the book was divided into chapters with practical titles such as "Establishing Order," "Paying Servants," and "How to Deal with Financial Matters." Alice's early life with her first husband was one of luxury, but she faced difficult times when he went bankrupt. Alice found herself having to bravely master all of these household matters. Once Impressionism was properly recognized, Alice and her family could afford a comfortable, even opulent, lifestyle; however, she never expressed any desire to exchange the simple, well-heeled life they had at Giverny for anything more ostentatious.

Claude Monet simply could not imagine anywhere better than Giverny. Here in Normandy, in his property close to the Seine, in his garden that he recreated in the colors of his paintings, he divided his time between work and family. We know from his correspondence how difficult and painful his work could be. "This devilish painting tortures me," he wrote in 1890 to his great friend Berthe Morisot. The letters he wrote to his wife whenever he travelled away from Giverny reveal the levels of distress he felt until he managed to capture a precise flash of light on the sea or a cliff or a river, and his intense relief when he was at last successful.

When he was happy, Monet could light up family life at Giverny. He would start singing passages from *Carmen* or every time he heard anyone mention his driver, Sylvain Besnard, by his first name, he would burst out with, "Sweet hope, Sylvain told me: I love you ..." from the comic opera *Les Dragons de Villars* that premiered at the Théâtre Lyrique in Paris. Monet would issue invitations, entertain his friends, whisk his family off on trains, on boats, in cars. His daughter-in-law, Blanche, recalled one boat trip on the *Normandie* that lasted several days, during which they joined friends from Le Havre to Cherbourg and back to witness the arrival of Tsar Nicholas II.

Monet's friends, members of his family and visitors to Giverny would all be charmed by the painter's generosity and his attentiveness to others. At dinner in his dining room, he would display a healthy appetite, doing justice to his cook's chosen recipes. Some of these meals were for everyday, while others would appear on special occasions and holidays like Christmas, or be served at one of the warm wedding celebrations held at Giverny. Without a doubt, Alice could be proud of her organizational skills, but if her management of menus, provisions, garden, staff and eight children sometimes went unrecognized, one can only hope that she had read Madame Millet-Robinet's book's concluding words meant for mothers: "A life that is well-filled is all that is needed and it will slip by at a speed which gives it a charm beyond words."

Florence Gentner

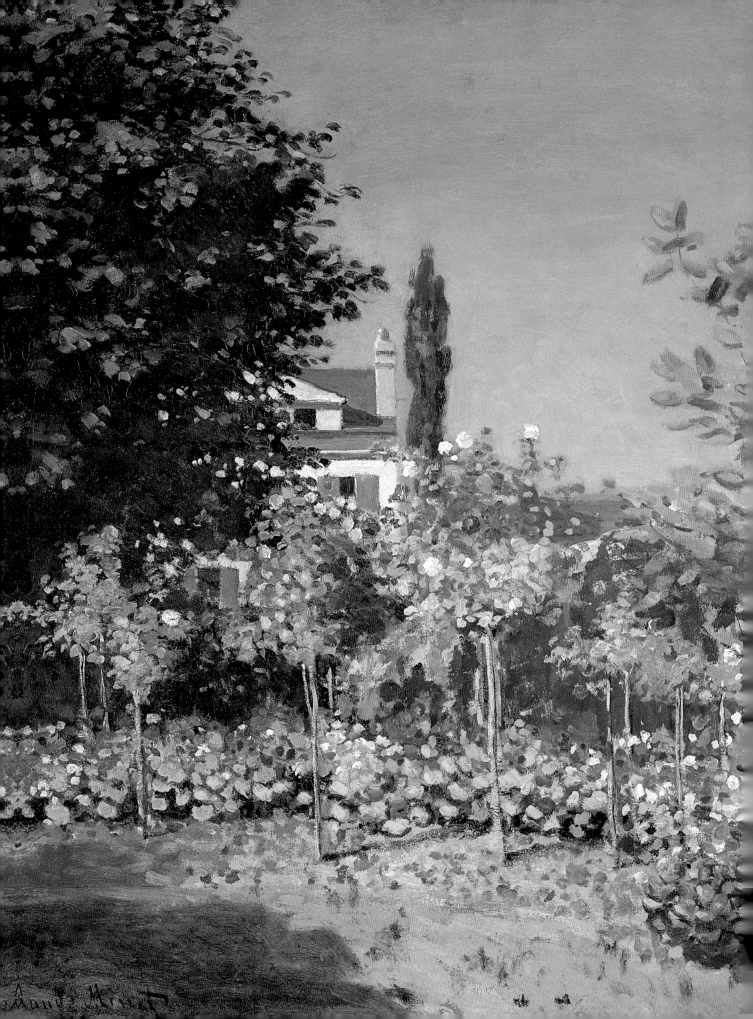

THE FOOD
of childhood

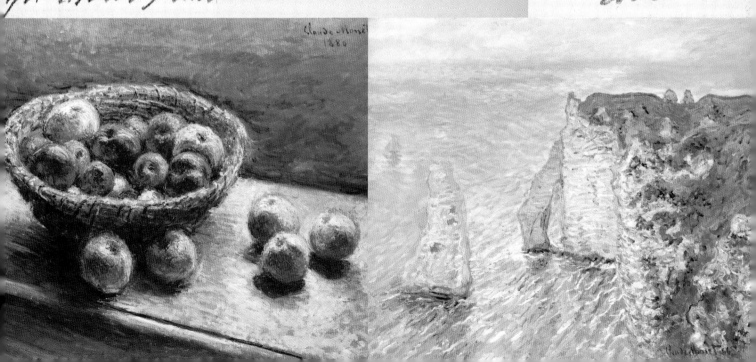

"I have always been a hearty eater, and it has never done me any harm."

❖

The recipes that were prepared in Claude Monet's house at Giverny were typical for a middle-class family. No doubt, Monet's lifestyle mirrored his childhood in Le Havre where his Paris-born parents moved with their two sons in 1845 when Claude was five. Monet spoke little about his early years, sharing only snippets to a handful of writers and journalists towards the end of his life. From these recollections we get a picture of an "innately unruly"[1] child growing up in a well-to-do environment. Monet's son-in-law, Jean-Pierre Hoschedé, remembered Monet declaring time and again that "friends are worth more than family"[2]. It was a view that most likely sprang from the resistance he got from his father when, at the age of nineteen, he announced that he wanted to go off and learn to be a painter. This experience may also explain his reluctance to share his early memories with his curious contemporaries.

By contrast, there is ample testimony from people who knew the adult Monet and who were privileged to sit down with him to a well-appointed table. What is abundantly clear is that he was a man with a predilection for the finest things, even at difficult periods in his life. In fact, it was a preference he never sought to deny: "I have always been a hearty eater, and it has never done me any harm,[3]" he told René Gimpel. His early exposure to the rich culinary traditions of Normandy almost certainly left him with a regard for fresh produce and instilled in him values shared by the gourmands of the day: a respect for quality ingredients and the pleasures of entertaining, a desire to broaden one's social circles, and an opportunity to give and exchange. For the generation of connoisseurs who flourished in the second half of the nine-teenth century, gastronomy was about good taste and a specific culture. Cookbooks were popular at this time, and they all described the mental attitude one needed to adopt in order to be a successful cook.

An Approach to Life and Living

The Physiology of Taste by Brillat-Savarin, first published in 1826 and reissued in 1848, opened with thirty "Meditations" on topics such as the "Senses" and the "Power of Taste." In the introduction, the writer and journalist Alphonse Karr declared that Brillat-Savarin had "brought a seasoning of wit, good humour, and good taste to a good dinner …" In *The Royal Cookery Book*, which was published in 1867 and set out to cover the "bases of domestic and high-class cookery," Jules Gouffé highlighted "the notions of art, science, taste without which it is impossible to be a true cook." This was a way of cooking that stressed organizational skills and economy. In *The Universal Cook*, Alphonse Karr wrote the preface plus an appendix devoted to "The Art of Using Leftovers."

Claude Monet may not have left us any specific accounts or memories of the food of his childhood, but we can readily picture the wealthy environment, which was both conventional and cultured. On the one hand, his childhood was marked by his father's conservatism, and on the other hand by his mother's passion for music, theatre, poetry and drawing. Monet's father, Claude Adolphe Monet, had left Paris for Le Havre to be near his half-sister Marie Jeanne Lecadre, whose husband ran a wholesale business where Monet's father was later employed. According to a friend of the family, Théophile Béguin Billecoeq, the Monet home in the Ingouville district of Le

Havre was large enough to accommodate visitors from Paris. Claude's mother, Louise Justine Monet, enjoyed entertaining local dignitaries at her table and in her elegantly furnished sitting room.

Meals with Aunt Lecadre

Following Louise Justine's death in 1857, Aunt Lecadre became an influential figure in the young Monet's life. An artist herself, she sensed Monet's talent and gave her nephew the run of her studio. In 1862, Aunt Lecadre hosted a meal in Sainte-Adresse at the house called "Le Coteau," whose beautiful garden full of flowers steeped in sunlight was the subject of Monet's painting, *The Garden at Sainte-Adresse*. Sainte-Adresse was a lively seaside resort made fashionable by the ubiquitous journalist Alphonse Karr. When Marie Jeanne invited her nephew to visit, he brought along the Dutch painter Jongkind and Jongkind's mistress. We know from a letter Marie Jeanne wrote to her friend Amand Gautier that she was shocked by Jongkind's unpolished ways: "I confess to my shame that I was repelled by his eccentric appearance and his reputation for loose living[4]."

By contrast, Marie Jeanne Lecadre was delighted by the sophistication displayed by Frédéric Bazille whom she entertained two years later at the same table in Sainte-Adresse, once again in the company of her beloved nephew. After his visit, Frédéric wrote to his mother, "I had lunch with Monet's family. They are delightful people, and have a delightful residence at Sainte-Adresse near Le Havre where life is just the same as it is at Méric[5]." In other words, it was no different from Bazille's own life on his vineyard estate at Méric, near Montpellier, which he captured in his famous group portrait entitled *Family Gathering*. The painting perfectly depicts the educated, middle-class environment into which Cézanne, Bazille and Monet were all born. What's more, it represents the standards of the time and the fact that the artists were pressured by their respective parents to ignore their artistic passions and urged to study law, medicine and commerce.

"Innately unruly"

From an early age, Claude Monet cut a rebellious figure. "Secondary school was always like prison to me, and I could never resign myself to being there, even for four hours a day, when the sun was so enticing, the sea so beautiful, and it was so good to be outdoors, running along the cliffs or splashing about in the water,[6]" he confided one day to Thiébault-Sisson. At school, which he attended sporadically, he didn't make much of an impression except as a caricaturist, poking fun at his teachers for the amusement of his peers. With this talent he gained quite the reputation in Le Havre and was able to earn some money after he left school around the age of sixteen. His "caricatures" of local dignitaries caught the eye of a framer in the city who exhibited them in his shop window and paid Monet on commission.

Monet's caricatures attracted Eugène Boudin, the quintessential painter of sunlit beaches and figures moving about in suits and crinolines. As a youth, Monet stubbornly rejected all forms of advice, but he took in Boudin's kindly words: "Study, learn to look, paint and draw. Do some landscapes. It is so beautiful, the sea and sky, animals, people and trees just as nature made them, with their characters, their true

essence of being, in the light, within the atmosphere, just as things are[7]." Eventually, the young Monet conceded. He agreed to accompany the celebrated painter of vast skies and scudding clouds on one of his open-air painting trips.

In 1859 it took all of Aunt Lecadre's efforts to convince Monet's father that her talented nephew should go off to Paris to learn to be a painter. Monet was able to submit a convincing portfolio (including *A View of Streets*) to the city of Le Havre's selection committee in support of his application for an endowment. His plea for financial assistance was turned down, however, and he set off for Paris to embark on his new career armed with only the money he had earned from his caricatures and some letters of introduction to painters his aunt knew. Once in Paris, he visited the official Salon and went to see academically trained masters whose teachings he rejected. He wrote regularly to Aunt Lecadre and Eugène Boudin.

Memories of Normandy

Claude Monet's rebellious childhood almost certainly gave him an abiding love of Normandy. He returned again and again with pleasure, to set up his easel on the cliffs of Étretat, Pourville, Trouville, Varengeville and Honfleur. He confided to Gustave Geffroy: "I have stayed loyal to the sea in front of which I grew up[8]." He was particularly entranced by the port of Le Havre in the early morning, just as his close friend, Maupassant, was captivated by the sight of its lighthouses: "… on each of the jetties there were two more lights, offspring of these giant ones, marking the entrance to Le Havre; and over there, on the other side of the Seine, there were others

still … staring with nothing other than the steady unchanging mechanical movement of their eyelids, 'This is me. I am Trouville, I am Honfleur, I am the river at Pont-Audemer.[9]'"

Like so many others, both Monet and Maupassant associated the beauties of Normandy with the pleasures of eating. Several restaurants in the region remained firmly implanted in Monet's memory, including the Ferme Saint-Siméon at Honfleur, which he frequented with Bazille, Boudin, Courbet and Jongkind. There was also the Belle Ernestine at Saint-Jouin-Bruneval, not far from Étretat, where he dined with Maupassant himself and with Alexandre Dumas, another celebrated gourmand of the day who always ordered Ernestine Aubourg's "prawn stuffing[10]."

Among the other culinary delights that he appreciated throughout his life, his letters single out lobster, duck, cider and fruit from the orchards of Normandy. Writing in his own inimitable style, Thadée Natanson recounts one of the few stories Monet shared about his youth, which involved eating oysters with his great friend Courbet and another friend, on a "golden morning" in a fish shop in the Halles district. "Of the three, Monet drooled most in anticipation of the treat in store, his appetite at twenty being "… more voracious than discerning (as it would later become)." Courbet gleefully ordered the sellers to start opening oysters. But they did not stop after a mere three or four dozen … carrying on far beyond that for a whole hour, wearing the oyster sellers out and leaving them understandably exhausted: the three of them between them had worked their way through at least twenty dozen …[11]"

The Principles of Good Cooking

Since Claude Monet was heavily influenced by the region where he grew up, he was happy to rediscover it much later when he moved to Giverny. In the warm environment that he created there, he embraced a way of living and an approach to entertaining that he remembered from his childhood, where the quality of the company and the care taken in preparing the food were equally important. Monet's philosophy was similar to what mine engineer and food connoisseur, Henri Babinski, known as "Ali-Bab," described in the introduction to *Practical Gastronomy*, first published in 1907: "One thinks ahead to the cooking; one discusses the menus in advance, one goes for each ingredient to suppliers one knows and who know themselves what they are doing; finally the preparation of every dish must be the object of the minutest care."

When it came to the quality of ingredients, Henri Babinski believed that French culinary art reached its peak in the second half of the nineteenth century. He ascribed this to a number of factors: "the richness of the soil which yielded exquisite produce; the skill of the farmers, gardeners and stockbreeders who developed the most wonderfully selected strains, in both the vegetable and the animal kingdoms; the art of the cheese and preserve makers, and the practice of extracting and preparing juices and purées which are the fundamental bases of good cooking; and finally the unrivalled quality of our wines, which complement them." In short, for a painter who loved the finest things, deciding to live in the Normandy countryside made perfect sense.

Like the testimony of Monet's guests at Giverny, the collection of Monet's favorite recipes proves that the painter was a consummate master of the art of convivial living. Monet famously quipped, "Beyond painting and gardening, I am good for nothing."[12]

In retrospect, he might have added that he was a gifted host, giving people he appreciated warm and delectable moments to savor.

1. Claude Monet, *My History*, collected by Thiébault-Sisson (published in *Le Temps*, November 26, 1900), Paris, L'Échoppe, 1998.
2. Jean-Pierre Hoschedé, *Claude Monet, ce mal connu. Intimité familiale d'un demi-siècle à Giverny de 1883 à 1926*, Genf, Pierre Cailler, 1960.
3. René Gimpel, *Diary of an Art Dealer* (1963), Paris, Hermann, 2011.
4. Marie Jeanne Lecadre, letter to Armand Gautier, October 30, 1862, former Blaise Gauiter collection.
5. Frédéric Bazille, letter to his mother, June 1, 1864, in F. Bazille, *Letters*, collected, edited and annotated by Didier Vatuone, Montpellier, Les Presses du Languedoc, 1992.
6. C. Monet, *op. cit.*
7. *Ibid.*
8. Gustave Geffroy, *Claude Monet, His Life and Work* (1924), edited and annotated by Claudie Jurain, Paris, Macula, 1987.
9. Guy de Maupassant, *Pierre and Jean* (1887), Paris, J'ai lu, "Librio littérature" series, 2014, *Posthumous notes by Blanche Hoschedé-Monet*, in J.-P. Hoschedé, *op. cit.*
10. *Posthumous notes by Blanche Hoschedé-Monet*, in J.-P. Hoschedé, *op. cit.*
11. Thadée Natanson, *Painted in their Turn*, Paris, Albin Michel, 1948.
12. Maurice Kahn, "From Day to Day: Claude Monet's Garden," *Le Temps*, June 7, 1904.

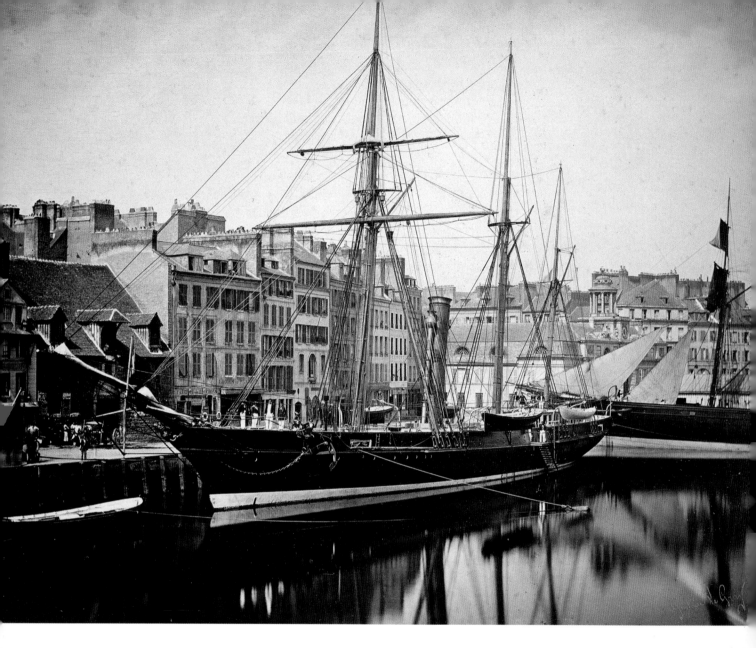

"The sun rises behind Le Havre and turns the white cliff top at la Hève pink."

Alphonse Karr, *The History of Romain of Étretat*, 1836.

Above: The imperial yacht *La Reine Hortense* in the port of Le Havre. Prince Napoleon, cousin of the emperor Napoleon III, set sail from the port of Le Havre on June 16, 1856 aboard this magnificent yacht on a voyage to the North Sea.

Right: Claude Monet was born on November 14, 1840 in Paris, in the rue Lafitte, which later became known as "Art Dealers' Street." His parents, Louise Justine Aubrée and Claude Alphonse Monet, subsequently moved to Le Havre in 1845. Monet painted the *View of the Port of Le Havre* in 1873, a year after *Impression, Sunrise*.

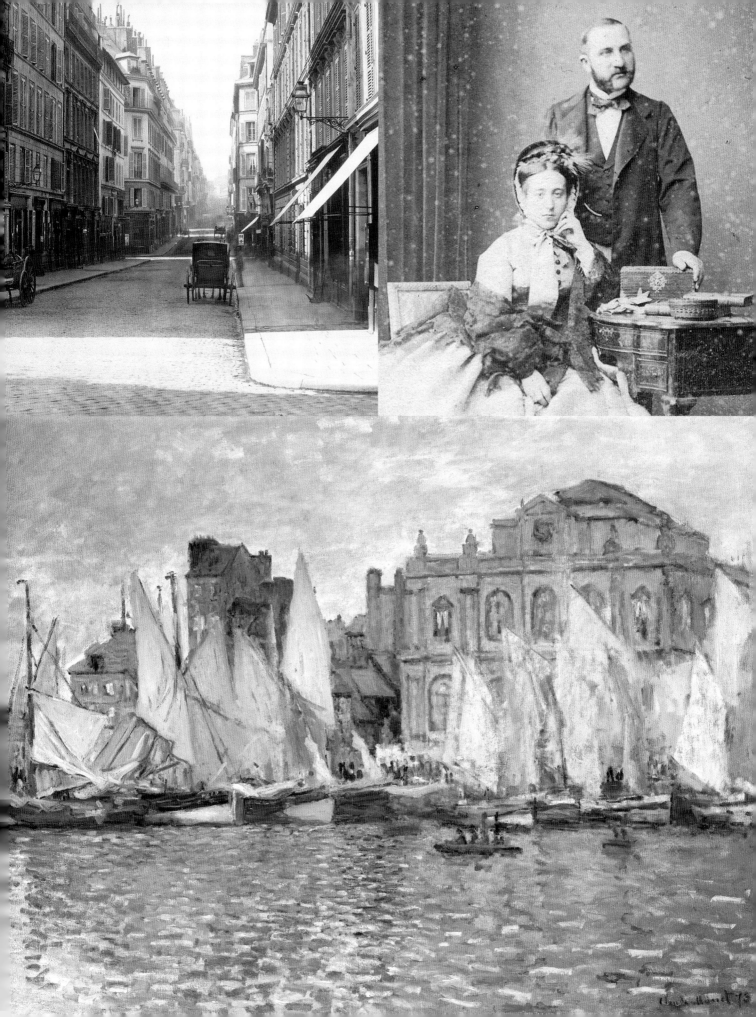

Tomato Soup

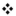

4 large ripe tomatoes 1 kg (2.2 lbs)
1 small onion
1 bay leaf
2 sprigs parsley
1 cube beef stock

1 pinch baking soda
1 tsp superfine sugar
1 tbsp butter
1 tbsp flour
Salt to taste

❖ *Serves 4 Preparation time: 15 minutes Cooking time: 25 minutes*

Scald the tomatoes and then immediately run them under cold water and peel.
Cut them into quarters, discarding the tough cores, and put in a saucepan.
Crumble the stock cube over the tomatoes, add 100 ml ($^1/_2$ cup) of water,
the parsley, bay leaf, baking soda and sugar. Mix well, cover and leave to
bubble gently for 15 minutes or until the tomatoes are cooked.

Peel the onion, chop into fine rings and gently sauté in a separate pan.
Stir constantly until the onion becomes translucent. Then sprinkle with
flour and continue to stir, making sure the onion and flour do not brown.
Mix a little of the cooking liquid from the tomatoes into the onion and flour
mixture, then add the tomatoes with the rest of the liquid. Stir well. Blend
the soup and add a little salt to taste. Serve immediately.

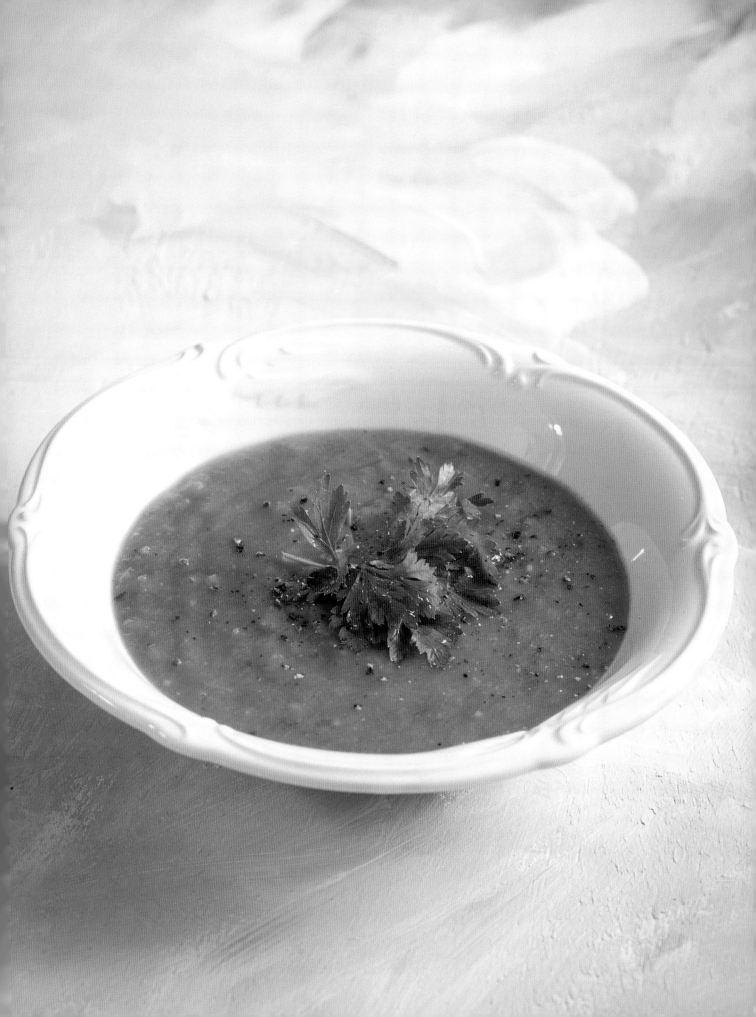

Cheese Soufflé

❖

2 eggs
60 g (4 tbsp or ¹/₂ stick) butter + 10 g (1 tbsp) for greasing the soufflé dish
60 g (¹/₂ cup) flour

250 ml (1 cup) milk
60 g (¹/₂ cup) grated Emmental
Salt + freshly ground pepper to taste

❖ *Serves 2 Preparation time: 10 minutes Cooking time: 30 minutes*

Grease a soufflé dish. Preheat the oven to 180°C (gas mark 4 or 350°F).

Melt the butter over a low heat and then remove from the heat and whisk in the flour until the butter is completely absorbed. Return the pan to the heat and cook the mixture gently, gradually adding the milk and whisking constantly. You should end up with a fairly thick sauce.

Separate the eggs. Take the pan off the heat, add the yolks one by one to the sauce: wait until the first yolk is fully mixed in before adding the second. Finally, add the grated cheese. Season with salt and pepper.

Beat the egg whites until they form stiff peaks, then carefully add them to the mixture, folding rather than stirring them in, and lifting the mixture up from the bottom. Pour the mixture into the soufflé dish, filling it no more than three-quarters full. Cook for about 20 minutes without opening the oven, until the soufflé has risen and has turned a lovely golden brown. Serve immediately.

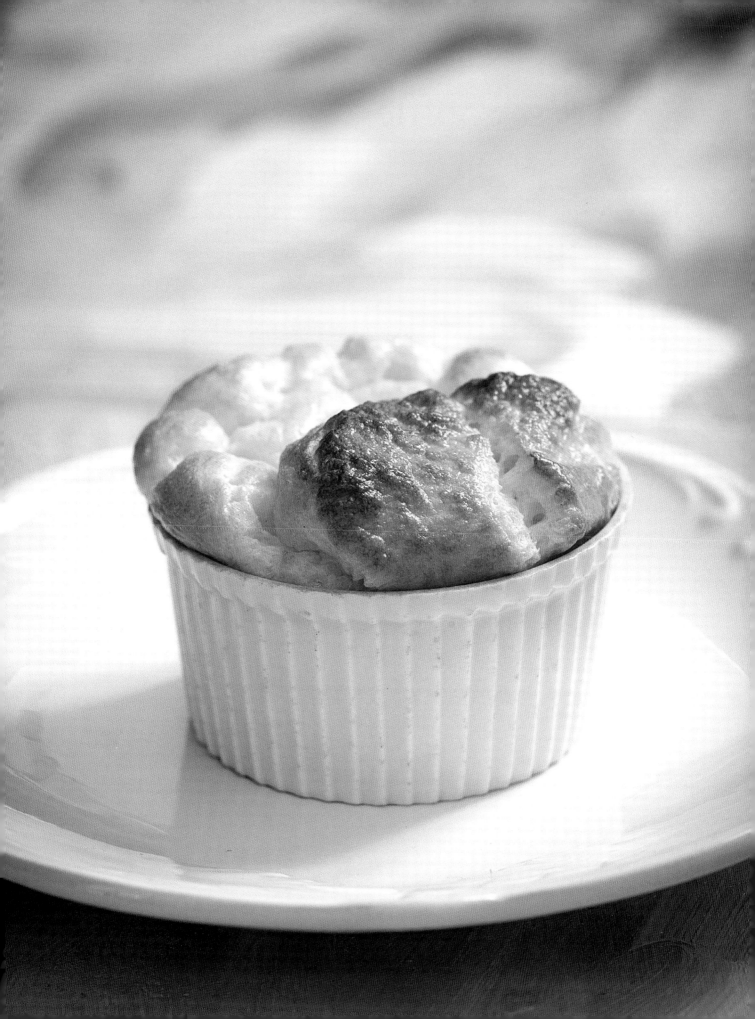

Mushroom Gratin

❖

200 g (3 cups) good quality button mushrooms
2 shallots
1 tbsp butter

150 ml (5 fl oz) light cream or half-and-half
1 tbsp cognac
1 tbsp flour
Salt + freshly ground pepper to taste

❖ *Serves 2 Preparation time: 15 minutes Cooking time: 35 minutes*

Trim off the muddy bases of the mushroom stems, then carefully wipe them and the mushroom caps to remove any grit, but do not wash them. Cut into fairly thin slices. Peel and dice the shallots.

Preheat the oven to 220°C (gas mark 7 or 425°F).

Put the butter in a medium saucepan to melt. When it begins to foam, add the shallots and mushrooms, cover and leave to sweat for about 10 minutes on a medium heat. Add the cognac and simmer for another 2 minutes.

Meanwhile, slowly mix the cream into the flour and then pour the mixture onto the mushrooms. Stir constantly to make sure that the mushrooms are coated with the cream and to thicken the sauce. Season with salt and pepper and then transfer the mixture to a gratin dish.

Bake in the oven for about 15 minutes until crisp and golden on top. Serve immediately.

Braised Beans

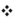

400 g (2 ¹/₂ cups) dried beans
(preferably Tarbais beans)
1 medium-sized piece bacon (200 g or
7 oz)
1 medium-sized piece smoked ham
(200 g or 7 oz)
6 Strasbourg sausages

2 medium onions
1 bouquet garni (1 large sprig
thyme + 2 bay leaves)
1 tbsp lard
100 ml (¹/₂ cup) fine red wine
Coarse salt to taste

❖ *Serves 6 Soaking time: 6 hours Preparation time: 15 minutes Cooking time: 2 hours 30 minutes*

Soak beans in plenty of cold water for at least 6 hours.

Peel the onions. Tie the thyme and bay leaves together into a bouquet garni.

Transfer the beans into a large casserole pan with the water they have been soaking in and add half of a tablespoon of coarse salt, the onions and the bouquet garni. Cover and cook over a medium heat for at least two hours. The beans should just simmer: turn down the heat as soon as the water begins to bubble to stop them from boiling. The beans should swell but not burst. When they are tender to the touch but not completely cooked, drain them in a colander over a bowl and reserve the cooking liquid. Cover the beans to keep them from drying out.

Dice the bacon and smoked ham into roughly 2 cm (³/₄ inch) cubes. Melt the lard in a large heavy-bottomed frying pan, add the bacon and ham and sauté until lightly golden but not brown. Then add the beans, red wine and about 400 ml (a bit more than 1 ¹/₂ cups) of the reserved cooking liquid. Put the sausages in the pan, gently submerging them. Cut a circle of greaseproof paper considerably larger in diameter than the pan and place it on top of the pan so that it overlaps with a tightly-fitting lid (to keep the steam in). Leave to simmer on a low heat for about 30 minutes, but take the lid off the pan from time to time to check how the beans are doing (without stirring them): they will be cooked when the sauce is almost completely reduced.

Carrots à la Fermière

❖

1 kg (2.2 lbs) large, bright orange carrots
1 small handful chervil, parsley and tarragon
Juice of 1 lemon
30 g (2 tbsp) butter

30 g (4 tbsp) flour
1 tsp superfine sugar
Salt + freshly ground pepper
to taste

❖ Serves 6 Preparation time: 20 minutes Cooking time: 1 hour 15 minutes

Peel the carrots and slice them into rounds. Put them in a saucepan, cover generously with water, season with salt and cook for about 15 minutes: the carrots should still be firm. Drain the carrots, reserving the cooking liquid.

Chop the herbs. Melt the butter in a frying pan. Remove from the heat and whip in the flour. Return to the heat and thicken, stirring constantly, then add the herbs. Season with pepper. Gradually stir in a ladle of the cooking liquid. Boil for a few minutes to allow the sauce to thicken again before adding the lemon juice and sugar. Add the carrots to the frying pan, cover them partway with a lid (to allow the steam to escape), and leave to cook over a very low heat. Add one or two more ladles of the cooking liquid, stirring gently to avoid crushing the carrots. After about an hour of cooking, they should be soft enough to melt in the mouth and be covered in a much-reduced sauce.

Warm a serving dish with boiling water and then arrange the carrots on it. Serve with braised meat.

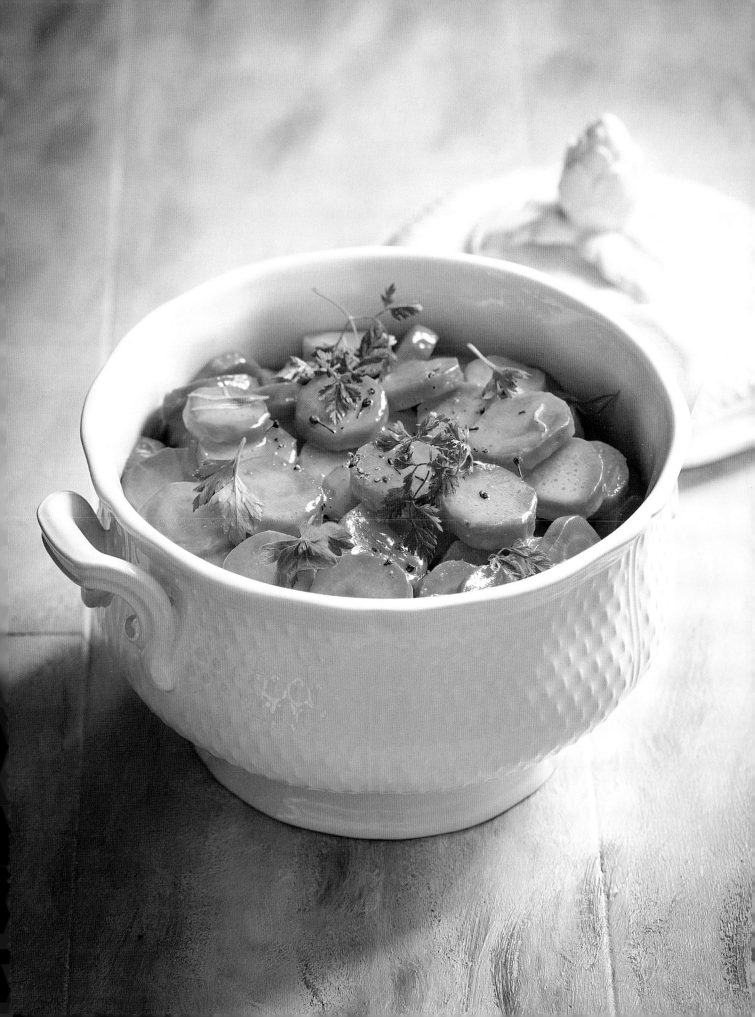

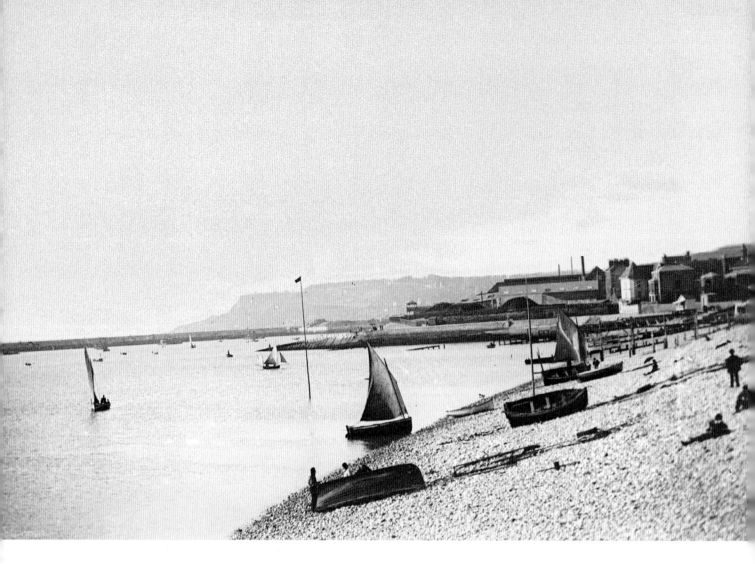

"To speak completely clearly, this dinner at Sainte-Adresse, near Le Havre, despite the fragrant scent of the sea, despite the very good local wines, the legs of veal and haunch of venison provided by the host, was a real mess."

Mérimée's dictation, 1857.

Above: Le Havre, photograph looking towards the Grand Jetty and Sainte-Adresse, a seaside resort made fashionable by the journalist and writer, Alphonse Karr.

Right: Marie Jeanne Lecadre, Claude Monet's father's half-sister, displayed great affection for her nephew and encouraged him on the difficult path he had chosen. Monet's Garden at Sainte-Adresse, painted in 1867, depicts his aunt's property, "Le Coteau."

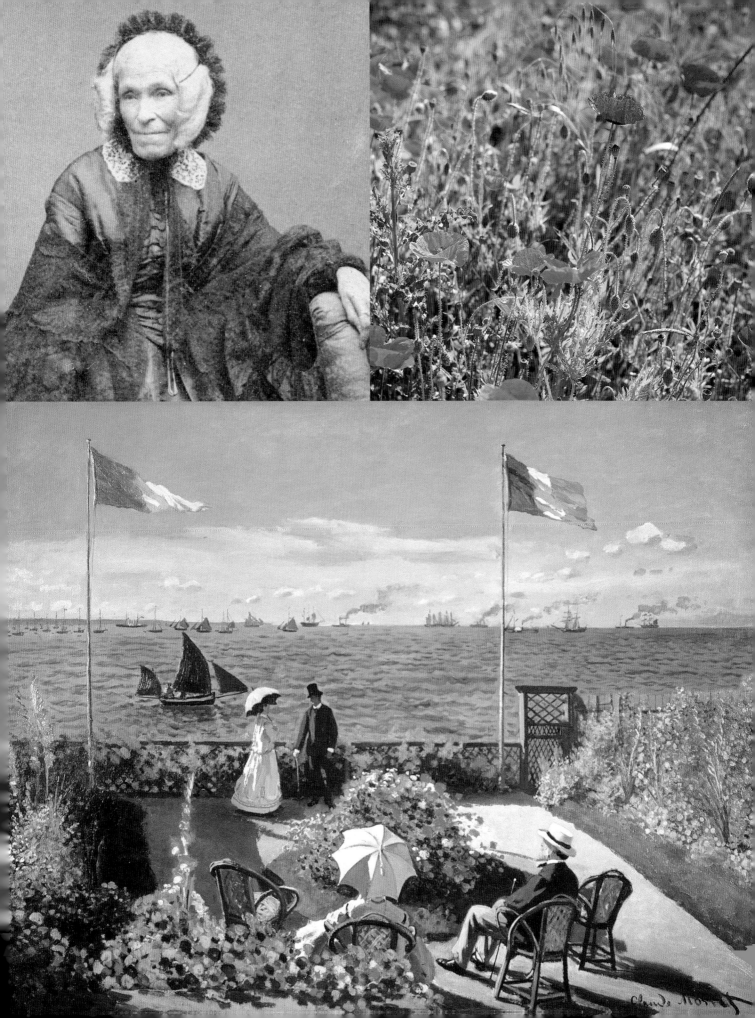

Chicken Chasseur

❖

1 medium free-range chicken, cut into pieces
250 g (4 cups) small button mushrooms
2 shallots
3 ripe tomatoes
30 g (2 tbsp)butter
3 tbsp oil
1 tbsp flour

1 tsp concentrated tomato purée
1 sprig tarragon
100 ml ($^1/_2$ cup) white wine
100 ml ($^1/_2$ cup) chicken stock (or 1 chicken stock cube dissolved in 100 ml or $^1/_2$ cup water)
Salt + freshly ground pepper to taste

❖ *Serves 4 Preparation time: 15 minutes Cooking time: 40 minutes*

Start by preparing the garnish. Wipe the mushrooms with a paper towel and cut off the muddy bases of the stems, then slice them lengthways from the caps down to the stalks. Peel and dice the shallots. Scald and then peel the tomatoes, de-seed them and roughly chop them.

Heat the butter in a large cast iron casserole pan with 2 tablespoons of the oil. When the mixture begins to foam, put in the chicken pieces and fry until golden, turning them several times. Remove from the pan when they are nicely golden and keep warm.

Add the remaining tablespoon of oil to the pan and slowly sauté the mushrooms. When they start to brown, add the chopped shallots and continue to fry for a few minutes until everything is golden. Sprinkle with the flour and mix well for two minutes with a wooden spoon. Mix in the white wine and simmer to reduce the liquid. Add the chopped tomatoes, tomato purée, sprig of tarragon and salt and pepper to taste. When the sauce has reduced by half, add the chicken stock and leave to simmer for 10 minutes.

...|...

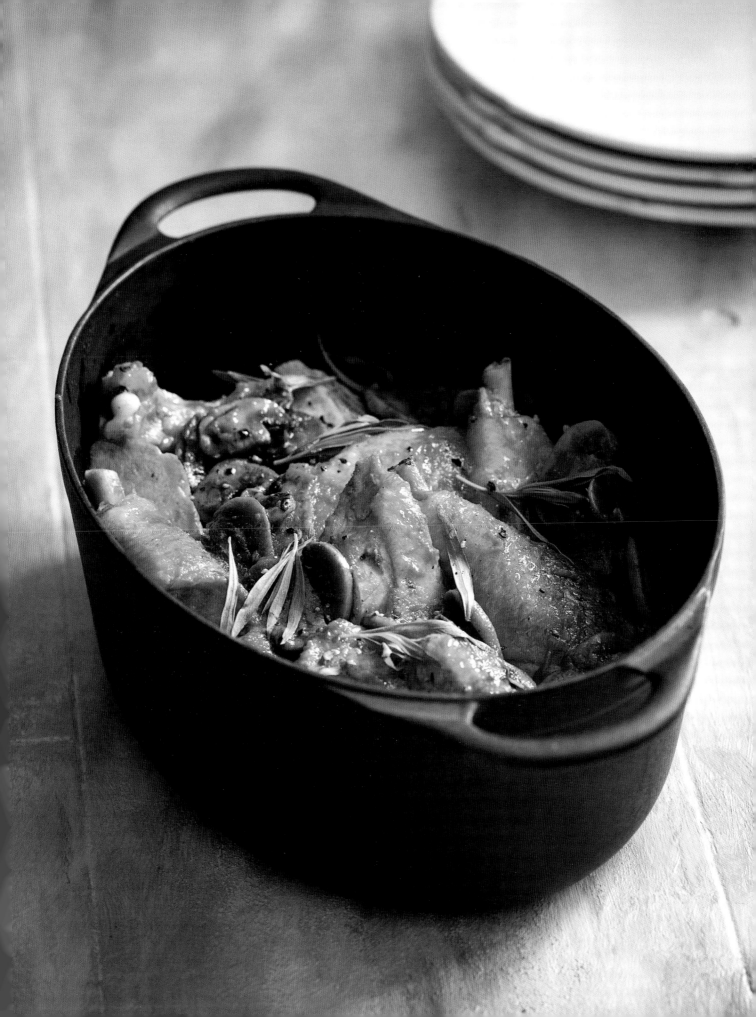

Put the chicken pieces back into the casserole with any juices they have generated while resting. Cook over a low heat for 20 minutes until tender and the sauce has thickened.

Remove the chicken from the pan and arrange on a serving dish. Keep warm. Return the pan to the heat and boil down the sauce if it is too liquid: it should coat the back of the spoon. Pour the sauce over the chicken pieces and serve immediately.

TIP

If tomatoes are not in season, substitute a carton of top quality chopped tomatoes or add 1 teaspoon of concentrated tomato purée.

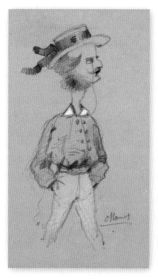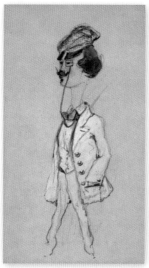

Above: In his youth at Le Havre, Claude Monet earned a real reputation as a caricaturist: "I was assailed on all sides by obsequious requests for caricature portraits," he told Thiébault-Sisson. The identities of the men with the boater and the monocle remain unknown, but the figure on the right is the writer Jules Husson, who wrote under the name of Champfleury.

Right: This portrait of Monet at the age of twenty-six by Alexandre de Séverac captures the bold, headstrong character that drove the young Monet to reject the teachings of academically-trained masters.

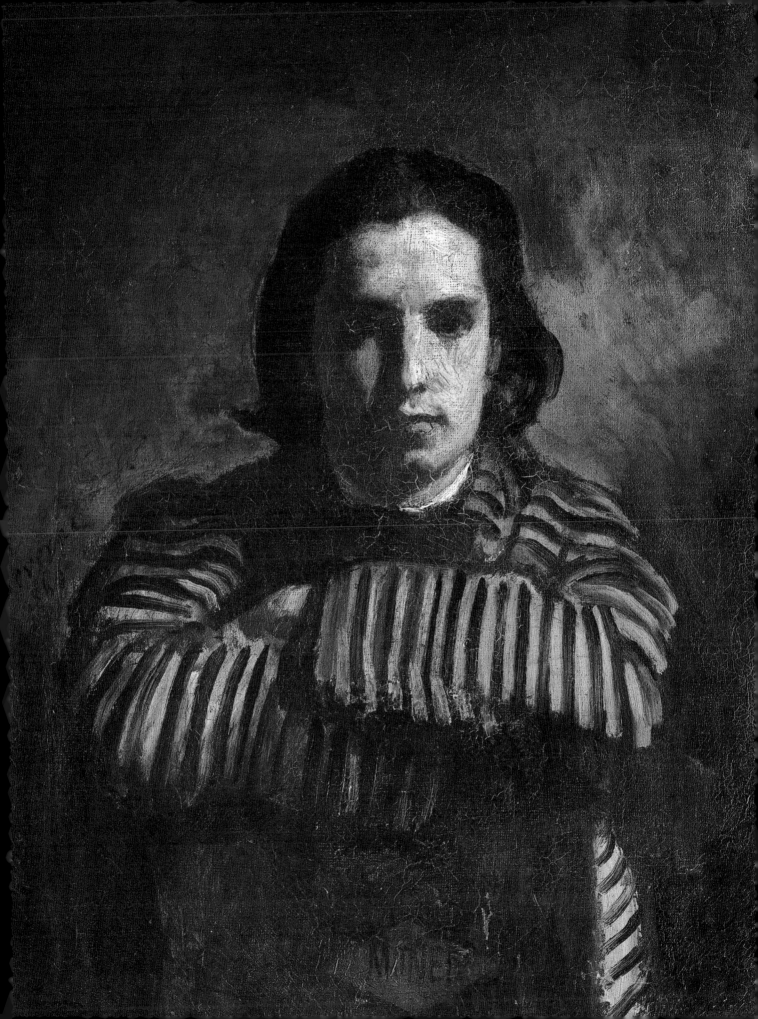

Grilled Chicken

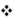

1 medium-sized free-range chicken
90 g (6 ¹/₂ tbsp) butter, softened
A few sprigs parsley or chervil

1 lemon
Salt + freshly ground pepper
to taste

❖ *Serves 4 Preparation time: 10 minutes Cooking time: 45 minutes*

Preheat the oven to 180°C (gas mark 4 or 350°F).

Lay the chicken breast-side down on a chopping board. Using a large knife, cut down one side of the backbone and then the other to remove it, pressing firmly on the knife to cut through the bone on either side. Butterfly the chicken and lay it on a large baking sheet, rub with about 60 g (4 tablespoons) of softened butter and season generously with salt and pepper.

Put the chicken in the oven and roast for 15 minutes. Remove from the oven and put under the grill for 30 minutes, turning it over regularly so that it turns golden on both sides.

To serve, melt 30 g (2 tablespoons) of butter in a pan and pour over the chicken. Sprinkle with chopped parsley or chervil and serve with quarters of lemon.

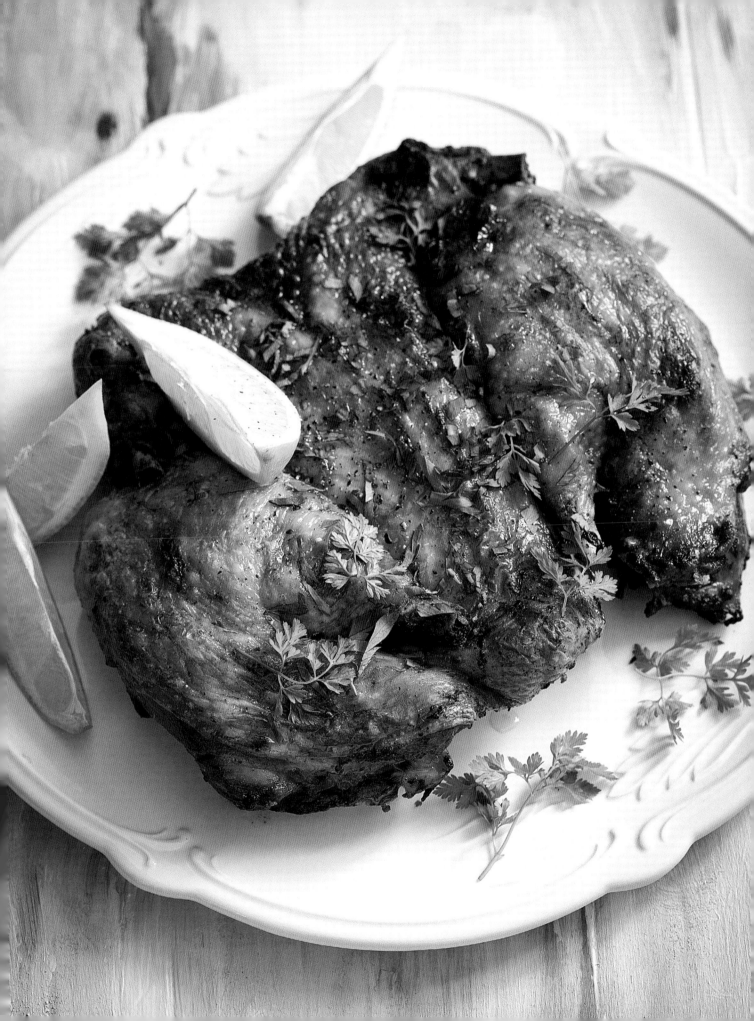

Fillet of Beef in Pastry

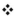

For the filling
200 g (7 oz) beef, cooked weight
1 onion
1 garlic clove
5 tomatoes
1 bunch parsley
1 handful tarragon
1 slice smoked fatty bacon
1 tbsp butter + 2 tsp for greasing the pan
1 whole nutmeg for grating

1 egg yolk
Salt + freshly ground pepper
to taste

For the pastry
500 g (4 cups) flour
30 g (1 oz) lard
100 g (7 tbsp or a bit less than 1 stick)
butter, softened
10 g (2 tsp) table salt

❖ *Serves 6 Preparation time: 40 minutes Resting time: 30 minutes Cooking time: 70 minutes*

Start by preparing the pastry. Sieve the flour onto a work surface with the salt and make a well in the center. Cut the lard and butter into small pieces and rub into the flour with your fingertips until the mixture resembles coarse breadcrumbs. Add enough water (100 ml or ¹/₂ cup or more as needed) to make a firm dough and then knead. Shape the dough into a ball and roll it out to three times its original size. Wrap in plastic wrap and leave to rest in the fridge while you make the beef.

Fillet the beef and cut it into very small pieces. Peel and dice the garlic clove and onion. Scald the tomatoes to make them easier to peel, remove the seeds and then chop them roughly and put in a colander to drain. Chop the herbs. Chop the bacon into small pieces. Put everything in a pan with a tablespoon of melted butter and gently sauté, turning regularly. Cook for about 10 minutes or until the meat mixture is fairly soft. Season with salt, pepper and grated nutmeg. Put in a dish and leave for 30 minutes or until completely cool.

Preheat the oven to 180°C (gas mark 4 or 350°F).

Grease a loaf pan. Divide the pastry into two unequal halves and roll out each to a thickness of 4mm. Use the larger piece to line the sides and base of the pan, add the meat mixture, and cover with the smaller piece of pastry. Pinch together the two pieces of pastry to seal, brush with beaten egg yolk, make a hole in the top center and insert a small cardboard funnel to allow the steam to escape. Bake in the oven for 1 hour. Serve warm or cold.

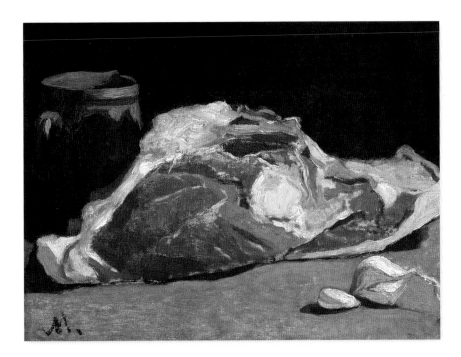

Claude Monet, *Still Life with Meat*, c. 1864.

Veal with Olives

❖

1 veal joint (fillet or equivalent), 1 kg (2.2 lbs) in weight
250 g (1 cup) quality green olives
48 small grelot onions

100 ml ($^{1}/_{2}$ cup) stock, hot
3 tbsp oil
Salt + freshly ground pepper to taste

❖ *Serves 4 Preparation time: 20 minutes Cooking time:1 hour 10 minutes*

Heat the oil in a casserole pan and sear the meat on all sides over a medium heat, turning frequently. Cover and cook for 30 minutes on a low heat.

Meanwhile, peel the onions and pit the olives (use an olive pitter so they stay whole).

Put the olives and onions in the pan around the meat. Season lightly with salt (because of the already salty olives) and season more generously with pepper. Cover again and cook for another 30 minutes.

Take the meat out of the pan and let it rest on a carving board. Make a sauce by pouring the stock into the pan and stirring vigorously, scraping the bottom of the pan to incorporate the meat residue. Boil to thicken and then pour into a gravy boat.

Carve the meat and arrange on a serving dish. Serve the sauce alongside.

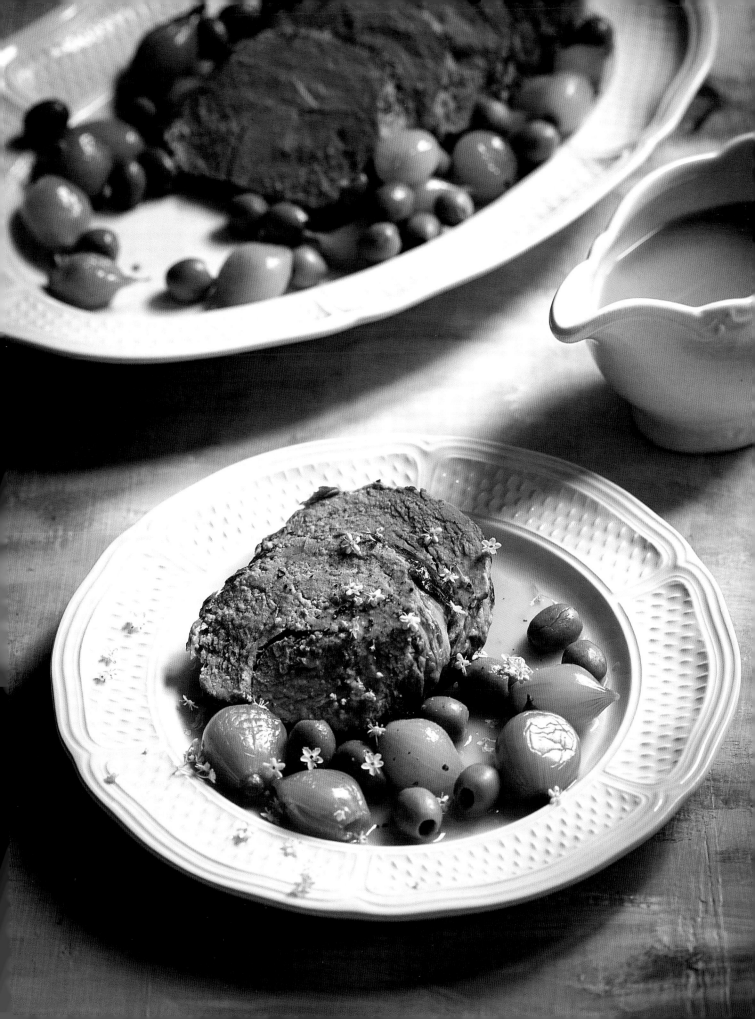

Duck with Turnips

❖

1 free range duck, dressed, 1.5 kg (3-4 lbs) in weight, liver and gizzard reserved
1 kg (2.2 lbs) small baby turnips

150 ml (5 fl oz) stock
2 tbsp duck fat (or 1 tbsp oil + 1 tbsp butter)
Salt + freshly ground pepper to taste

❖ *Serves 4 Preparation time: 20 minutes Cooking time: 1 hour 30 minutes*

Cut the duck liver and gizzard into small pieces, season generously with salt and pepper and place in the cavity of the bird. Heat the duck fat in a casserole pan (substituting the butter and oil for this if necessary). When the fat begins to smoke, brown the duck on all sides, turning frequently. Season generously with salt and pepper, then pour in half of the stock, cover the pan and simmer over a low heat for 30 minutes.

Meanwhile, peel the turnips and cut them in halves or quarters depending on size. Put them in the pan, add a little more stock if the cooking liquid has greatly reduced, bring to a gentle boil and then turn down the heat. Cover and leave to cook for 1 hour. To check if the duck is cooked, insert the point of a knife into the fold of the thigh: the juice should run clear. If it is still a little pink, return to the heat and cook for about 15 minutes.

When it is done, cover the duck with foil and leave to rest on a carving board for 5 minutes before carving. Meanwhile, keep the turnips warm.

Carve the duck and arrange the slices on a serving dish. Garnish with turnips and pour the cooking juices over the top. Serve immediately.

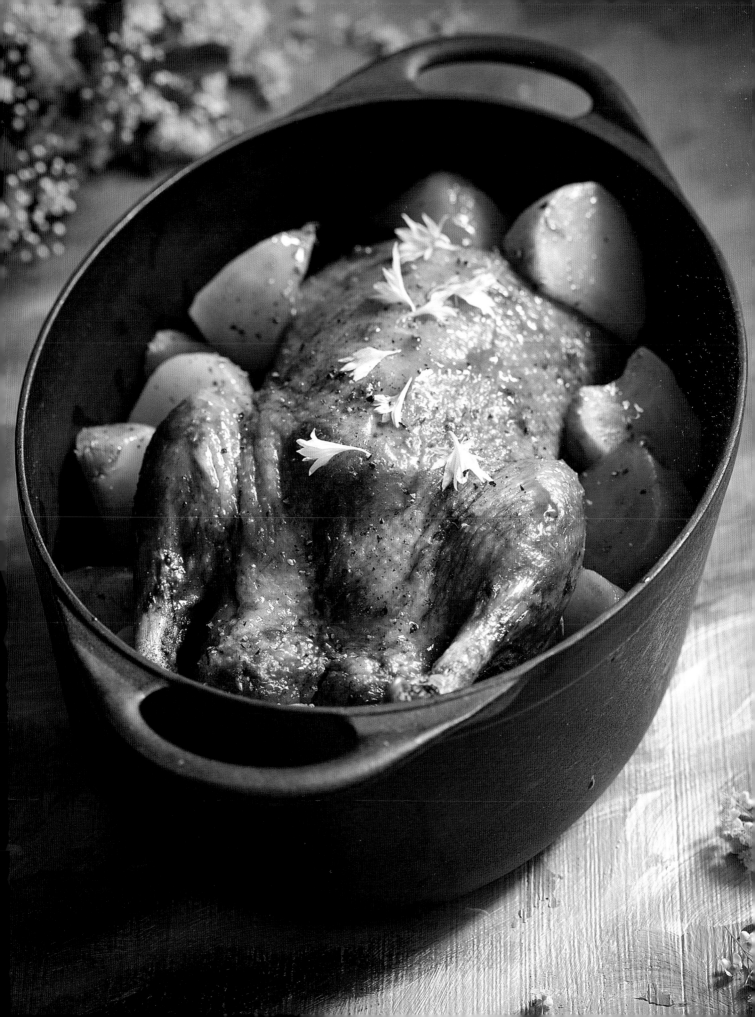

Oysters with Sausages

❖

2 dozen oysters, size 3 (medium)
8 small sausages

❖ *Serves 4 Preparation time: 10 minutes Cooking time: 10 minutes*

Open the oysters, tip away any water and lay them flat on plates.

Cook the sausages in a frying pan for about 10 minutes, turning them over several times so that they are crispy all over.

Serve the hot sausages along with the oysters. Eat the two together: the tastes contrast perfectly!

TIP

Traditionally, this recipe from the Gironde used local sausages made with white wine and cognac, but chipolatas make a perfectly good substitute. If necessary, make two small sausages out of one larger one by pinching it in the middle and twisting the casing.

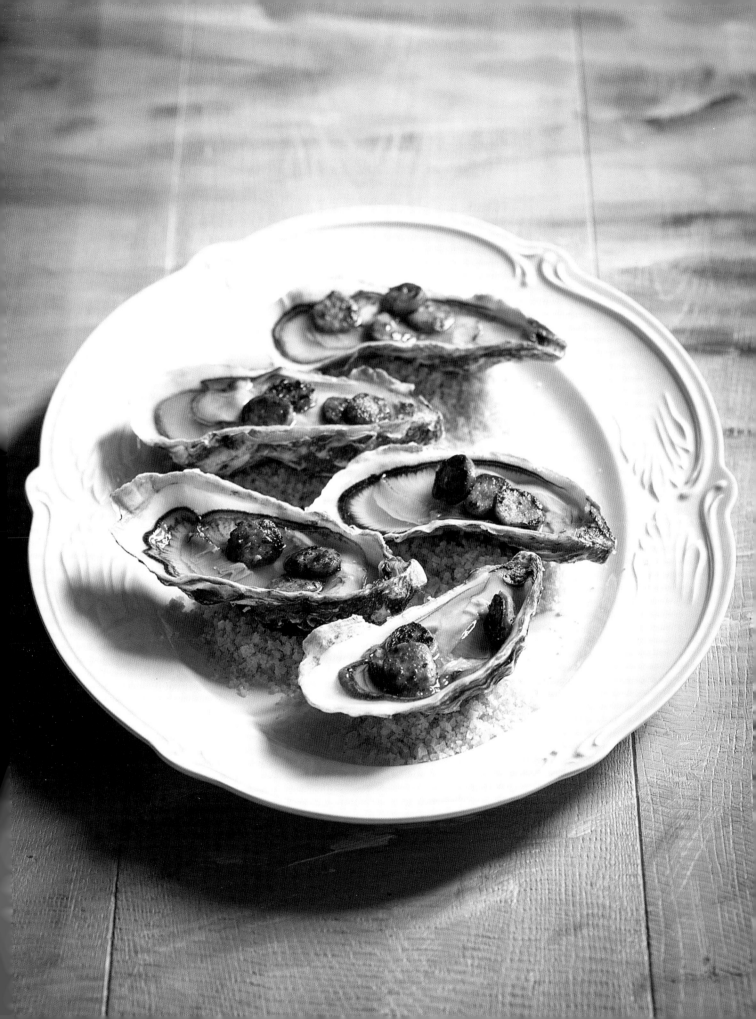

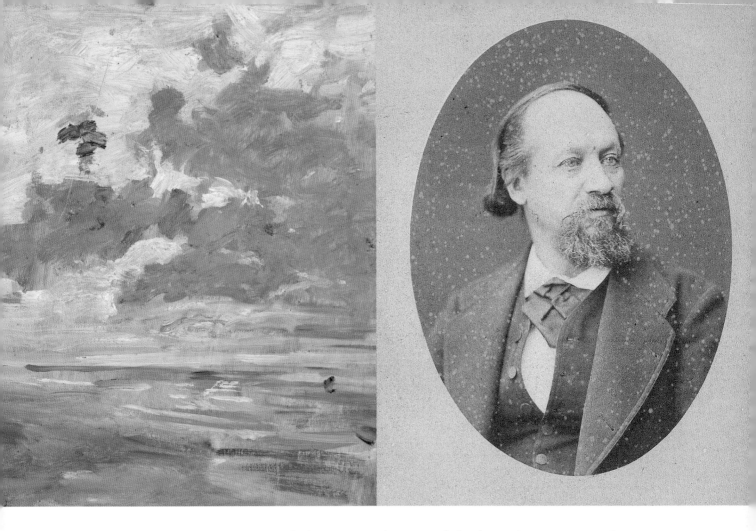

"And Boudin, with his inexhaustible kindness, took it upon himself to educate me. With time, my eyes began to open and I really started to understand nature. I also learned to love it. I would analyse its forms with my pencil. I would study its colourations."

Claude Monet, *My History*, collected by Thiébault-Sisson, 1900.

Above left: Eugène Boudin, *Large Sky*, c. 1888–1895.

Above right: Boudin came across the young Monet's caricatures and encouraged him by saying, "Study, learn to look, paint and draw. Do some landscapes" (Claude Monet, *My History*, 1900).

Right: Eugène Boudin, *The Jetty at High Tide, Trouville*, c. 1888-95.

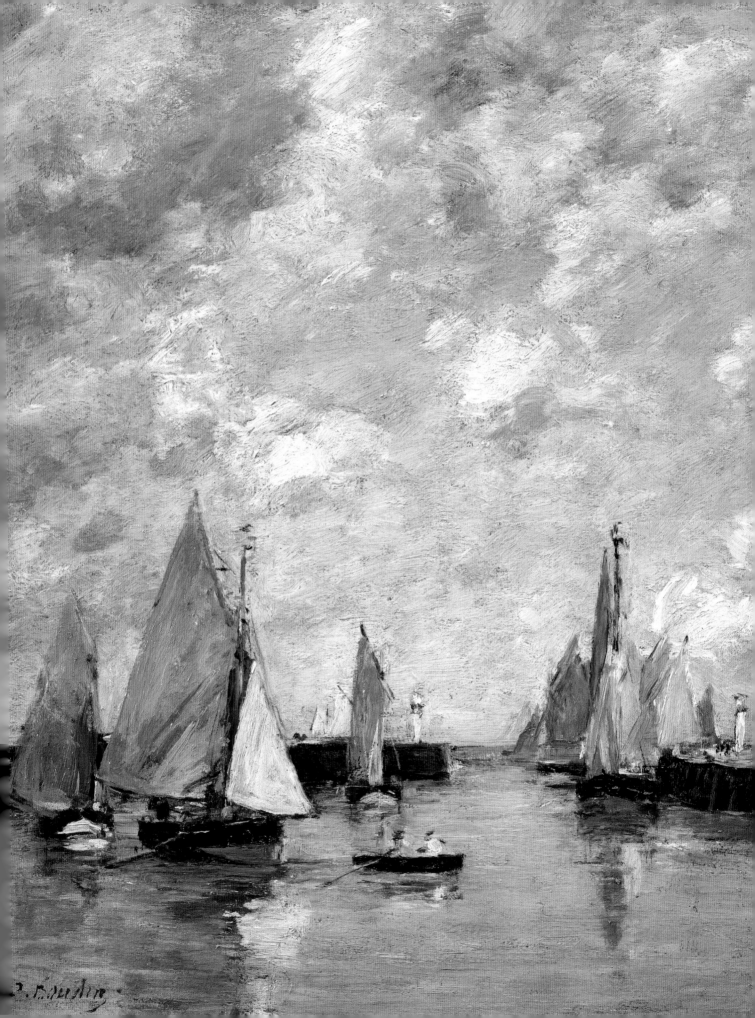

Mackerel Fillets à la Flamande

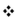

For the Fish
4 small mackerel or 2 larger ones
1 egg
40 g (3 tbsp) butter
1 tsp oil
1 lemon (or verjuice)

For the Maitre d'Hotel Sauce
2 tbsp parsley and chives, chopped
1 tbsp butter
1 level tbsp flour
nutmeg (grated)
Salt + freshly ground pepper to taste

❖ *Serves 4 Preparation time: 15 minutes Cooking time: 20 minutes*

Dress the mackerel: cut off the heads and trim off the tails and fins with scissors. Gut the mackerel and then lift out the fillets off of the backbone.

Make the Maitre d'Hotel Sauce: melt the butter over a low heat, sprinkle in just enough flour to thicken the sauce. Whisk together. When the flour has absorbed all the butter, add the finely chopped herbs, and then pour in 100 ml (½ cup) of water. Whisk briskly, then season with salt, pepper and a pinch of grated nutmeg. Cook until the sauce has thickened and keep warm.

Break an egg into a bowl and beat. Heat the butter in a frying pan with a dash of oil. Dip the mackerel fillets into the beaten egg, shake off any drips, then fry them for 3 minutes on each side, turning them over with a spatula so they do not break. Reheat the sauce and thin slightly with a splash of lemon juice or a dash of verjuice.

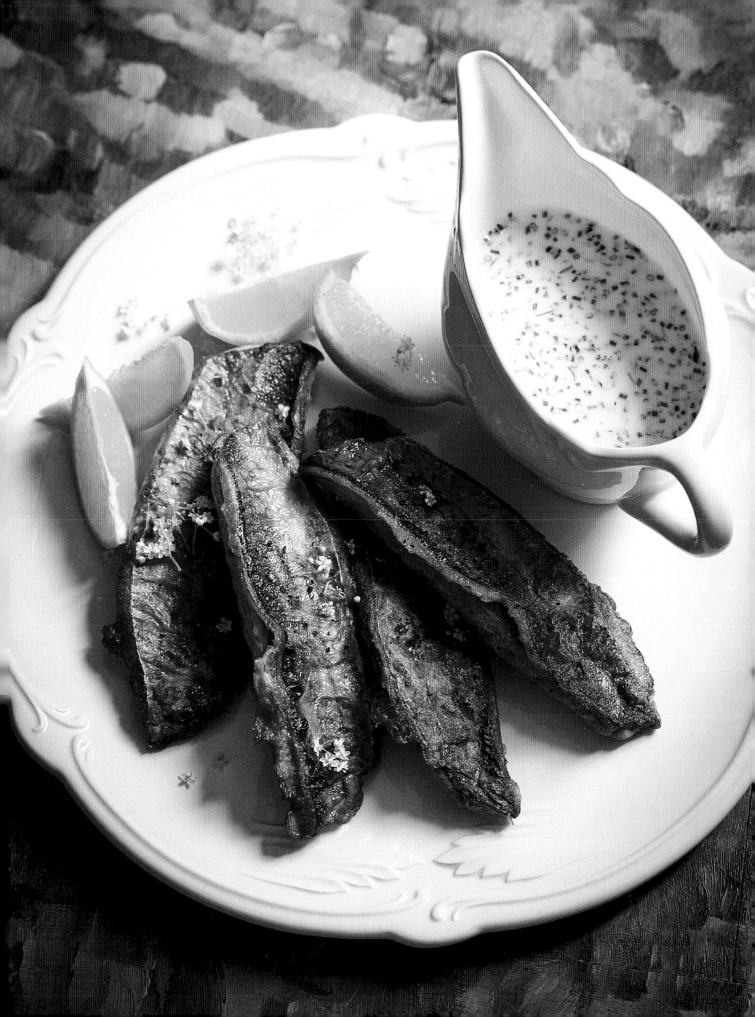

Fish Soup

❖

1.5 kg (3-4 lbs) fish, cut into chunks (hake, cod, bream, conger eel)
4 leeks
4 carrots
2 medium-sized garlic cloves
2 medium-sized onions

200 ml (1 cup) olive oil
4 slices *pain de champagne* (sourdough bread)
1 pinch chili powder
1 pinch saffron (threads)
3 egg yolks
Salt + freshly ground pepper to taste

❖ *Serves 6 Preparation time: 25 minutes Cooking time: 2 hours*

Rinse the fish chunks under cold water and dry them well. Put them in the fridge while you make the stock.

Prepare the vegetables for the stock: peel the carrots and cut into rounds; wash the leeks and cut them into chunks; peel and dice the onions; peel and crush the cloves of garlic. To flavor the stock, start by gently frying the onions and garlic in a large stew pot for 10 minutes with 3 tablespoons of olive oil. Add the carrots and leeks and keep cooking over a low heat, then pour in 2 liters (8 cups) of water. Season with a little salt and plenty of pepper, cover and simmer for 1 hour 30 minutes.

Add the chunks of fish and poach for 20 minutes. Meanwhile, cut the bread into croutons and fry these in hot oil. Drain.

Remove the fish from the stew pot and reserve the best-looking bits and keep warm. Mash the rest in a bowl. Strain the stock, season with chili and saffron, bind with the egg yolks and then add the mashed fish. Serve with the reserved bits of fish and croutons.

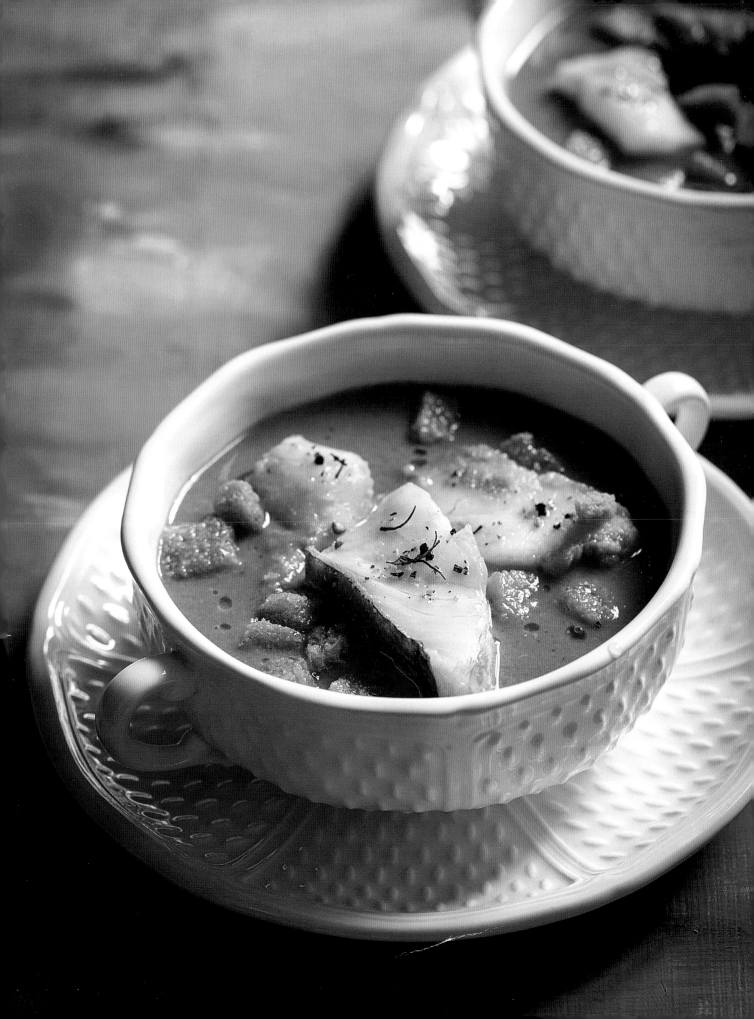

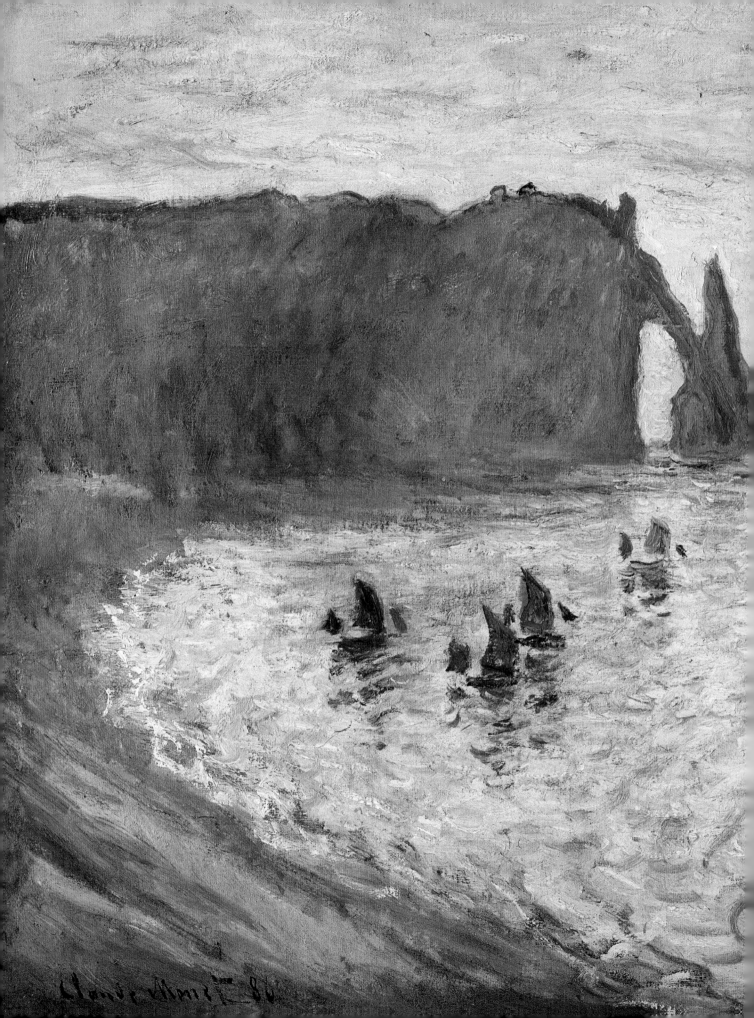

Claude Monet, *The Cliffs at Étretat*, 1885. Monet returned again and again to paint in the area where he had grown up. The changeable Norman weather often made his work difficult, so much so that on one occasion in November 1885 he ended up soaked and clinging to a rock: "But then the excitement passed and no harm was done, the worst of it was that I lost my painting which quickly got broken to bits, along with my easel, bag etc.," he wrote to Alice.

Lobster à l'Américaine

❖

1 medium-sized lobster (about 1 kg or 2.2 lbs)
3 shallots
2 garlic cloves
1 onion
2 tbsp olive oil
80 g (5 tbsp) butter

50 ml (3 tbsp) cognac
200 ml (1 cup) dry white wine
1 tbsp concentrated tomato purée
1 pinch cayenne pepper
Salt + freshly ground pepper
to taste

❖ *Serves 4 Preparation time: 15 minutes Cooking time: 25 minutes*

With a sharp knife, cut the lobster in two, separating the body from the tail and reserve the liquid that runs out of it. Break the body in two down the middle and discard the gritty pocket; reserve the roe and intestines. Break off the claws. Cut the tail into chunks along the markings.

Peel and dice the shallots and onions. Peel and crush the garlic cloves.

Heat the oil in a large frying pan until bubbling and stir-fry the chunks of tail and the claws. Season with salt and pepper. Cook for 5 minutes. Remove the lobster and discard the oil.

Throw half of the butter into the hot pan. Immediately put the pieces of lobster back into the pan along with the finely chopped shallots, onions and the crushed garlic.

.../...

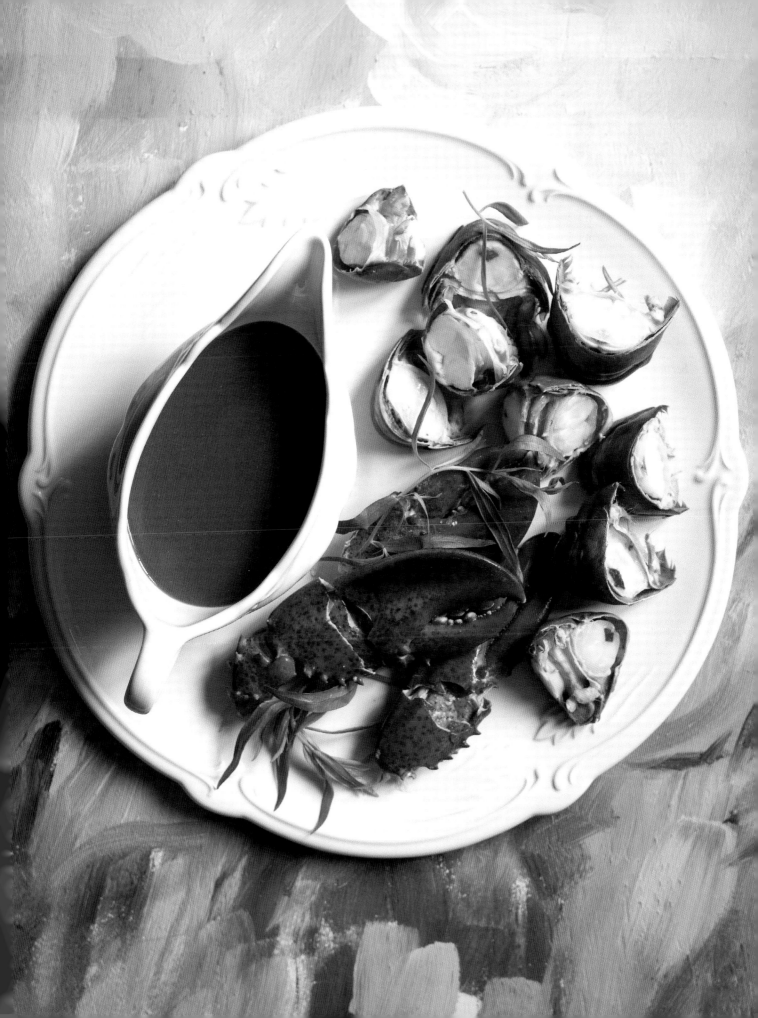

When the lobster is a nice red color, pour in the cognac and flambé; then pour in the white wine, add the tomato purée and mix well. Season with salt and pepper and a pinch of cayenne pepper. As soon as it begins to bubble, cover, turn down the heat and simmer for 10 minutes.

Thicken the sauce by gradually stirring in the remaining butter with a whisk.

Arrange the lobster on a serving dish and pour the sauce over it. Serve immediately.

TIP

Break the large claws first to make them easier to shell.

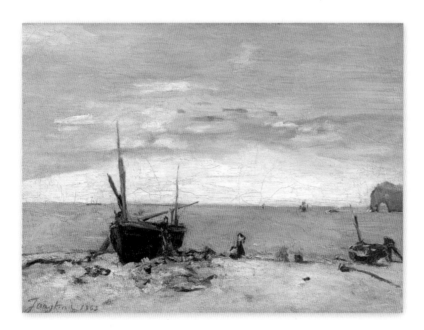

Above: Johan Barthold Jongkind, Étretat, 1865. The Dutch painter completed Monet's education. Monet enjoyed his joyful personality: "Never was a meal so cheerful. Outside in the open air, in a little country garden, under the trees, a good rustic spread before him, a full glass of wine in hand and a pair of obviously sincere admirers at his side, Jongkind was not altogether at ease" (Claude Monet, *My History*, 1900).

Crème à la Vanille

❖

1 liter (4 cups) milk	1 vanilla pod
200 g (1 cup) superfine sugar	2 eggs + 6 egg yolks

❖ *Serves 6 Preparation time: 15 minutes Cooking time: 1 hour*

Preheat the oven to 150°C (gas mark 2 or 300°F).

Make a bain-marie by putting a roasting pan of water in the oven.

Put the milk and sugar in a saucepan, split the vanilla pod in two, scrape the seeds into the milk, throw in the pod and bring to a boil.

Beat the eggs and yolks in a bowl. Add a little hot milk, stirring briskly. Next pour the eggs into the pan and bring to a boil, whisking constantly to thicken the cream. Strain through a fine colander or sieve, pour into a dish and cook for 1 hour in the bain-marie.

Take the dish out of the oven and leave until completely cool. Serve cold.

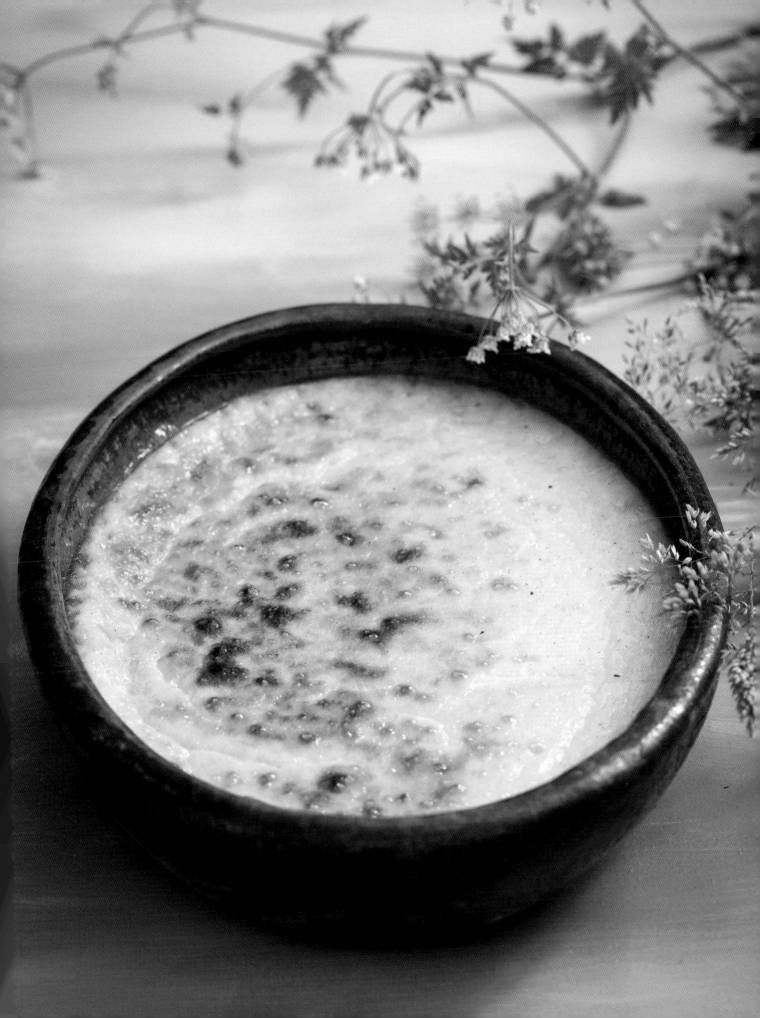

Tarte Tatin

250 g (2 cups) flour
400 g (3 ¹/₂ sticks or 14 oz) butter
1 egg yolk

6 reine de reinettes (King of the Pippins)
apples
225 g (1 cup + a pinch) superfine sugar
Salt to taste

❖ *Serves 4 Preparation time: 40 minutes Resting time: 1 hour Cooking time: 45 minutes*

Preheat the oven to 200°C (gas mark 5 or 400°F).

Cut the butter into small pieces. Sift the flour onto a work surface
and place 75 g (6 tablespoons) of sugar, the egg yolk, a pinch of salt and
50 ml (3 tablespoons) of warm water in a well in the center. Knead together,
then add 250 g (2 sticks + a bit or 9 oz) of butter in small pieces and knead
again into a smooth dough. Roll out once, then shape back into a ball and
put in the fridge to rest for 1 hour. Roll out again to a thickness of 5 mm
(¹/₂ cm).

Peel the apples, cut them into slices and place them in a dish with fairly
high sides with the rest of the chopped butter (150 g or 1 ¹/₄ sticks or 5 oz)
and 150 g (about 1 ²/₃ cup) of sugar. Cover with the pastry. Bake in a hot oven
for 45 minutes.

Turn out of the dish before serving. It is best to serve hot.

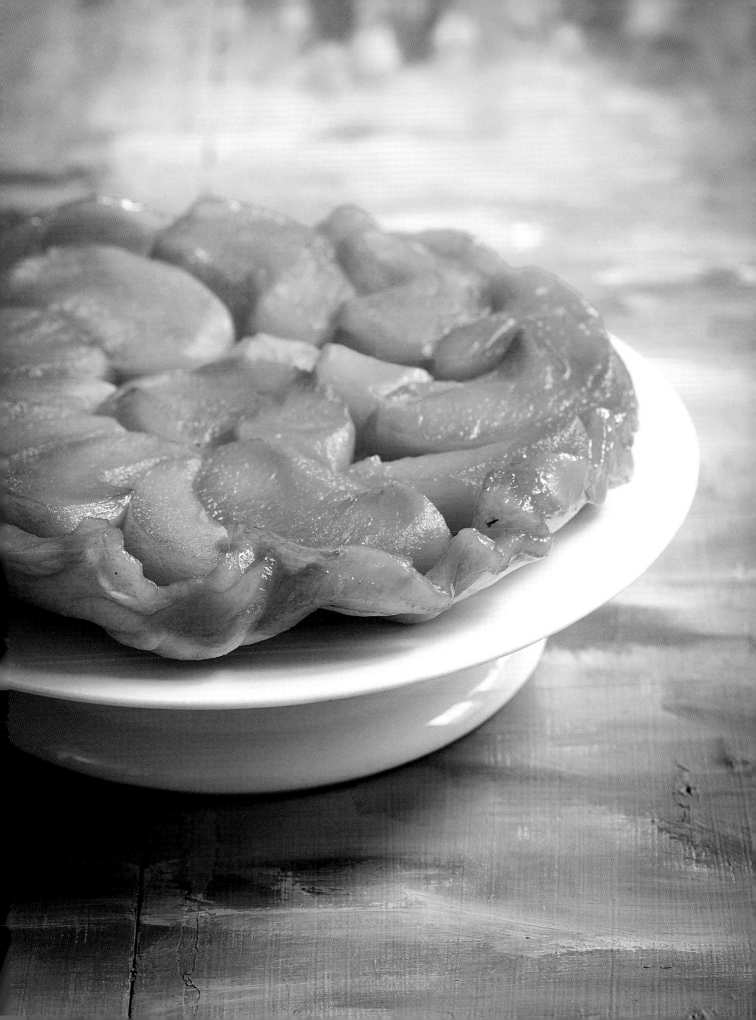

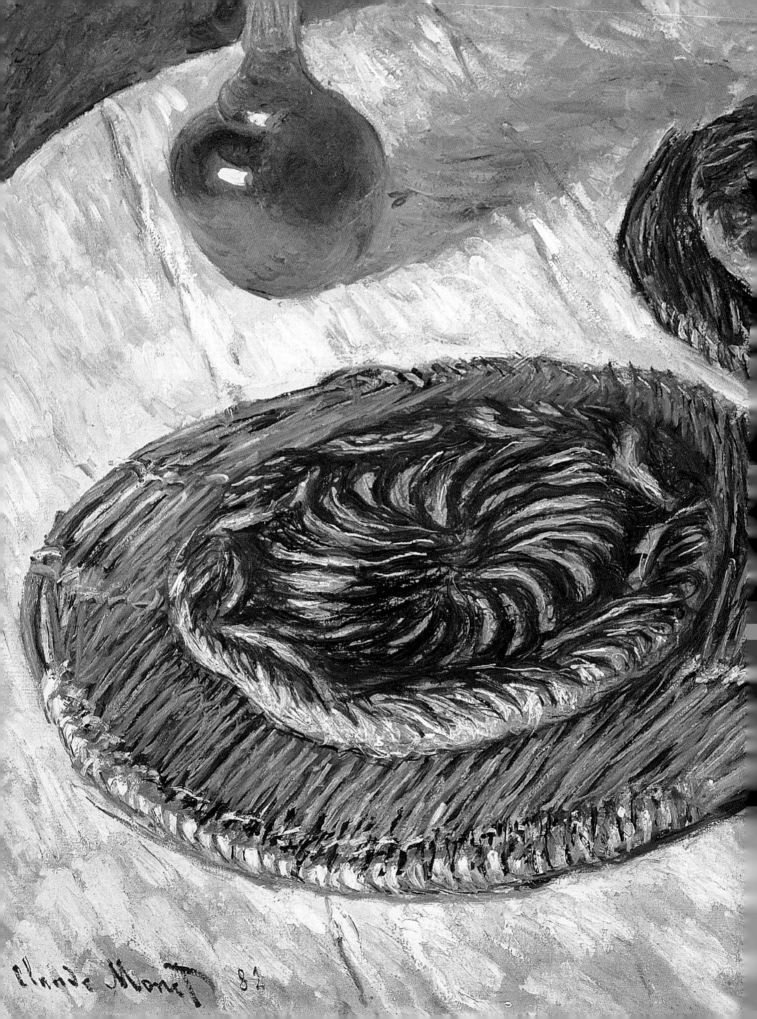

Claude Monet 82

Claude Monet, *The Galettes*, 1882.

Monet painted this picture at Pourville, in the Auberge du Père Paul, where Gustave Geffroy saw it displayed as follows: "In this inn at Pourville, where I also stayed, I saw Monet's portraits of the innkeeper and his wife, Père Paul in his chef's clothes and Mère Paul in a bonnet, with a terrier in her arms. Hanging between the two was another picture, of a galette and a carafe of cider, and the still life was as beautiful as the portraits were expressive. These three paintings hung in the linen store, among the tablecloths and napkins. Today they are seen all over the world" (Gustave Geffroy, *Claude Monet, His Life and Work*, 1924).

Nantes Cakes

❖

500 g (4 cups) flour
250 g (1 cup) superfine sugar + a few pinches
for dusting
250 g (1 stick + a bit or 9 oz) butter, softened +
extra for greasing the parchment paper

100 g ($^1/_2$ cup) blanched almonds +
a few flaked almonds for decoration
4 eggs
1 lemon

❖ *Makes about 20 cakes Preparation time: 20 minutes Cooking time: 15 minutes*

Preheat the oven to 180°C (gas mark 4 or 350°F).

Coarsely grind the almonds. Grate the lemon to a fine zest.

Pour the flour into a large bowl, make a well in the center and put in
the sugar, butter cut into pieces, ground almonds, lemon zest and eggs.
Mix everything thoroughly to form a stiff dough.

Roll out the dough to a few millimeters ($^1/_4$ cm) in thickness. Using a
thin-rimmed drinking glass, cut out rounds of dough and place these
on a baking tray lined with a sheet of lightly greased parchment paper.
Decorate each cake with flaked almonds and sprinkle with sugar.

Bake in the oven for 15 minutes.

Leave to cool. It is best to wait 24 hours before serving.

Genoese Sponge

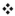

250 g (1 ½ cups) blanched almonds
125 g (1 stick + and a bit or 4.5 oz) butter + extra
for greasing the pan
300 g (1 ½ cups) superfine sugar

5 eggs
100 g (a bit less than 1 cup) flour
50 ml (3 tbsp) kirsch

❖ Makes 8 Preparation time: 25 minutes Cooking time: 40 minutes

Preheat the oven to 180°C (gas mark 4 or 350°F).

Cream the butter in a bowl and add the sugar. Beat until creamy. Continue beating and add the eggs one at a time.

Grind the almonds to a fine powder and then add them into the cake mixture with the kirsch. Add the flour last.

Grease a spring-form cake pan, pour in the cake mixture and bake in the oven for 40 minutes. Insert the point of a knife into the middle of the cake: the blade should come out clean.

Leave to cool before turning out onto a serving plate.

Lemon Madeleines

125 g (5/8 cup) superfine sugar
125 g (1 stick + a bit or 4.5 oz) butter,
softened + some shavings for greasing
the pans

125 g flour (1 cup + a bit) + a few pinches
for dusting the pans
4 eggs
1 lemon

❖ *For 12 Madeleines Preparation time: 25 minutes Cooking time: 10–15 minutes*

Preheat the oven to 170°C (gas mark 3 or 325°F).

Combine the sugar, butter and egg yolks in a bowl. Beat until pale.
Whip the egg whites into soft peaks. Add the egg whites and flour to
the mixture, one spoonful at a time, alternating between the two
until they are used up. Add the finely grated lemon zest.

Grease the madeleine pans and dust lightly with flour. Place a small spoon-
ful of mixture into each mould. Bake in the oven for 10 to 15 minutes, but
do not leave the madeleines in for any longer or they will dry out.

Turn them out of the pan as soon as they come out of the oven and leave
to cool.

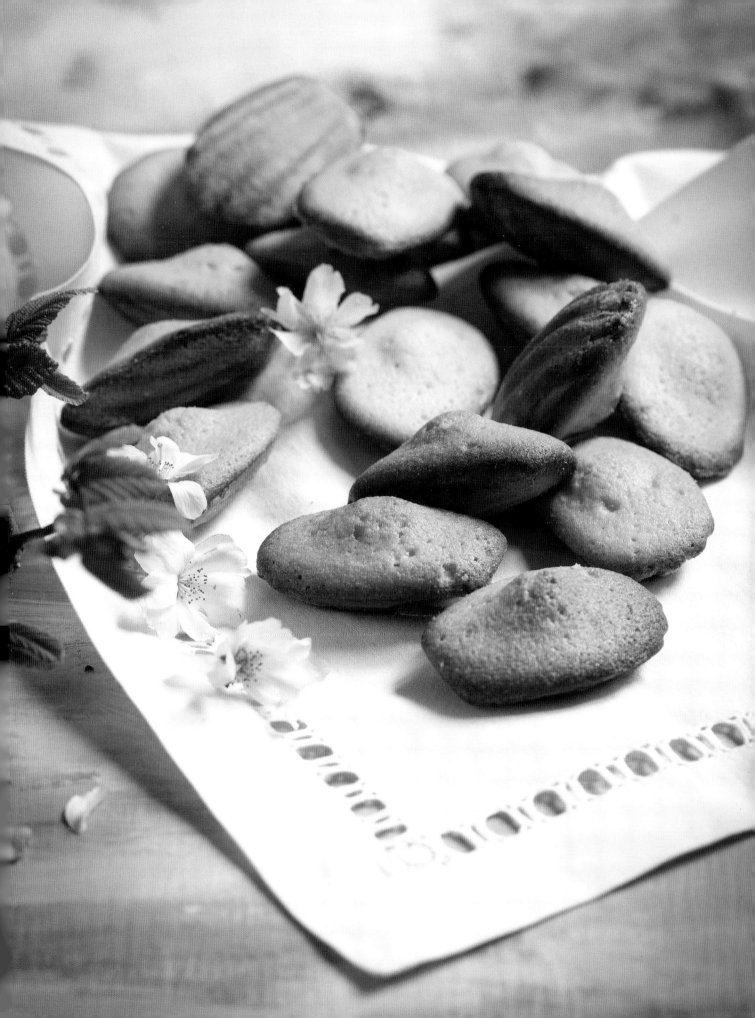

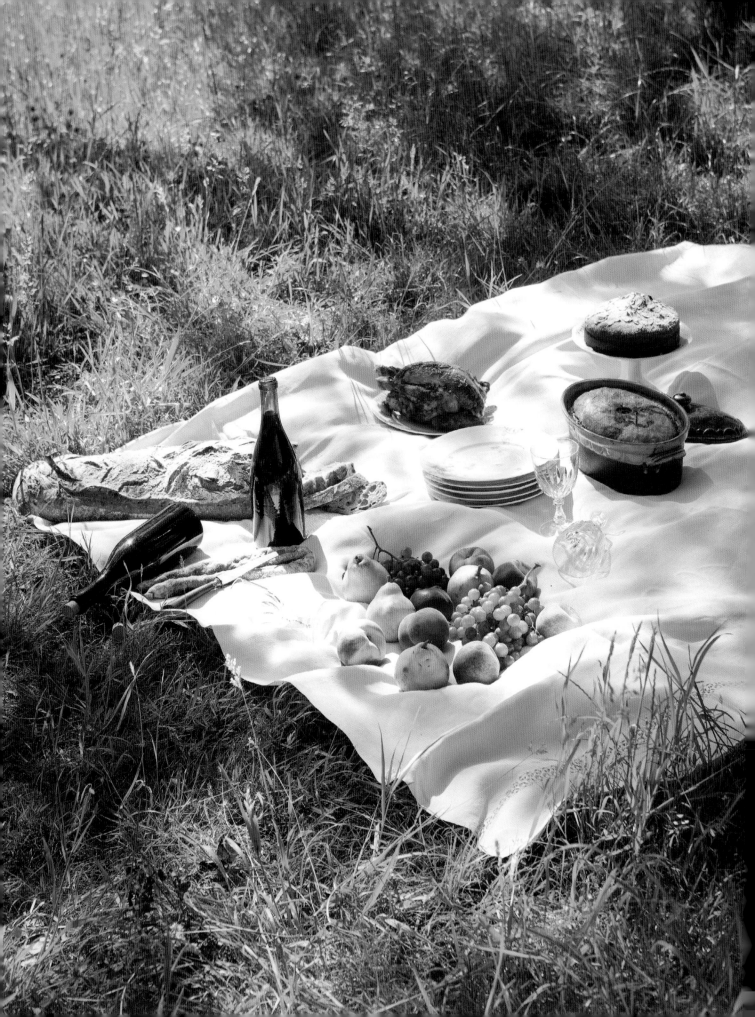

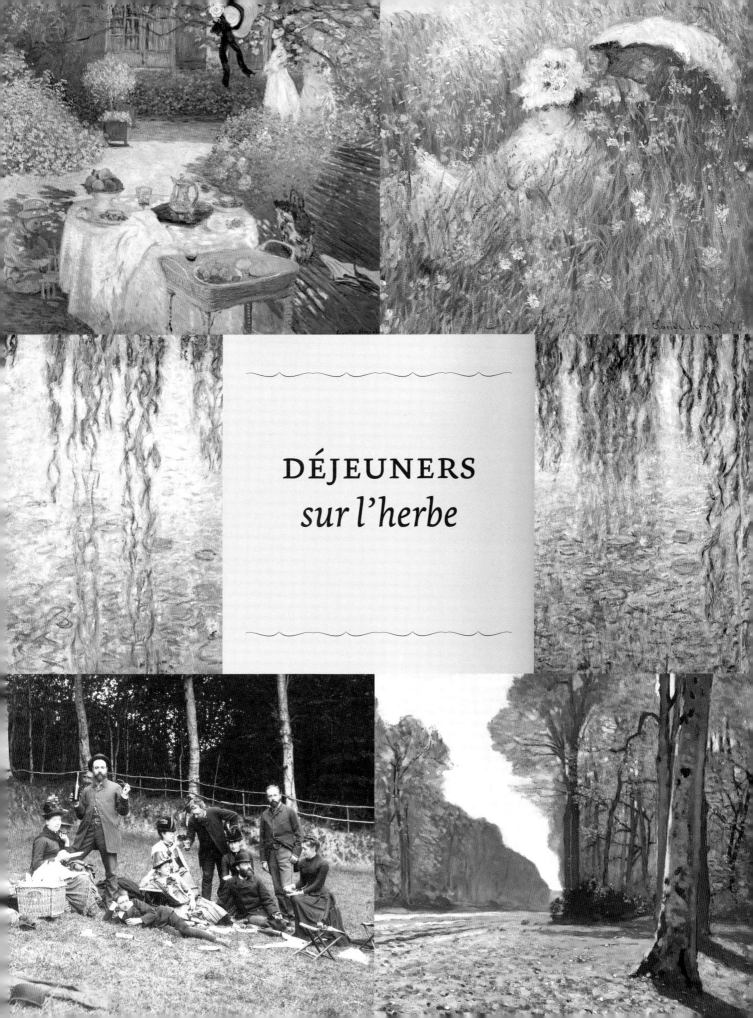

DÉJEUNERS
sur l'herbe

"[...] they would sing, cook together"

❖

When Claude Monet moved to Paris in 1859, he moved away from the middle-class world of his family. He embarked on a groundbreaking path as an artist, which took him far from the establishment and academic art. He rejected the advice imparted by the painters his Aunt Lecadre had recommended and instead chose to enroll at the Académie Suisse, a free art academy on the Quai des Orfèvres where he could paint for himself. He spent a great deal of his time outside the academy with other independently-minded artists, including Camille Pissarro and Paul Cézanne. This was the beginning of a tradition that continued for many years: devoting hours to many friendships. These hours were profitable on an artistic level, but less so on a financial one. However, they were always full of jollity when the friends gathered around a table in a Paris café or in a country inn.

In Paris, one of Monet's particular haunts was the Brasserie des Martyrs in Pigalle, far from the Grands Boulevards and the elegant Restaurant Tortoni. Monet liked to immerse himself in the more lively, down-to-earth atmosphere of the café, relishing the hustle and bustle conjured up by Alphonse Daudet when he described how "beer glasses rolled, waiters ran, discussions became heated. There was shouting, gesticulating, shaking of locks."[1] Another of the regulars there, Firmin Maillard, in a book entitled *The Last of the Bohemians*, described the clientele of "chasers after pictures, polishers of sentences, knights errant of pen and brush, brave searchers for infinity, impudent peddlers of dreams, builders of towers of Babel."[2] In the Brasserie, which the Goncourt brothers bitingly called the "cavern and tavern of great men with no name,"[3] Monet, no doubt, once again made an

impression with his talents as a caricaturist. He later turned his back on the bohemian atmosphere, telling Geffroy that the brasserie "was really bad for him[4]."

Interlude in Algeria and Return to Le Havre

Monet's first stay in Paris was abruptly interrupted when he was randomly called up for military service and was obliged to return to Le Havre and his father. Infuriated by his son's unruliness, Claude Adolphe Monet made it clear that he would not pay for anyone to go in Monet's place if he had the "bad luck" to be sent off to serve his country for seven years, which, of course, is what transpired. Monet chose to enlist in military service in North Africa in 1861, and recounted that he was enthusiastic about going to Algeria: "Nothing seemed more attractive to me than riding out all day in the sun, going on raids, hearing the crack of gunpowder, wielding a sabre, bedding down in a tent in the desert at night, and I responded to my father's ultimatum with proud indifference,"[5] he told Thiébault-Sisson.

Monet fell ill in Algiers and was invalided back to Le Havre at the beginning of 1862. He showed such a passion for painting during his convalescence that his Aunt Lecadre bought out his remaining years of military service and convinced his father to pay for him to go back to Paris. During this period in Normandy he painted the beaches and countryside and met Jongkind who gave him all kinds of advice. The lightness and openness of Jongkind's approach confirmed for Monet once and for all what Boudin and his friends at the Académie Suisse had already told him: the establishment and its ways were not for him. So, yet again Monet defied his father's authority during his second

stay in Paris. He opted to leave Charles Gleyre's studio, despite having promised that he would diligently apply himself there. He was joined in this latest act of rebellion by three other young painters whom he had met in the studio and who shared his taste for freedom: Renoir, Bazille and Sisley. They were to live through difficult times, seeking to challenge conventions and change opinions. Together they pioneered what was later to be called Impressionism.

Country Inns

The young artists' search for new ways of painting periodically took them to the Forest of Fontainebleau or to Normandy. There they would experiment with different techniques and have long discussions as they strolled along footpaths, paused in glades, or stopped in a variety of modest inns where they knew they would eat well. For years, eating establishments in the area around Barbizon had been catering to the "school of 1830." Its followers came in droves to do as Millet and Corot advocated: to paint "from nature." One of these venerable establishments was the Ganne Inn at Barbizon, described here by Jules and Edmond de Goncourt in their novel *Manette Salomon*: "glasses flowed with fizzy local wine, customers stabbed at dishes with forks, tossed plates about, banged knives raucously on the table calling for extras [...] They guffawed into their plates [...] And the racket only died down when the salad arrived and they finally secured the raw egg yolk they had begged for the mustard dressing they solemnly set about making."[6] We know, however, that Renoir, Monet and their friends preferred less popular places (according to Renoir, "in Barbizon, you bumped into a Millet on every street

corner") and that a bad omelette they were served at the Ganne finally pushed them to leave Barbizon ("the bacon was tougher than a piece of leather,"[7] Renoir told his son, Jean). They felt appreciably better at Chailly-en-Bière, as evidenced in a letter Bazille wrote to his mother in which he reports that he and Monet are staying "in the excellent Cheval Blanc inn where for 3 francs 75 a day one is fed and accommodated to perfection."[8] Marlotte became another of their haunts. There they frequented the Cabaret de la Mère Anthony, depicted by Renoir in his famous painting of the same name. The painting shows his friends the painters Sisley, Jules le Coeur and possibly Claude Monet himself around a table.

The food they would have eaten in these places would have been very simple, like a salad with mustard dressing and the bacon omelette served up at the Ganne where, as the Goncourt brothers noted in their Diary, "the tablecloths had stains and the pewter forks left marks on the fingers."[9] Apart from showing a promising virtuosity and an early sense of composition, the few still lifes Monet painted before and after leaving Le Havre reveal a marked interest in a well-chosen chop or cut of meat. The magnificent *Hunting Trophy*, now in the Musée d'Orsay, reflects a taste for partridges, woodcocks and pheasants: subjects he painted again later and which he already enjoyed eating. In 1864, he took his friend Bazille to Normandy. Frédéric was delighted by the landscapes of Normandy and once again by the pleasant conditions they found themselves in on the trip, which he described in a letter to his mother: "We started looking out for landscapes to paint from the moment we arrived in Honfleur. They are easy to find because

this region is paradise [...] We are staying in Honfleur itself with a baker who has rented us two small rooms. We eat at the Ferme de Saint-Siméon on the cliff just above Honfleur. That is where we work and spend our days[10]." When his friend left, Monet stayed on at the excellent Ferme de Saint Siméon along with the painters Boudin and Jongkind. When at last it came to settling his bill at Mère Toutain's, he had to appeal to Bazille for help.

The Woman in a Green Dress

There were many other jaunts that combined painting and eating. On a repeat visit to Chailly in 1865, for instance, Monet embarked on a huge painting of *Déjeuner sur l'herbe*. This work revisited the subject of Manet's painting of the same name, which provoked such an outcry when it was first exhibited three years earlier. There is no naked young woman with a provocative gaze in Monet's painting; instead, an elegant group of young people gather around a white cloth spread with untouched pâtés, cold fowl, baskets of fruit and fine-looking bottles. The picture was never finished, but Monet painted another one in the space of just a few days. He submitted this one to the Salon exhibition of 1866 and it was accepted: *The Woman in a Green Dress*. The picture won Monet high praise from Émile Zola and even with his family, until his father and aunt discovered that the model for *The Woman in the Green Dress* was Monet's mistress, Camille Doncieux (who gave birth to Monet's eldest son, Jean, in 1868). His father and aunt never asked to meet Camille, and from that moment on, Monet's father harshly refused to have anything to do with his son. Monet was then living in Saint-Michel in very

difficult circumstances, as witnessed by Renoir who dropped in now and then and brought the little family a bit of bread. He reported, "they don't eat every day."[11] During this period of near destitution, Monet repeatedly wrote appeals for financial help and there is a real sense of despair in his these letters: "I was so overwhelmed yesterday that I stupidly threw myself in the water; luckily, no harm came of it,"[12] Monet even wrote to Bazille in June 1868. But the happiness he got from painting and good company always had him bouncing back. Six months later he wrote to Bazille from Étretat: "I am very pleased, quite delighted."[13] In Paris, his get-togethers with his friends at the Café Guerbot supplied Monet with what he called "stocks of enthusiasm."[14] Painting again in Normandy that same year, 1868, his friend Courbet introduced him to Alexandre Dumas. The three of them enjoyed some delectable moments together. Monet later told Gustave Geffroy: "When Dumas and Courbet were not talking, they would sing and cook together. Courbet's recipes were from Franche Comté, and Dumas had recipes from all over the world!"[15]

From Argenteuil to Vétheuil

When the Franco-Prussian War broke out in 1870, Claude Monet had just married Camille and they took refuge in London. There he met the art dealer Paul Durand-Ruel, a meeting that would shape his future. Durand–Ruel immediately bought two paintings from Monet, the first acquisitions of many. All in all, during his life, Durand-Ruel bought twelve thousand paintings, over a thousand of which were by Monet. In London, Monet was able to escape the harrowing siege of Paris, where starving citizens had resorted

to eating the animals in the Jardin des Plantes. After a spell in Holland with Camille and Jean, Monet returned to Paris in the autumn and soon settled in Argenteuil. There he painted pictures bathed in sunlight, sometimes with Renoir or Manet. Although we know from Monet's letters that his situation remained precarious, the scenes in his paintings, with elegant gardens, crisp white tablecloths set with fine place settings, and a team of household staff in the background, suggest a life of relative ease. However, when Durand-Ruel fell into financial difficulties and stopped buying, Monet and his friends had to exhibit their work together, sometimes without the dealer's help. Eight Impressionist exhibitions were held in Paris between 1874 and 1886, but they did not succeed in changing people's opinions. Only a few collectors were impressed, among them Ernest Hoschedé, who went so far as to buy the painting that caused such a stir: *Impression, Sunrise*. The journalist Louis Leroy thought the title was ridiculous and it prompted him to coin the highly ironic adjective "impressionist." In 1876, when Hoschedé invited Claude Monet to spend several months painting on the grounds of his home at the Chateau de Rottembourg, he could not have foreseen that their lives were about to be turned upside down. The wealthy textile magnate went bankrupt and his wife, Alice, had to cope with the seizure of the chateau, the furniture and her husband's magnificent collection of paintings. Already the mother of five children, she gave birth to a sixth, Jean-Pierre, on August 20, 1877 while on a train heading back to her family in Biarritz. Several months later on March 17, 1878, in the Monet household, Camille Monet gave birth to her second son, Michel.

Monet's financial situation worsened when Durand-Ruel could no longer help him. As debts mounted for both families, the Hoschedés and Monets decided they should move in together, first into a small house and then another one in Vétheuil. Camille, who had become seriously ill after giving birth to Michel, died in September 1879 after an agonizing sickness. During this appalling period, while Ernest Hoschedé spent less and less time at home, Alice nursed Camille, looked after the eight children they had between them and dealt with the creditors. The servants and cook left one by one. In 1881, Claude Monet rented a house in Poissy. Alice braved the scandal and went to live with him with all of her children. After a rainy summer at Pourville and a flood at the Poissy house, Monet decided that for the happiness of this big family he must find a new haven for them all.

1. Alphonse Daudet, *Thirty Years of Paris and of My Literary Life*, Paris, C. Marpon et E. Flammarion, 1888.
2. Firmin Maillard, *The Last of the Bohemians: Henry Murger and His Times*, Paris, Librairie Sartorius, 1874.
3. Edmond and Jules de Goncourt, *Journal. Memoirs of Literary Life* (1851–1896), Paris, Laffont, "Bouquins" series, 2014, 31.
4. G. Geffroy, *op. cit.*
5. C. Monet, *op. cit.*
6. E. and J. de Goncourt, *Manette Salomon* (1868), Paris, 10/18, 1978.
7. Jean Renoir, *Renoir, My Father* (1962), Paris, Gallimard, "Folio" series, 1981.
8. F. Bazille, letter to his mother, April 8, 1863, in F. Bazille, *op. cit.*
9. E. and J. de Goncourt, *Journal, op. cit.*
10. F. Bazille, letter to his mother, June 1, 1864, in F. Bazille, *op. cit.*
11. Pierre-Auguste Renoir, letter to F. Bazille, quoted by Anne Distel, *Renoir. "One must embellish"* Paris, Gallimard "Découvertes" series, 1993.
12. C. Monet, letter to F. Bazille, June 29, 1868, in Daniel Wildenstein, *Claude Monet: Biography and Catalogue Rraisonné*, Lausanne, La Bibliothèque des Arts, 1979, vol. 1.
13. *Ibid.*
14. C. Monet, *My History, op. cit.*
15. G. Geffroy, *op. cit.*

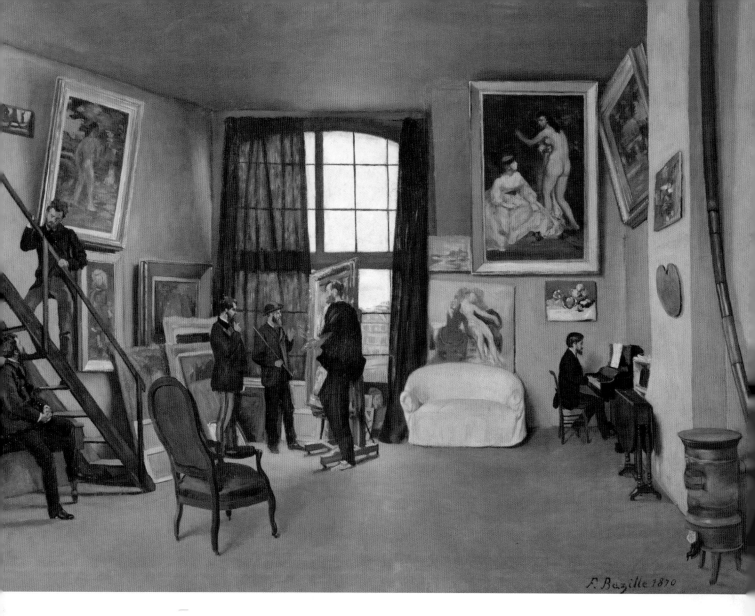

"There I would meet Fantin-Latour and Cézanne, Degas, who arrived shortly afterwards from Italy, the art critic Duranty, Emile Zola who was just starting out on his literary career, and a number of others. I would take Sisley, Bazille and Renoir along with me."

Claude Monet, *My History*, 1900 (about the Café Guerbois).

Above : Frédéric Bazille, *Bazille's Studio*, 1870.

Right: Monet is depicted reading a newspaper in a painting by his friend Renoir, while Renoir himself can be seen in the photograph at about age twenty-five. Fantin-Latour's famous painting of *A Studio at Les Batignolles* shows Édouard Manet surrounded by some of the leading innovators of the day, including Renoir (wearing a hat), Zola (who has his back to him), the towering Bazille, and on the right, Claude Monet.

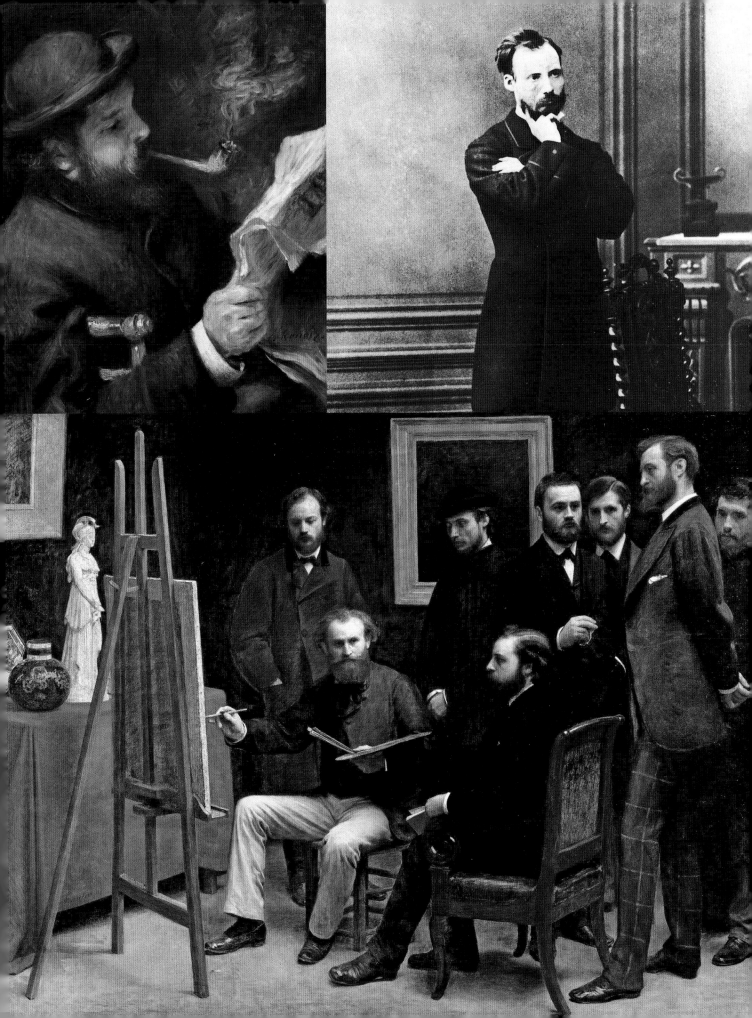

Garlic Soup

For the soup
15 medium garlic cloves
6 eggs
3 tbsp butter
1 small bunch flat-leaf parsley
Salt + freshly ground pepper to taste

For the croutons
6 medium-sized slices stale bread
1 tbsp butter
1 tsp oil

❖ *Serves 6 Preparation time: 20 minutes Cooking time: 30 minutes*

Peel the garlic cloves, slice them in half and remove the green core, then put them in a saucepan with 1.2 liters (5 cups) of cold water. Add salt and plenty of pepper and bring to a boil. Boil for about 20 minutes or until the garlic is quite soft.

Meanwhile, cut the bread into little squares and fry these in butter and oil. Warm a soup tureen with boiling water.

Remove the garlic cloves from the pan and blend to a fine purée. Thin the purée with a little of the cooking liquid.

Break the eggs into a large bowl, pour in a little of the cooking liquid and beat well. Add the egg mixture and crushed garlic to the remaining cooking liquid and mix well. Stir constantly over a low heat. Add the butter. Do not let the liquid boil.

Put the fried croutons in the tureen and pour the soup over them. Sprinkle with finely chopped parsley and serve immediately.

Leek and Potato Soup

❖

6 large leeks
4 floury potatoes 600 g (1.3 lbs)

1 tbsp butter
Salt + freshly ground pepper to taste

❖ *Serves 6–8 Preparation time: 20 minutes Cooking time: 70 minutes*

Strip the coarse outer leaves from the leeks. Cut them in half lengthways and rinse. Slice into rounds and keep the dark green ends of the leeks for future use (to flavor a stock, for instance).

Melt the butter in a baking dish until foaming and then add the leeks, stirring constantly until soft. Cover with 1 cup or more of hot, salted water. Leave to simmer.

Peel and cube the potatoes. Cook the leeks for 45 minutes and then add the potatoes.

After roughly 20 minutes, insert the point of a knife into a piece of potato to check if it is soft. Pour into a soup tureen, add a generous lump of butter, give one last stir and serve.

Eggs Orsini

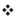

6 eggs
40 g (2 tbsp) grated cheese

Butter
Salt + freshly ground pepper to taste

❖ *Serves 6 Preparation time: 10 minutes Cooking time: 30 minutes*

Separate the eggs, keeping the yolks in their shells and removing as much of the whites as possible without breaking the yolks. Tip the whites into a large bowl. Prop up the shells with a scrunched up dish towel so they remain upright.

Preheat the oven to 180°C (gas mark 4 or 350°F).

Season the egg whites with salt, then whisk until they form very stiff peaks: they should be firm enough to withstand the weight of a small spoon without sinking in.

Liberally grease a tray with butter and pour the egg whites onto it in one fluid motion. Smooth out with a wooden spoon. Make 6 reasonably deep hollows a good distance apart, and then carefully place a yolk in each one. Season with pepper and then sprinkle with grated cheese and butter shavings.

Carefully place at the back of the oven. After about 30 minutes the top should be crispy and golden, and the yolks just set. Serve immediately.

TIP

This simple dish is almost impossible to get wrong, but it cannot be allowed to stand.

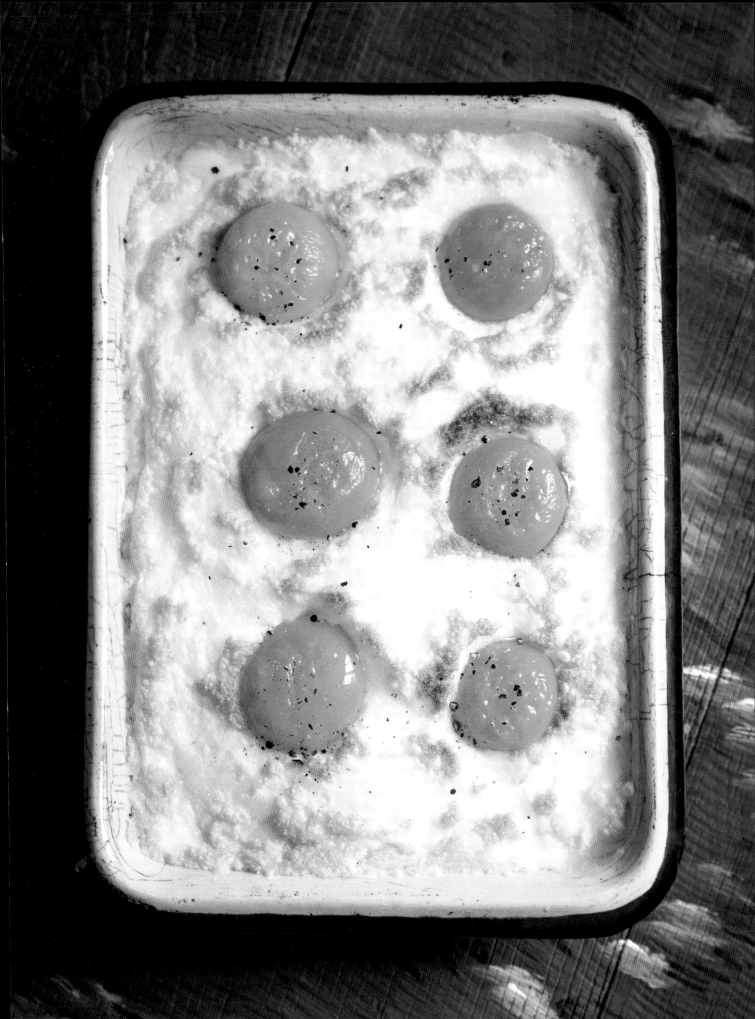

Béarnaise Sauce

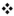

2 shallots
70 ml (5 tbsp) white wine vinegar
1 bouquet garni (1 bay leaf, 1 sprig thyme, 2
sprigs flat-leaf parsley)
3 sprigs tarragon

3 sprigs chervil
3 very fresh egg yolks
100 g butter (7 tbsp or a bit less than 1 stick)
Salt + freshly ground pepper to taste

❖ *Preparation time: 10 minutes Cooking time: 20 minutes*

Peel and dice the shallots. Place in a small saucepan with the vinegar and bouquet garni. Cook over a very low heat until the liquid has reduced by half. Remove the bouquet garni and leave to cool.

Meanwhile, dice the tarragon and chervil. Melt the butter in a small saucepan over a very low heat. Heat some water in a large pan for a bain-marie and leave barely simmering.

When the shallot mixture is lukewarm, add the egg yolks one at a time, whisking constantly. Place the saucepan in the bain-marie and thicken the sauce over a very low heat until smooth and creamy. Remove from the heat and gradually trickle in the melted butter, whisking constantly. The sauce should have the consistency of mayonnaise. Season with salt and pepper. Finish by gently stirring in the diced herbs. Serve hot or warm.

TIP

This sauce goes well with grilled meat and fish. It can be served hot or just warm, so it should not be made too far in advance.

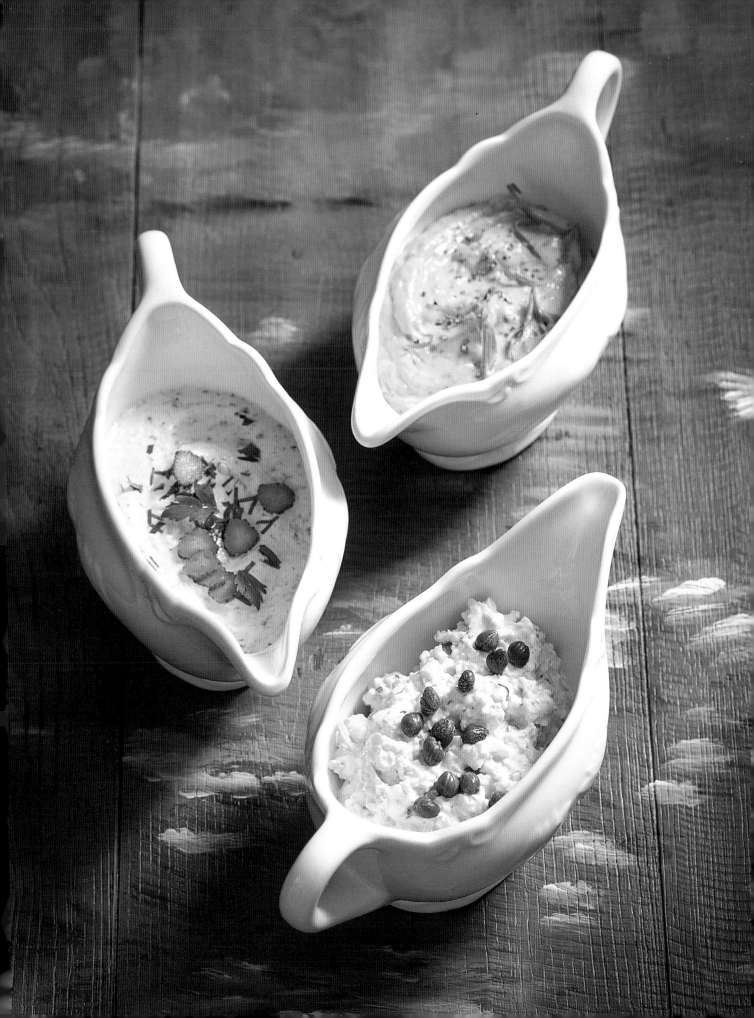

Horseradish or Radimsky Sauce

❖

5 eggs
1 small piece horseradish root
3 small onions
1 handful mixed herbs (chives, parsley and chervil)

1 tsp small capers
Stock
Vinegar
Olive oil
Salt + freshly ground pepper to taste

❖ *Preparation time: 20 minutes Cooking time: 10 minutes*

Boil some water, put in the eggs and cook for 10 minutes until hardboiled. Remove them from the pan, run them under cold water and then peel. Peel the horseradish and finely grate it until you have a small plateful.

Mash the egg yolks with the horseradish. Dice the egg whites and then combine with the egg and horseradish mixture.

Peel and dice the onions and herbs. Season with salt and pepper and add to the horseradish and egg mixture along with the capers. To finish, bind together with 1 tablespoon of warm stock and a dash each of oil and vinegar.

TIP

Serve in a sauceboat with crudités, smoked fish and cold meats.

Tartare Sauce

3 eggs
3 shallots
2 sprigs parsley or chervil
6 chives or 2 sprigs tarragon
1 tsp small capers

2 tbsp Dijon mustard
1 tbsp white wine vinegar
4 tbsp groundnut (peanut) oil
Salt + freshly ground pepper to taste

❖ Preparation time: 15 minutes Cooking time: 15 minutes

Boil some water in a pan, put in the eggs and cook for 10 minutes until hardboiled. Remove them from the pan, run them under cold water and then peel. Peel and dice the shallots and dice the herbs and capers.

Roughly chop the egg yolks and combine with the mustard and vinegar. Add the diced shallots and herbs, then gradually trickle in the oil and mix until the sauce has the consistency of mayonnaise. Season with salt and pepper to taste.

TIP

This sauce goes well with fish of all kinds, particularly grilled eels, and with cold meats and poultry.

Hollandaise Sauce

100 ml (¹/₂ cup) heavy cream (optional)
200 g (14 tbsp or a bit less than 2 sticks) good quality butter

2 very fresh egg yolks
1 tbsp vinegar or juice of 1 lemon
Salt

❖ *Preparation time: 5 minutes Cooking time: 15 minutes*

If you want to make a particularly smooth sauce, you can add whipped cream, but you will need to have this ready before you make the hollandaise. Leave the heavy cream in the fridge until you are ready (it needs to be cold), then put it in a bowl and whip by hand or with an electric beater until very thick.

Dice the butter and melt over a low heat. Put the egg yolks in a pan with the vinegar (or lemon juice) and a good pinch of salt. Whisk together until frothy. Turn down the heat to the lowest setting and gently beat the mixture. When it starts to thicken, trickle in the melted butter, beating constantly until smooth. If you are using the whipped cream, add it just before serving.

TIP

To prevent the sauce from cooking too quickly, prepare in a bain-marie, over a pan of barely simmering water. Serve hot with fish cooked in broth or poached vegetables, particularly asparagus.

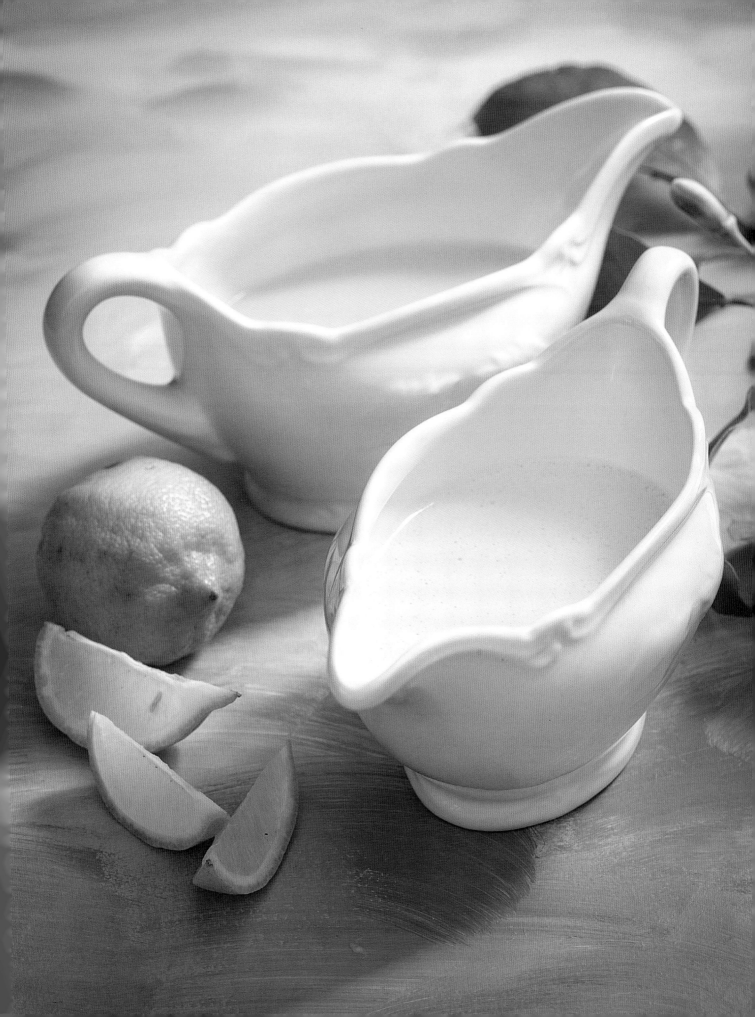

Potato Pie

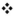

For the pastry
500 g (4 cups) flour
250 g (17 tbsp or bit more than 2 sticks) butter,
at room temperature
2 egg yolks
Salt

For the filling
6 (1.2 kg or 2 ¹/₂ lbs in all) medium-sized,
firm potatoes
3 onions
1 small bunch parsley
150 ml (5 fl oz or a bit more than ¹/₂ cup)
heavy cream
1 whole egg
Salt + freshly ground pepper to taste

❖ *Serves 8 Resting time for the pastry: 2 hours Preparation time: 30 minutes Cooking time: 2 hours*

Start by preparing the pastry: cut the butter into small cubes and place in a bowl, add the flour with 1 pinch of salt, then mix together with your fingertips until the mixture resembles fine breadcrumbs. Mix in the egg yolks and shape the dough into a ball.

Place the dough on a lightly floured work surface. Press out the dough with your palm, working from the center to the sides to obtain a smooth dough. Repeat the process several times until the dough is even. Shape it into a ball again, wrap in plastic wrap and leave to rest in the fridge for 2 hours.

When you are ready to use the pastry, preheat the oven to 180°C (gas mark 4 or 350°F).

Peel the potatoes and slice into rounds. Soak the potato slices in cold water. Peel the onions and cut into rounds. Dice the parsley.

Take the pastry out of the fridge and divide into two uneven-sized pieces. Place the larger piece onto a floured surface and roll it out into a circle large enough to line the bottom and sides of a shallow, round, earthenware dish. The pastry should slightly overlap the sides. Roll out the second piece of dough into a circle just a little larger than the dish.

…/…

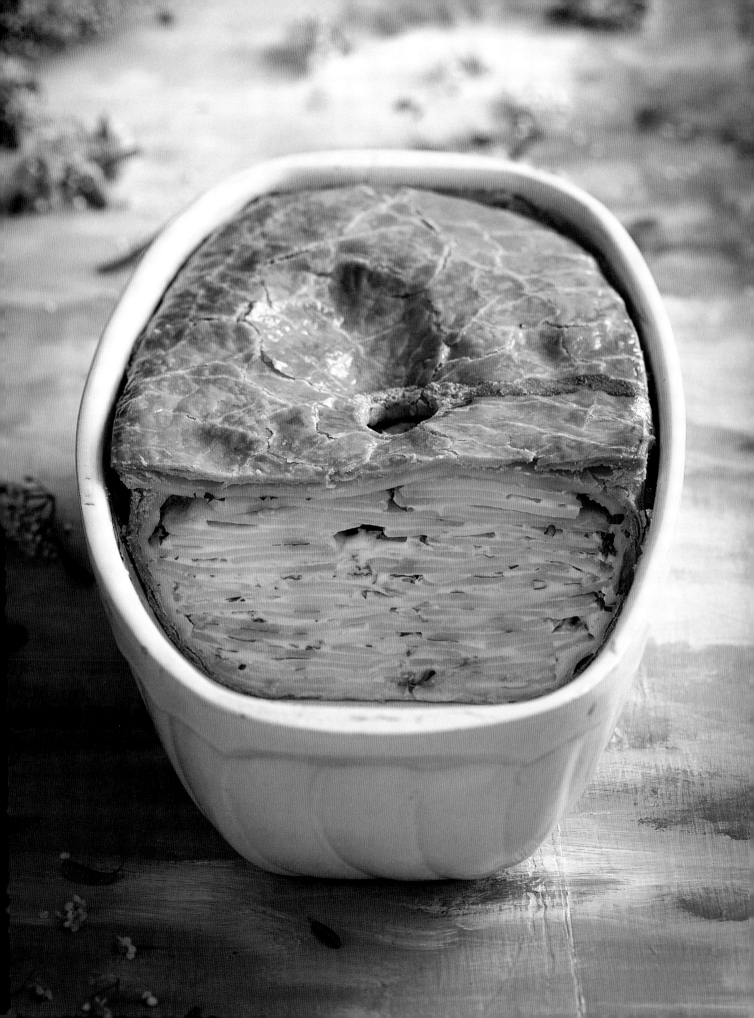

Drain the potatoes and dry them with a clean paper towel. Arrange them in the dish in a single layer and scatter with the onion rings and diced parsley. Season with salt and a generous amount of pepper, than add the cream. Cover with the second circle of pastry, pinching the two sheets of pastry together to seal the edges.

Make a hole in the middle of the pastry top (to let the steam escape while cooking) and carefully insert a funnel made by rolling up a small piece of thick paper. Beat the whole egg and brush the pastry with it before it goes into the oven. The pie should take 2 hours to cook. If it turns golden before then, cover it with a piece of lightly greased parchment paper.

Above: In this picture, painted in 1875, Monet portrays his young first wife, Camille, doing embroidery. She had already given birth to Jean, who was born in 1867, and she was to die of cancer in 1879, eighteen months after the birth of her second son, Michel.

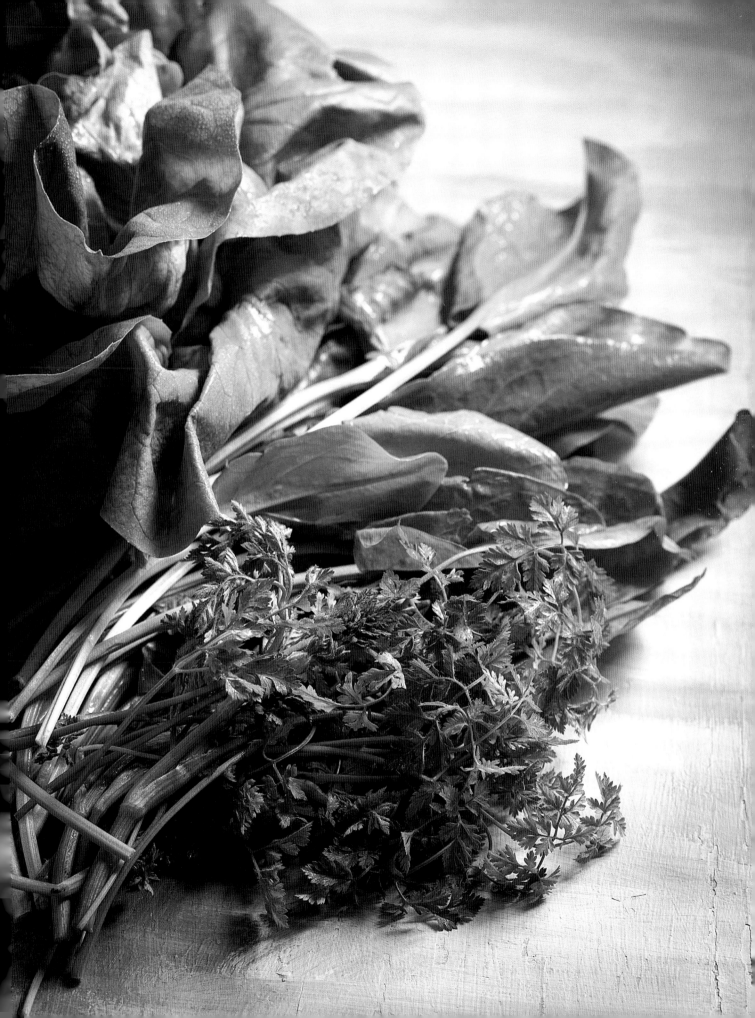

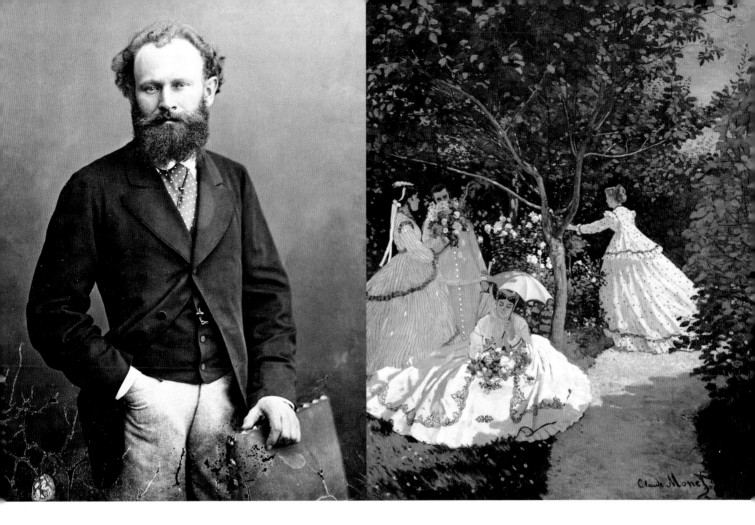

"Monet conjures up out of his palette every facet of light, every magical nuance in the atmosphere, every shift and trace of mist."

Octave Mirbeau, "Impressions of Art," *Le Gaulois*, June 16, 1886.

Left: Claude Monet, *Woman with a Parasol – Madame Monet and Her Son*, 1875. This painting depicts Monet's pretty wife, Camille, with her son, Jean.

Above: Born in 1832, Édouard Manet had caused an uproar at the Salon des Refusés in 1863 with his brazen *Déjeuner sur l'herbe*. He was initially annoyed when the young Monet, whose name was almost as well known as his, first began to enjoy success. However, he was to become friends with Monet and to draw from Impressionism in his own painting. Monet's *Women in the Garden* was rejected by the Salon in 1867. To help support his friend, Bazille bought the painting; it subsequently entered the collection of his family at their estate at Méric, near Montpellier.

Cheese Galettes

200 g (a bit less than 1 cup) fromage blanc
1 egg
100 g (a bit less than 1 cup) flour

1 tbsp butter
1 tbsp oil
Salt + freshly ground pepper

❖ Serves 4 Preparation time: 10 minutes Cooking time: 5 minutes

Put the fromage blanc in a bowl, break the egg over it and beat together. Season generously with salt and pepper, then gradually add the flour and mix into a smooth dough.

Shape into 12 little galettes, flattening them with your hand. Melt the butter and oil in a large non-stick frying pan, put in the galettes and cook for 5 minutes, turning them over halfway through so that they are golden brown on both sides. They should be very crispy.

TIP

You can flavor the galettes by adding finely chopped herbs such as flat-leaf parsley, chives, or spring onions to the mixture before the flour goes in.

Fried Chicken

❖

500 g (1 lb approx.) cooked chicken Oil
250 g (2 cups) flour Salt
1 egg

❖ *Serves 4 Preparation time: 10 minutes Resting time: 2 hours Cooking time: 10 minutes*

Mix together the flour, beaten egg, 100 ml ($^1/_2$ cup) of water and a pinch of salt to make a thick batter in which to fry the chicken. The batter needs to rest for at least 2 hours.

Heat 3 cm (1 inch) of oil in a large saucepan. While it is heating, cut the cooked chicken into small bite-sized pieces.

Check that the oil is hot enough by dropping in a little bit of batter: it should fry straightaway. Dip the pieces of chicken in the batter and carefully drop them into the hot oil, watching out in case it spits. Turn the pieces continually so that they fry evenly on all sides. When they are crisp and golden on the outside, lift the pieces of fried chicken out of the pan with a slotted spoon and drain on paper towels. Serve immediately.

TIP

This recipe is perfect for using up leftover chicken, for instance, after a big family meal.

Chicken with Crayfish Butter

❖

For the crayfish butter
12 live crayfish
250 g (a bit more than 2 cups) unsalted butter
+ 1 tbsp for cooking the crayfish

For the chicken
1 medium-sized, free range chicken

2 carrots
1 onion
1 bouquet garni (2 sprigs thyme, 1 bay leaf,
2 sprigs flat-leaf parsley)
500 ml white wine (2 cups)
1 tsp cornflour
Salt + freshly ground pepper to taste

❖ *Serves 4 Preparation time: 20 minutes Cooking time: 1 hour 20 minutes*

To make the crayfish butter, melt the tablespoon of butter in a saucepan until foaming. Next, gut the crayfish one at a time: lay each one down with its abdomen flat on a board, grip firmly by the central dorsal fin (on the tail) and pull gently to remove the gut. Throw the crayfish into the foaming butter, and quickly repeat with the rest of the crayfish. Cook the crayfish over a high heat for 10 minutes without adding any liquid and stirring constantly.

Next, pound the whole crayfish (in their shells) and add the butter and 2 table-spoons of hot water. Continue pounding into a smooth, creamy paste. Place over a low heat and cook gently without boiling for 1 hour. You should end up with a deeply-colored and richly-flavored sauce. Strain through a fine sieve over a pan of clean water. The crayfish butter will solidify as it hits the water.

While the crayfish butter is cooking, make the chicken. Peel the carrots and cut them into fairly large pieces. Peel the onion. Put the vegetables into a stew pot with the bouquet garni, white wine and 500 ml (2 cups) of water. Season with salt and pepper and bring to a boil. Add the chicken and cook gently for about 1 hour. Leave it sitting in the stock until ready to serve.

Put the crayfish butter in a saucepan and dilute it with a ladleful of stock. Add the cornflour and mix to a creamy sauce. Cut up the chicken, arrange on a serving dish and pour the crayfish butter on top. Serve very hot.

Entrecôtes Marchand de Vin

❖

2 medium-sized entrecôte (rib-eye) steaks
(2 cm thick)
3 shallots
50 ml (3 tbsp) stock
100 ml (¹/₂ cup) good quality red wine

40 g (a bit less than 3 tbsp) butter
20 g (2 ¹/₂ tbsp) flour
3 tbsp oil
Salt + freshly ground pepper to
taste

❖ *Serves 2 Preparation time: 5 minutes Cooking time: 30 minutes*

Peel and dice the shallots and gently sauté with 1 tablespoon of butter.
Pour in the red wine and cook until reduced by half. Season.

Next, make a roux: heat 20 g (1 tablespoon) of butter in a small saucepan
until it begins to foam, whisk in the flour, then pour in the stock and cook
to thicken. Strain the reduced wine mixture through a sieve and mix it
into the roux. Keep the sauce warm.

Melt the rest of the butter in a frying pan with the oil. When the butter
and oil begin to smoke, add the entrecôtes and fry for 4 minutes if you
want the steaks saignant (rare) or 5 minutes if you want them à point
(just pink). Turn the steaks over and cook in the same way and for the
same amount of time on the other side.

Serve the entrecôtes immediately with the warm sauce poured over them.

TIP

~~

The sauce can also be made with white wine.

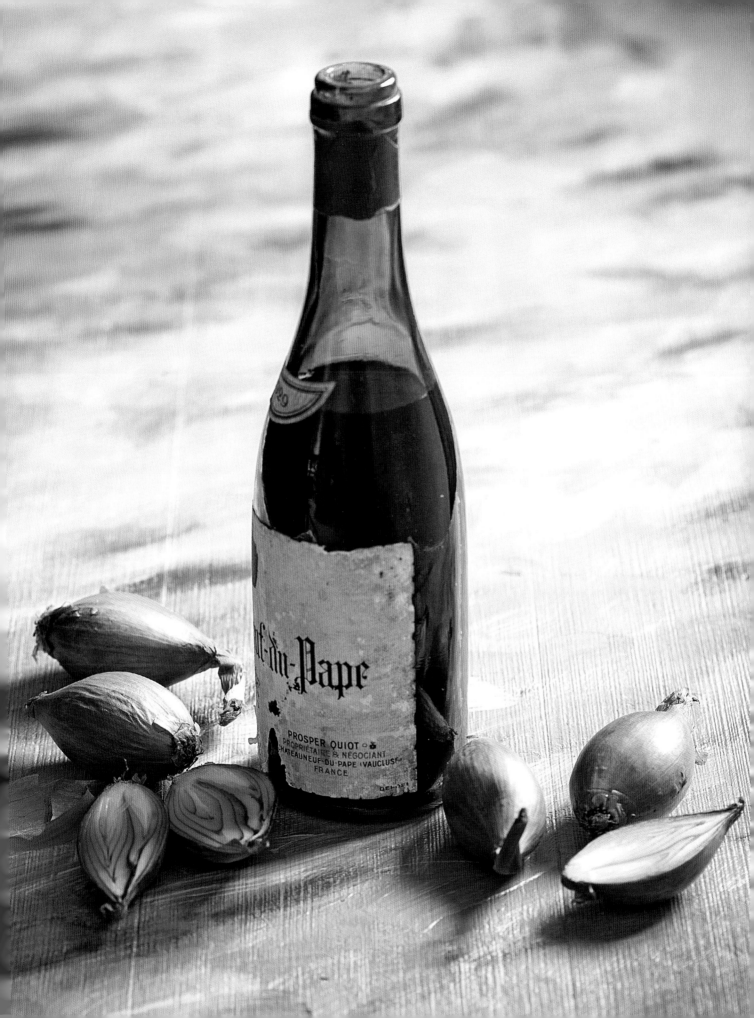

Veal Meatballs

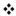

For the meatballs

500 g (1 lb) minced shoulder of veal

1 egg

150 ml (5 fl oz) milk

2 slices stale bread, crusts removed

1 bunch parsley

1 lemon

Nutmeg (for grating)

1 tbsp flour

Salt + freshly ground pepper to taste

For the sauce

4 onions

250 ml (1 cup) beef stock (or 1 stock cube dissolved in 250 ml or 1 cup water)

1 tbsp butter

1 tbsp oil

❖ *Serves 4 Preparation time: 40 minutes Cooking time: 35 minutes*

Start by making the sauce: peel and dice the onions, heat the butter and oil in a saucepan, add the onions and stew over a low heat until they are very soft and begin to caramelize. Pour in the stock and gently simmer. Keep warm.

Soak the bread in the milk, squeeze dry and put in a bowl. Add the finely chopped parsley, the minced veal and the beaten egg. Season with salt and pepper and a bit of grated nutmeg. Shape into little balls, roll these in flour and cook for 10 minutes in the sauce. Flavor with a squeeze of lemon juice before serving.

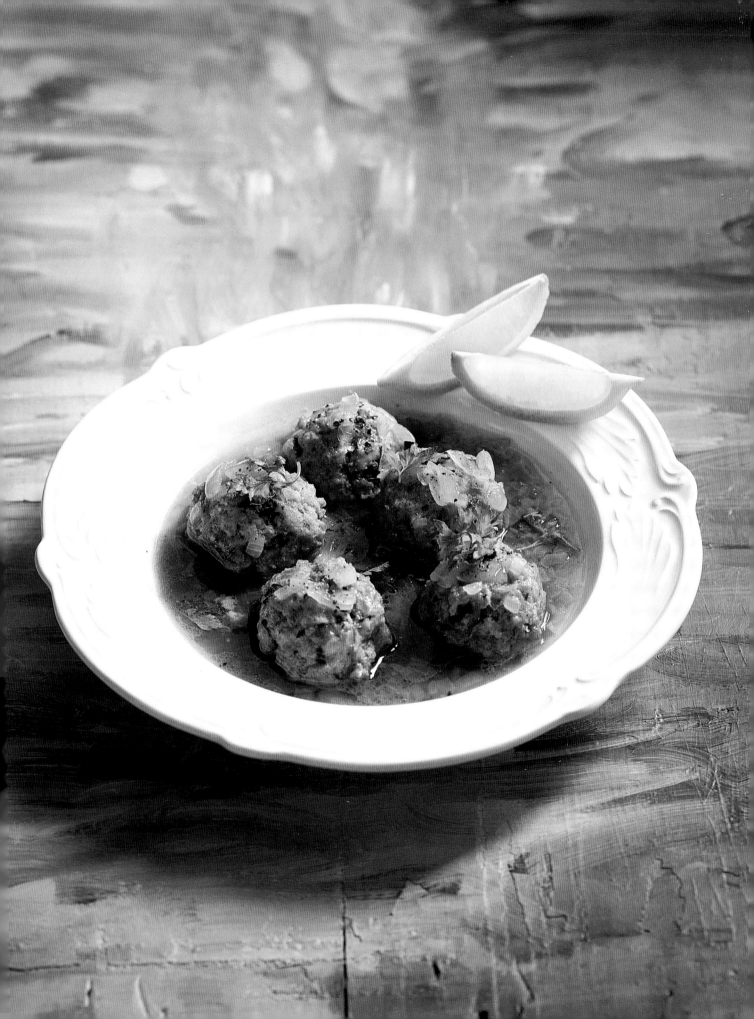

Duck Baked in Pastry

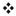

For the pastry
600 g (5 cups) flour
30 g (2 tbsp) lard
60 g (4 tbsp or a bit less than ¹/₂ stick) butter, softened
2 egg yolks
6 g (¹/₂ tbsp) superfine sugar
12 g (2 tsp) salt

For the filling
1 free range duck, dressed (1.5 kg or 1.3 lbs)
750 g (1.6 lbs) veal fillet
150 g (5 oz) sausage meat
150 g (5 oz) lean bacon
80 g (1.3 cups) stale breadcrumbs
200 ml (1 cup) white wine
6 tbsp cognac
100 ml (¹/₂ cup) meat juices
1 fat slice bacon
Salt + freshly ground pepper to taste

❖ *Makes enough for a 24 cm (9 in) long rectangular dish Preparation time: 1 hour 15 minutes Resting time for the pastry: 24 hours Marinating time for the meat: 1 hour Cooking time: 3 hours*

Make the pastry a day ahead: put the flour, lard, butter, eggs and sugar in a bowl. Rub the lard into the flour with your fingertips until it is well mixed. Gradually add up to 180 ml (6 fl oz) of water until you have a smooth, stretchy dough that is not sticky: the amount of water needed will depend on the quality of the flour. Shape the dough into a ball, wrap in plastic wrap and leave in the fridge to rest for 24 hours.

Bone the duck and cut the fleshy parts (the breast and thighs) into long thin strips. Similarly, cut the veal fillet into very thin pstrips. Marinate the duck and veal separately, each in 100 ml (¹/₂ cup) of white wine mixed with 3 tablespoons of cognac and leave for 1 hour.

Take the wings off the duck and strip off the meat from the wings and the rest of carcass and mince with a knife. Dice the bacon. Mix the breadcrumbs with the minced duck, bacon and sausage meat. Season with salt and pepper.

Preheat the oven to 200°C (gas mark 5 or 400°F).

···/···

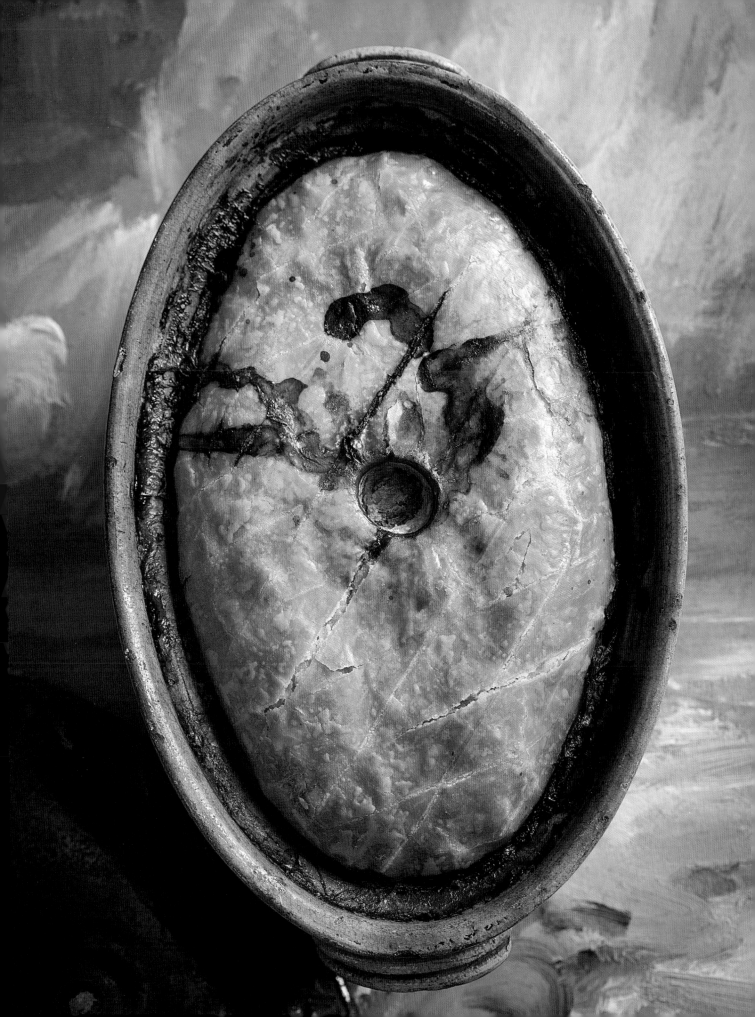

Divide the pastry into two unequal halves: one for the sides and base of the pan, the other to cover the duck. Roll the larger of the two out to a thickness of 3 mm and use it to line a rectangular spring-form pan.

Remove the strips of duck and veal from their marinade. Spread these out onto the pastry and follow with a layer of minced duck and sausage meat. Continue with alternating layers of meat strips and minced meat until everything is used up. Press down, then cover with the slice of bacon.

Roll out the second piece of dough to make a pastry top and lay this on the bacon. Pinch the edges of the two pieces of pastry together to seal, make a hole in the center of the top and insert a small cardboard tube (to be used to pour out the meat juices into the filling). Put the pan in the oven and bake at 180°C (gas mark 4 or 350°F) for 3 hours. Serve cold.

"He was very fond of game and especially woodcock which I would get for him when it was in season, notably at Christmas and New Year."

Jean-Pierre Hoschedé, *The Little-Known Claude Monet*, 1960.

Rabbit Potine

1 medium-sized free range rabbit	1 bay leaf
(2 kg or 4.4 lbs)	10 juniper berries
12 thin slices bacon	150 ml (5 fl oz) stock
1 fat slice bacon	50 ml (3 tbsp) brandy
3 onions	Flour for sealing the lid
2 sprigs thyme	Salt + freshly ground pepper to taste

❖ *Makes enough for a 24 cm (9 in) long terrine dish (with lid) Preparation time: 40 minutes Cooking time: 2 hours Resting time: at least 6 hours*

Cut the rabbit into pieces (keep the breast and head for another recipe). Peel and dice the onions.

Cover the base of a terrine with half of the thin slices of bacon, then arrange the pieces of rabbit in layers, seasoning each one with salt and pepper as you go. Add the onions, bay leaf, thyme and juniper berries. Finish with a layer of thin bacon and cover with the fat slice of bacon. Pour the brandy over the top.

Preheat the oven to 180°C (gas mark 4 or 350°F).

Make a fairly sticky dough with flour and water and roll into a thin sausage shape. Put the lid on the terrine and lay the dough around it to completely seal it. Cook in the oven for about 2 hours.

Boil the stock until it has reduced by half (this will take about 10 minutes).

Take the terrine out of the oven, remove the lid, and pour the stock over the rabbit. Leave to cool. Turn out the terrine while it is still warm, reserving the juices. Skim the fat off of the juices, put the rabbit back in the dish and pour the juices all around it. Let it sit until it is completely cool. Let rest for at least 6 hours before serving.

Green Mussels

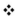

1 kg (2.2 lbs) fresh mussels
1 tbsp butter + a bit more
1 onion
1 stalk celery
1 bunch parsley

3 or 4 sprigs chervil
3 or 4 sorrel leaves
2 sprigs tarragon
100 ml ($\frac{1}{2}$ cup) white wine
1 tsp cornflour

❖ *Serves 4 Preparation time: 20 minutes Cooking time: 15 minutes*

Peel and roughly chop the onion and roughly chop the celery. Dice the parsley, reserving 2 or 3 sprigs. Dice these extra sprigs in another bowl along with the chervil, sorrel and tarragon.

Clean the mussels: scrub the shells, pull off the beards, rinse them in cold water, and then brush them off. Repeat the process two or three times, discarding any mussels that are already open or have a broken shell.

Melt a tablespoon of butter in a large stew pot, throw in all of the mussels along with the onion, celery and parsley. Cover and cook over a high heat until the mussels open, briskly stirring several times so that they heat through evenly.

When they are all open, tip them into a colander, reserving the cooking liquid, and then put them back in the pan. Melt a small bit of butter in a saucepan and add the chopped chervil, sorrel, parsley and tarragon. Pour in a little of the cooking liquid from the mussels and the white wine and bring to a boil. Put the corn-flour in a cup, stir in a little of the cooking liquid from the mussels, then tip this mixture into the saucepan and slowly thicken the sauce. Pour the sauce over the mussels and serve immediately.

TIP

For a more elegant dish, serve the mussels without their shells.

"All around La Grenouillère there were crowds of people ambling under the vast trees which make this little island corner the most delightful place to stroll in the world."

Guy de Maupassant, *Paul's Mistress*, 1881.

Above: Renoir painted *Dance at le Moulin de la Galette* in 1876. He told his son Jean that he had to convince the mothers of Montmartre to let their daughters pose for him. For the male figures he used his brother Edmond and his friends Lhote and Lestringuez as models.

Right: In 1869, Renoir and Monet painted next to each other at La Grenouillère. The resort was a favorite with Parisians, including Maupassant, who went there to swim and mix with the riff-raff. Renoir had a prevailing love for places dedicated to popular entertainment, such as the Moulin de la Galette, seen here in a photograph taken by Eugène Atget in 1900, and with events such as the Boatmen's Ball, captured on the right in an anonymous photograph from around 1860.

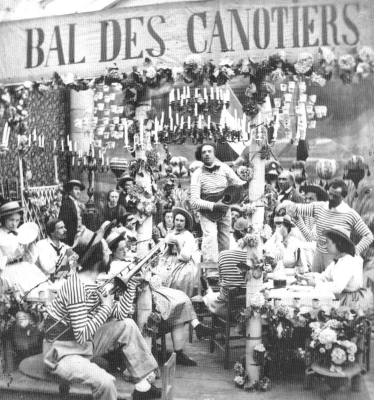

Fish à la Créole

400 g (2 cups) rice
6 pieces hake (or other white fish)
100 g (7 tbsp or a bit less than 1 stick) butter
1 lemon
1 tsp concentrated tomato purée

1 chili
1 bouquet garni (2 sprigs thyme, 1 bay leaf,
2 sprigs flat-leaf parsley)
1 egg yolk
Salt + freshly ground pepper to taste

❖ *Serves 6 Preparation time: 15 minutes Cooking time: 25 minutes*

The fish and the rice need to be ready at the same time and take a similar amount of time to cook. Therefore, you need to make sure everything is synchronized.

Put the pieces of hake to soak in salted water with a little lemon juice while you begin cooking the rice.

Preheat the oven to 180°C (gas mark 4 or 350°F).

Rinse the rice several times. Bring a large pot with plenty of salted water to a boil. Throw in the rice, stir and cook for 15 to 20 minutes.

Melt the butter in a frying pan, put in the pieces of hake and cover with hot water. Add the chili and bouquet garni, season with salt and pepper, and cook uncovered for 15 minutes over a low heat.

Drain the rice, quickly run it under cold water to refresh it, and then drain it again. Put it into a dish and then into the oven. Stir it periodically to separate the grains of rice.

Mix the tomato purée with a little of the cooking liquid from the fish, pour the mixture into the frying pan and reduce. Arrange the fish on a hot serving dish and finish the sauce by adding in the egg yolk to bind it. Arrange the rice in a ring around the fish and pour the sauce on the top. Serve immediately.

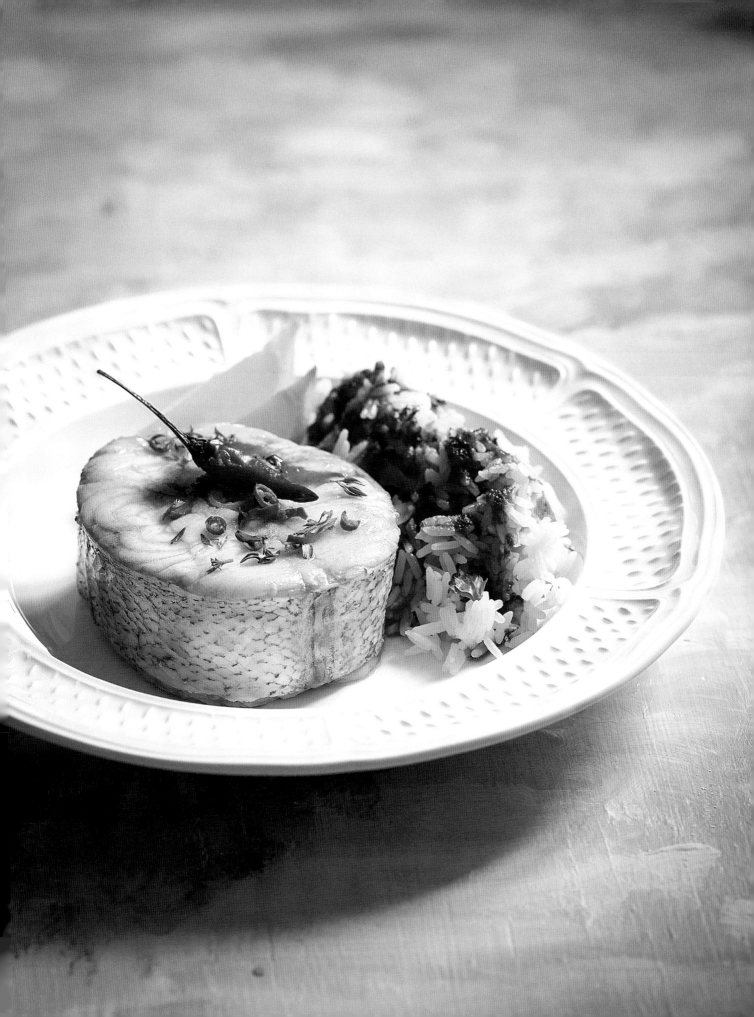

Coquilles Saint-Jacques
à la Florentine

❖

12 scallops in shells
1 kg (4 ¹/₂ cups) fresh spinach
50 g (3 ¹/₂ tbsp or a bit less than ¹/₂ stick)
butter
30 g (4 tbsp) flour

200 ml (1 cup) milk
Nutmeg (for grating)
200 ml (1 cup) white wine
50 g (¹/₂ cup) grated Emmental
Salt + freshly ground pepper to taste

❖ *Serves 4 Preparation time: 30 minutes Cooking time: 30 minutes*

Scrub the scallop shells under running water and then slide the point of
a knife carefully between the two halves of the shells to prise them open.
Pull out the scallops and roe and remove the little black sack surrounding
the scallop. Rinse the scallops and dry well. Keep cool. Wash and brush the
hollow halves of the shells (throw the others away) and dry well.

Wash the spinach, drain carefully and then strip off any coarse stalks.
Chop the leaves and wilt in a frying pan with 20 g (1 ¹/₂ tbsp) of butter.

Make a béchamel sauce: melt 30 g of butter, add the flour and whisk together.
When the mixture begins to foam, gradually pour in all of the milk while
stirring briskly to make sure there are no lumps. Cook over a low heat for
10 minutes to thicken, then season with salt, pepper and nutmeg. Put to
one side.

Preheat the oven to 180°C (gas mark 4 or 350°F).

Pour the white wine into a saucepan. When it is simmering, add the scallops
and corail (roe) and poach for about 2 minutes.

Place the cleaned shells on a baking sheet, spoon some spinach into each
shell, set a scallop and corail (roe) on top of this, pour the béchamel on top
and sprinkle with the grated cheese. Bake in the oven for about 10 minutes
until golden and crispy.

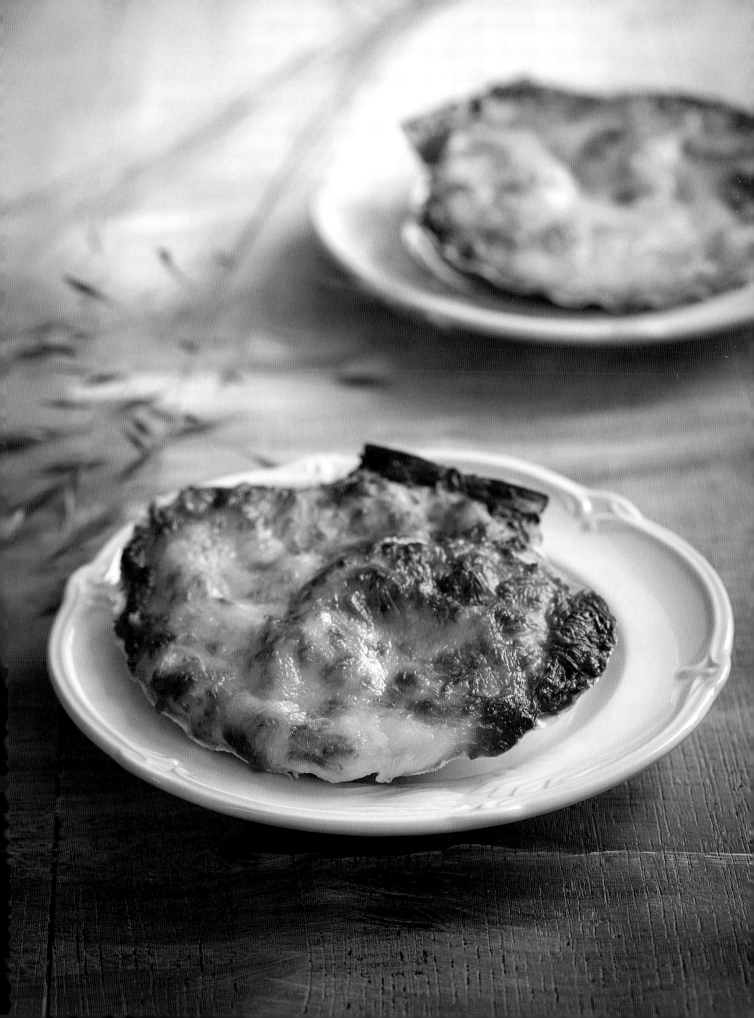

Clafoutis

500 g (1 lb) cherries
125 g (1 cup) flour
100 g ($^1/_2$ cup) superfine sugar
2 eggs

100 ml ($^1/_2$ cup) milk
1 tbsp butter for greasing the pie dish
Salt

❖ *Serves 6 Preparation time: 10 minutes (if you do not remove the cherry pits) otherwise 20 minutes
Cooking time: 45 minutes*

Preheat the oven to 180°C (gas mark 4 or 350°F).

Take the cherries off of their stems and remove the pits if you like, but they add flavor and you can leave them in. Make a pancake-like batter with the flour, 50 g ($^1/_4$ cup) of sugar, eggs, milk and a pinch of salt. The batter should not be too runny.

Butter a pie dish, pack the cherries in tightly, pour the batter over them and top with the remaining sugar. Put in the hot oven and cook for about 45 minutes.

"I seem to remember Hoschedé, whom

I saw in Paris, telling me that you do not

much like the local Grancey wine: we are

drinking a lot of it at the moment, which

suits me to a tee."

Camille Pissaro, letter to Claude Monet, second half of November 1884.

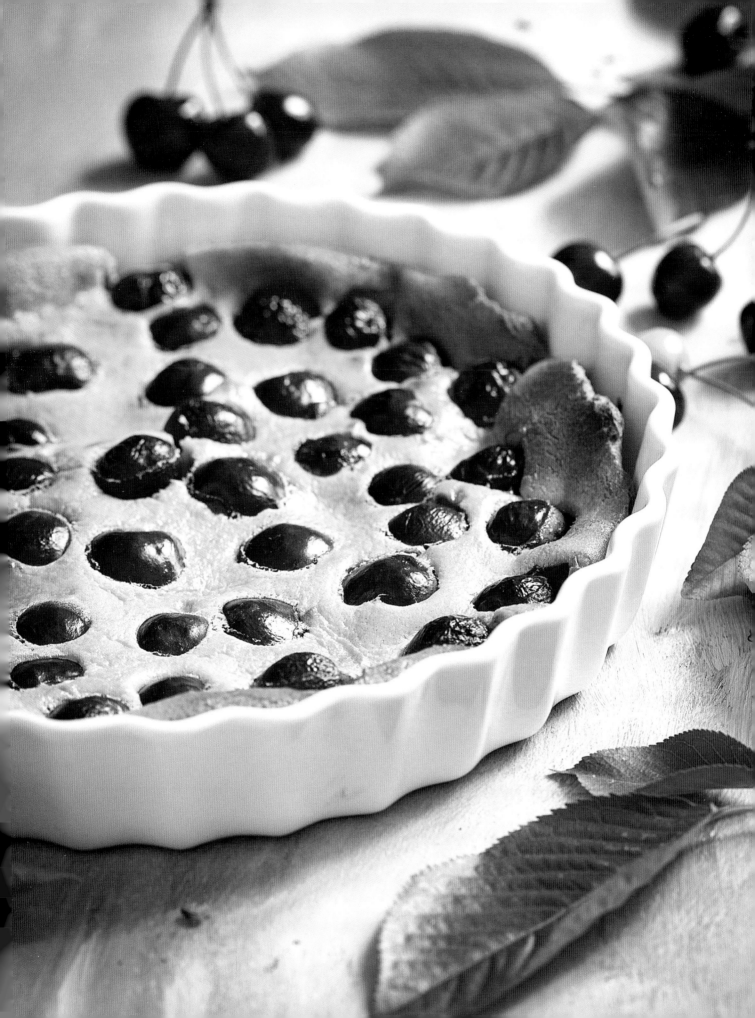

"The Seine! I have painted it all my life, at all hours of the day, at all times of year, from Paris to the sea ... Manet laughed at this and kept saying: Then tell Monet to leave some for other peoples!"

Marc Elder, *At Giverny with Monet*, 1924.

Above: Claude Monet, *The Bridge at Argenteuil*, 1874. Monet's paintings of Argenteuil demonstrate his growing fascination with water and reflections and with the peaceful atmosphere of this corner of the Île-de-France. Monet painted this bridge seven times and the little railway bridge, also at Argenteuil, four times. He captured them in luminous pictures that show no sign of Impressionism's difficult beginnings.

Right: The pleasures of bathing, photographed at the end of the nineteenth century by Paul Lhuillier (1860-1943).

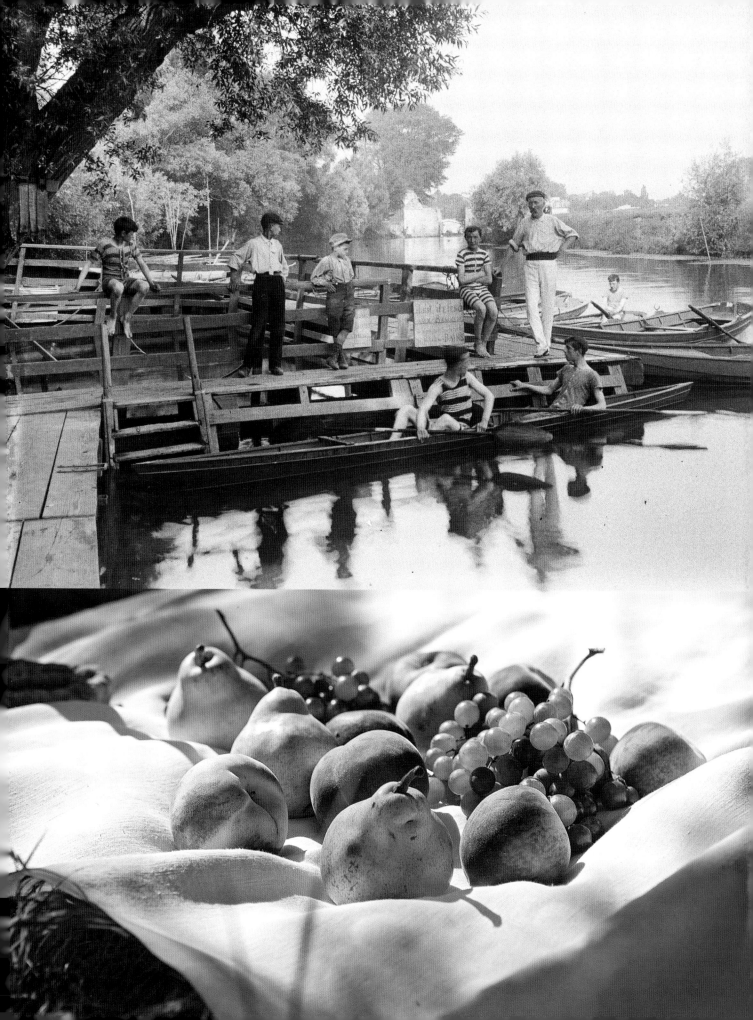

Strawberry Mousse

❖

250 g (1 ¹/₂ cups) strawberries
20 g (1 ¹/₂ tbsp) superfine sugar
4 egg whites

1 tbsp butter for greasing the dish
Salt

❖ *Serves 4 Preparation time: 10 minutes Cooking time: 10 minutes*

Preheat the oven to 150°C (gas mark 2 or 300°F).

Mash the strawberries into a purée and pass through a sieve. Sweeten the strained purée to taste: you will need more or less sugar depending on the quality of the strawberries.

Whip the egg whites into stiff peaks with a pinch of salt and then carefully fold in the strawberry purée. Pour the mixture into a greased dish and cook in the oven for 10 minutes. Serve immediately.

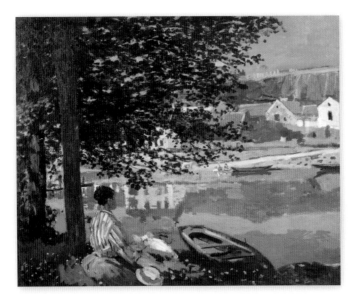

Above: Claude Monet, *On the Bank of the Seine*, 1868. Painted at Bennecourt, this picture shows Camille at the time when the young couple were in dire financial straits.

Swiss Roll

For the dough
4 eggs
100 g ($^1/_2$ cup) sugar
100 g (a bit less than 1 cup) flour
1 tbsp rum
1 medium jar apricot jam
Salt

For the caramel icing
100 g ($^1/_2$ cup) sugar
100 ml ($^1/_2$ cup) water

❖ *Serves 6 Preparation time: 30 minutes Cooking time: 20 minutes*

Preheat the oven to 200°C (gas mark 5 or 400°F).

Separate the eggs. Beat the sugar and egg yolks together for about
10 minutes. Gradually add the flour and then the rum.

Whip the egg whites into stiff peaks with a pinch of salt and then add
them carefully to the yolks and sugar mixture.

Grease and line the base and sides of a rectangular baking tray with
greaseproof paper. Pour in the cake mixture so that it makes a layer
1 cm deep. Bake for about 20 minutes until golden.

Take the cake out of the oven and turn it out onto a clean tea towel that
is spread on a marble surface. Peel off the greaseproof paper and spread
the top of the cake with jam. Roll up the cake while it is still hot and then
leave it to cool.

To make the caramel icing, heat the water in a small saucepan, add the
sugar and mix until it turns golden. Pour over the cake immediately.
Serve cold.

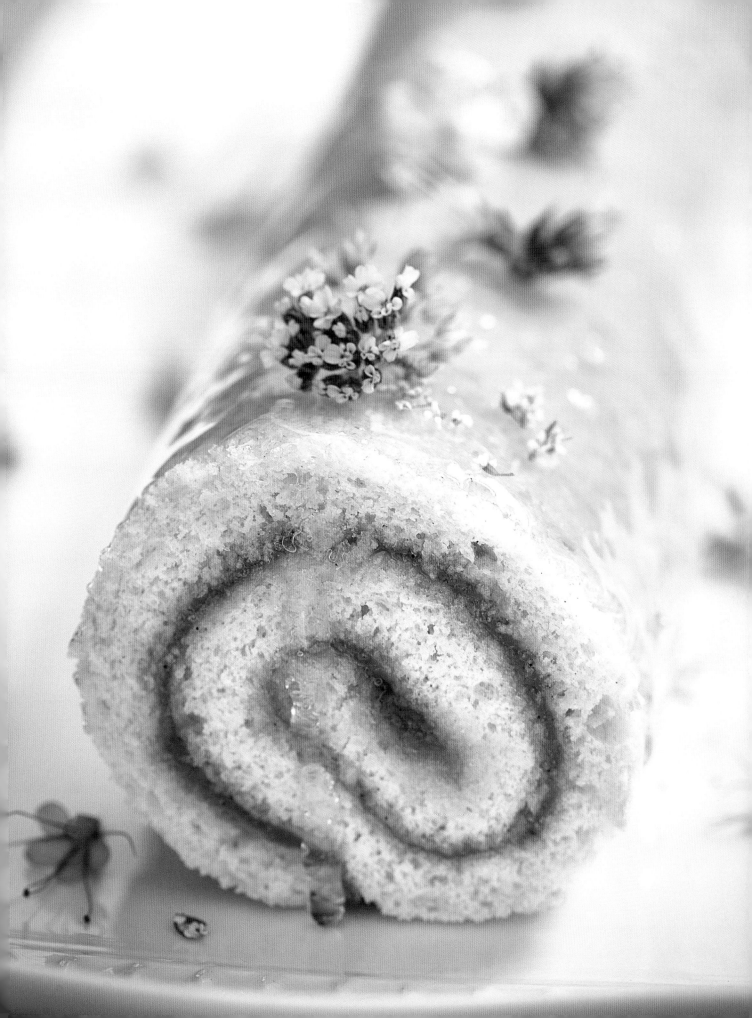

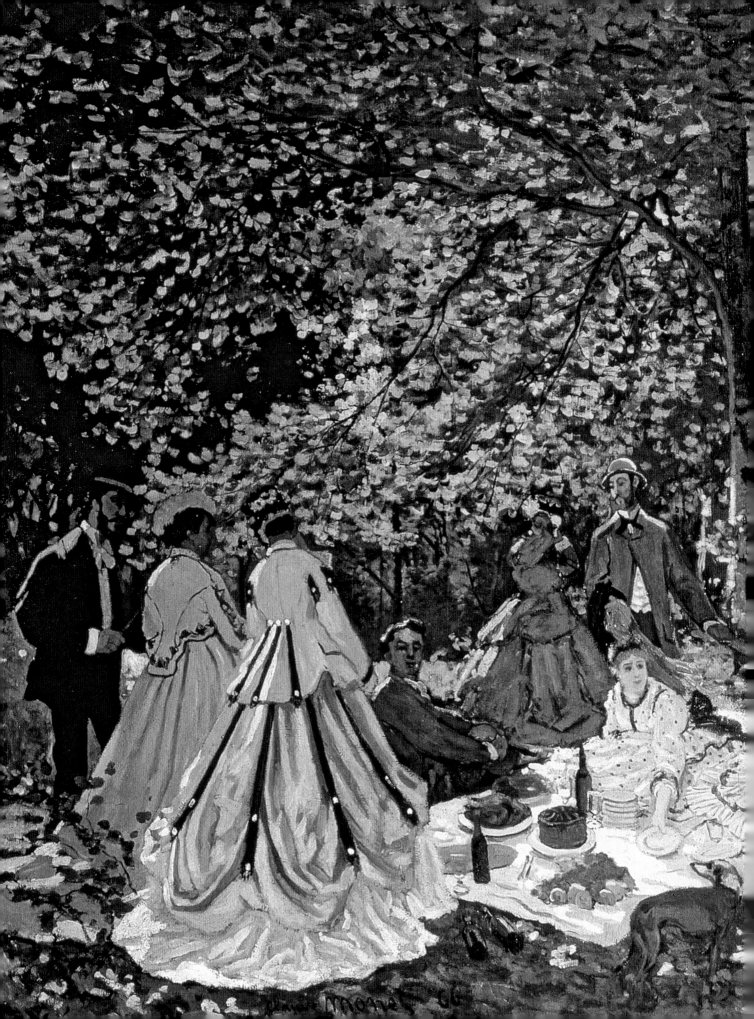

Claude Monet, *Le déjeuner sur l'herbe*, 1865–6.

Monet set about painting this picture after the uproar caused in 1863 by Manet's painting of the same name.

f°

le 18 Avril

LISTE DES VÉGÉTAUX

és par Monsieur Claude MONET.

-:-:-:-:-:-:-:-:-

unda atrosanguinea tige à.........60.00

rose tige à................60.00

pleno tige à................60.00

es à................50.00

s à................25.00

urs doubles,tiges à................40.00

double
double

nouilles fortes "Anglaise" à.....20.00

eri rose double,tige très forte 200.00

-:-:-:-:-:-:-:-

THE DELIGHTS
of Giverny

2 1 Malus floribunda atrosangui
2 2 d° d° rose tige
1 1 d° rosea pleno tige à...
4 2 Glycines tiges à..........
 4 Pêchers tiges à..........
 2 Cerasus à fleurs doubles,ti
3/4 Wistaria 1 rose double
 1 blanc double
 2 Cerisiers quenouilles forte

Plante remarquée:

9 1 Cerasus Watereri rose doubl

-:-:-:-:-:-:-:-

1 Eg fume ebensores
2 Wiburnum
4 Crabler

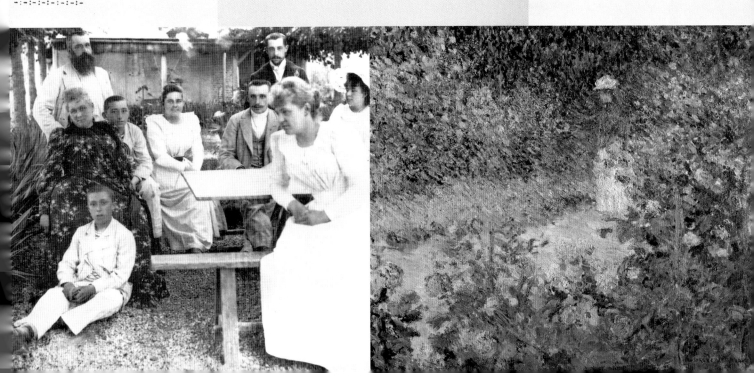

"Giverny is a splendid place for me"

❖

When he set foot in Giverny in April 1883 and came upon the Maison du Pressoir, Claude Monet found somewhere that was not only conducive to his painting, but to the simple and straightforward way of life he was looking for and valued so much. In this patch of countryside near Vernon, he found the Norman light that he had cherished so dearly when he had explored the area some years earlier. It was a peaceful village, nestled among gentle hills and surrounded by farmland and vineyards. The only thing that disturbed the peace was the little train that quietly passed though four times a day on its way to and from Pacy-sur-Eure and Gisors. Monet had been searching for a home for several weeks, a safe haven were he could permanently settle with his partner and the eight children they had between them. It was no surprise that he instinctively looked to the west of Paris where he had been painting for several years. This area was on a train line from the Gare Saint-Lazare, and in 1877, it had provided him with the subject of a wonderful series of paintings.

Monet was to live there for forty-three years, exactly half of his life, until his death in 1926. When he first laid eyes on the house it was pleasant enough, so he immediately rented it. Over the course of time, it was to become even better. In 1890, after they bought the house, Alice and Monet set about renovating it. Monet made his first studio in a barn to the west of the main house. Two others were to follow in the main house and the original studio was turned into the airy sitting room we see today, full of light from the big window.

There are a few steps between this sitting room and a smaller room, which leads via the "grocery" to the dining room and then the kitchen. The dining room and kitchen encapsulate the charming way of life expressed by those who visited Giverny. Painted in two shades of yellow with the focus on a huge table capable of seating fifteen people, the dining room is joyful and welcoming. The room is both bright and refined, with blue accents on the mantlepiece beautifully complimenting the luminous yellow walls. Monet took the same care with its decoration that he did with the composition of a painting. There is a photograph showing him proudly posing in his dining room in font of walls covered with the Japanese prints he collected throughout his life. The room is simple, elegant, original and modern, its style entirely in keeping with Monet's vision of a comfortable family dining room and space for entertaining people whose company he enjoyed.

Decorated in blue and white tiles, the kitchen offers a wonderful contrast to the yellow dining room. Everything about it, from the imposing stove and striking copper pans to the red tiles on the floor, suggests an organized yet bustling atmosphere. One can almost smell the game, poultry and fish being prepared and see the kitchen staff wrestling with recipes, the fresh vegetables from the kitchen garden piled high on the table, the birds waiting to be plucked, the mistress of the house drawing up menus and the master setting down his paintbrushes to lift a saucepan lid as he passes by.

A Garden Full of Colors and Flavors

Soon after he arrived in Giverny, Monet wrote to Théodore Duret: "I am in raptures. Giverny is a splendid place for me."[1] Monet's extensive correspondence

tells us, among other things, of his immediate priorities. He had to find moorings for the four boats that would provide him with wonderful vantage points by the Seine and the Epte as well as a closer study of the intriguing reflections on the water. The garden was another priority; he set his entire family to work on it and created a magnificent garden that he loved to cultivate. Adjoining the house was the walled-in Norman garden, which was divided into symmetrical flowerbeds and bisected by a central pathway. This went all the way to the far wall with the railway track and the little Rû river behind it. It was originally planted with spruces and cypresses, but Monet ignored Alice's advice and had them cut down and replaced with arches of roses. Every autumn the path was carpeted with dazzling nasturtiums that were sown every year from April onwards. To the west of the path and the flowerbeds, Monet had greenhouses erected so he could enjoy and study the plants growing there.

As time went on and the Monets became increasingly wealthy, additional staff was hired to help with the day-to-day running of things, including gardeners, linen maids, cooks, and before long, drivers including first Fouillard, then Sylvain Besnard. Soon, thanks to the greenhouses and the tender care of Félix Breuil and his team of gardeners, the walled-in Norman garden was brimming with flowers and inspiring subjects for paintings. However, with this garden and the hen house and rabbit hutch (a source of entertainment for the children and supplies for the kitchen) to the east of the main house, and the beautiful orchard (that yielded delicious plums for a very fine and much appreciated plum brandy), to

the southeast, there was no room left to grow any of the cardoons, turnips, cabbages or celery needed for the family's favorite recipes. In turn, Monet bought a large plot on the rue du Chêne on the far side of the village where he planted a vast kitchen garden. Adjoining the plot was a little house called the "Maison Bleue," which became home to another gardener, Florimond, hired specifically to tend Monet's kitchen garden.[2]

In 1890, as a result of Paul Durand-Ruel's efforts and success, Monet was able to buy the house and garden at Giverny. He then set about turning what had hitherto been a dream into reality: having a water garden of his own, on his own land. He bought a plot beyond the railway track and diligently sought permission to divert the course of the Rû so that he could create a pond and fill it with wonderful water lilies. A new gardener, Lebret, helped him with this project, overseeing the planting and the upkeep of the banks and the pond. In 1901, Monet acquired another piece of land and enlarged the pond, adding a wooden bridge and overhanging wisteria. Finally, the water garden was complete. Today, it is recognized as the inspiration for the series of paintings of *Water Lilies* and *The Japanese Footbridge*, which are hanging in museums all over the world.

Daily Life at Giverny
Meticulous planning ensured that the cooks who prepared the meals were supplied with all the vegetables they needed. Alice would draw up the week's menus in advance, paying attention to what was in season and how many guests were expected. She would go into Vernon on Saturdays and come back

with meat and game. The vegetables she wanted would be brought over daily from the Maison Bleue to the Maison du Pressoir, and the cook would begin preparing a favorite recipe to be served in the yellow dining room. A key figure in running the household was Marguerite, who presided over the stove, copper pans, and a number of other cooks.[3] Marguerite's recipes are characteristic of life at the time: vegetable soups, roast birds and rich desserts renamed after guests or "Bonne" ("Nanny") as Alice was called (first by her grandchildren and then by the rest of the family).

Most of what we know about everyday life at Giverny comes from the almost daily letters Alice and Monet exchanged when Monet went looking for new motifs to paint in Normandy, Italy, Belle-Île, Antibes, the Creuse or Norway. In many of the letters, Monet is genuinely upset after hearing that Alice is dealing with sick children, financial difficulties, suppliers and staff who let her down. Although he often refers to his own problems, such as his frequent difficulties with painting and his frustration at being dependent on the weather wherever he is, he also describes the happiness he gets from painting, and sometimes mentions a good meal he has had or a meeting with friends. At Pourville, for instance, he congratulated himself on enjoying galettes prepared by "an excellent cook"[4] called Paul. At Étretat, he was delighted by a grocer who offered him six larks he had caught on the cliff: "What could be kinder?"[5] At Belle-Île, by contrast, he complained that the meals were rather monotonous: "Eggs and lobster, that is what I will mostly eat and probably get heartily sick of ..."[6]

When Monet was at Giverny, the family was careful to leave him to his work. Monet would get up early to paint outdoors, sometimes taking one of the young men with him to ferry brushes and canvases in a wheelbarrow. He might also work indoors in his studio, finishing a painting he had started en plein air. When he came in for lunch, the family could gauge from his mood whether or not he was pleased with his work. If his work had gone badly because of the weather or because he could not manage to capture a particular reflection, his mood could be foul. His rages would petrify the household, and nobody could stop him if he began furiously scraping, ripping or burning his canvases. By contrast, when everything was going well, he was the most charming head of family imaginable! Over the years at Giverny, when he was pleased with his work, he was attentive to everyone, displaying real affection for both his own sons and for Alice's children.

A Large Family at Leisure

In his memoirs, Jean-Pierre Hoschedé conjures up the happy times the family enjoyed and the frequent adventures Monet organized for them all. For Alice, there were evenings out in Paris to take in the theater, dance shows, and wrestling, as well as dinners at Prunier's or Drouant's. The boats in Giverny that Monet used for his work would be commandeered for delightful swimming trips around the Île aux Orties (Nettle Island), the island Monet had bought at the junction of the Epte and the Seine. We learn in passing that Monet was "as good a diver as a swimmer."[7] In the autumn the family would go mushroom gathering and in the winter the children would go ice

skating on the frozen marsh. There were occasions when Monet would take his entire family to the fair or on an expedition by train or boat. "Once," he told Marc Elder, "the whole family went off to Rouen in my ark. The children took it in turns to row and the current pulled us along. On the way back we took a tug behind a load of barges. What an outing that was!"[8]

Life in Monet's Giverny house moved to the rhythm of the family's joys and sorrows. In 1892, a year after Ernest Hoschedé's death, Suzanne Hoschedé told her mother that she wanted to marry the American painter, Theodore Butler. Monet was initially very resistant to the idea. Butler was one of the first of many American painters to descend on Giverny over the years as Monet's fame spread, and Suzanne had met him on a cheerful ice skating expedition on the frozen marsh: "...You have a moral duty not to give your daughter's hand away to some American," Monet wrote to Alice, "unless he is known to us through family or friends, and not someone she has simply bumped into on the street."[9]

Monet quickly developed both respect and affection for Butler, however, and Butler became the father of Alice's first two grandchildren, Jimmy and Lily. A few days before Suzanne's and Butler's wedding, Monet decided to set his own situation to rights, marrying Alice first in the church and then at the Mairie in Giverny on July 16, 1892. And in 1897, Monet found himself at another wedding. His son Jean married Blanche Hoschedé, although Monet had initially been surprised by that match, too.

The house was gripped by sadness a few years later in 1899 when Suzanne died at the age of thirty.

Her sister, Marthe, helped Butler look after the children, and subsequently became his second wife eighteen months after Suzanne's death. The house was lively once again with their wedding, as shown in the photographs of the large happy family gathered together on the steps. Other weddings followed. In 1902, it was Germaine's turn. When she married Alfred Salerou, tables were once again moved into the large sitting room for the wedding breakfast because the yellow dining room was too small to accommodate the elegant crowd.

1. . C. Monet, letter to Théodore Duret, May 20, 1883, quoted in D. Wildenstein, op. cit., vol. 2.
2. Claire Joyes, *Monet's Table: The Cooking Journals of Claude Monet*, Paris, La Chêne, 1989.
3. *Ibid.*
4. C. Monet, letter to Alice Hoschedé, Pourville, February 17, 1882, quoted in D. Wildenstein, op. cit., vol. 2.
5. C. Monet, letter to Alice Hoschedé, Pourville, February 21, 1882, quoted in D. Wildenstein, op. cit., vol. 2.
6. C. Monet, letter to Alice Hoschedé, Belle-Île, September 16, 1886, quoted in D. Wildenstein, op. cit., vol. 2.
7. J.-P. Hoschedé, *op. cit.*
8. Marc Elder, *At Giverny with Monet* (1924), Paris, Fayard – A Thousand and One Nights, "La Petite Collection" series, 2010.
9. C. Monet, letter to his wife, March 10, 1982, quoted in D. Wildenstein, op. cit., vol. 3.

"The little ones are very sweet to have written to me, I am delighted to know that they are being good, give them each a big kiss from me, and the big ones too, I am writing to Germaine, tomorrow it will the boys' turn, give my love to Marthe, all my dearest thoughts to you."

Claude Monet, letter to Alice Hoschedé, Étretat, February 1, 1883.

Above: Claude Monet, *Portrait of Michel Monet in a Blue Jumper*, 1883, and *Portrait of Michel Monet in a Pompom Hat*, 1880. Born in 1878, Monet's younger son died at the age of eighty-seven in a car accident. He had inherited the property at Giverny, and with it all of the paintings still in the studio. On Monet's death, he bequeathed the entire estate to the Académie des Beaux Arts.

Right: This photograph of Jean at age three was taken in 1871 in Holland, where his parents, Claude and Camille Monet, stopped on their return from London. The family did not go back to France until the autumn. They returned to a Paris devastated by the events of the Commune. Jean Monet married Blanche, one of Alice Hoschedé's daughters, and died of an illness in 1914.

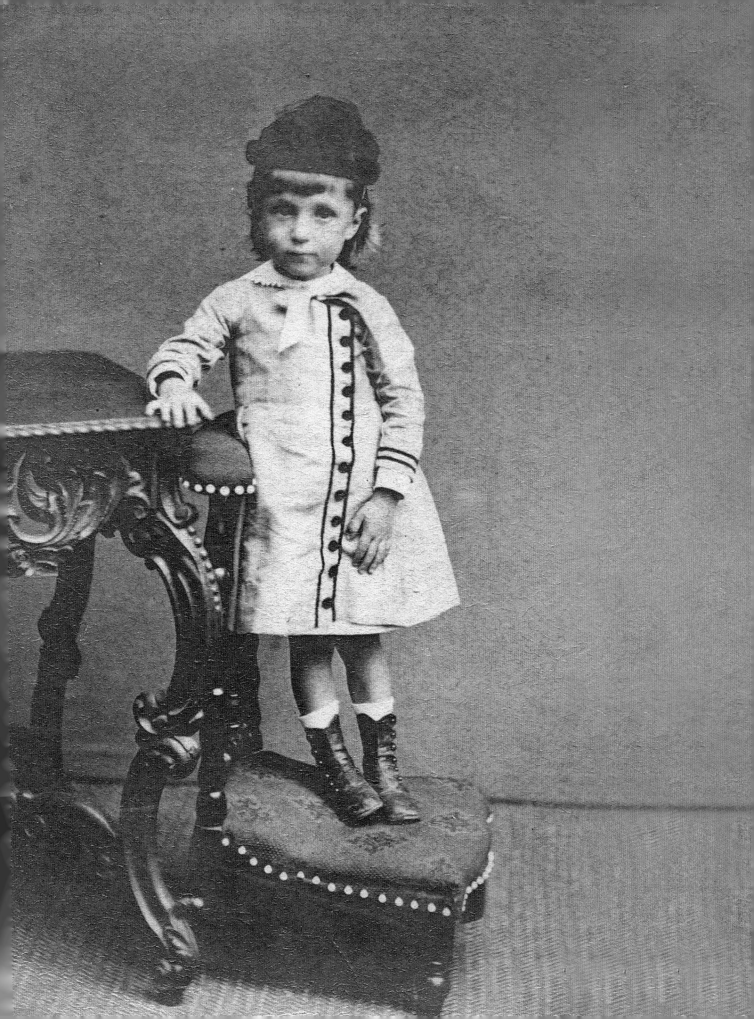

Celeriac Soup

❖

1 large celeriac (800 g or 1 ¹/₂ to 2 lbs)
3 medium-sized, floury potatoes (400 g or 1 lb)
40 g (3 tbsp) butter

6 slices *pain de champagne* (sourdough bread)
Salt + freshly ground pepper to taste

❖ *Serves 6 Preparation time: 30 minutes Cooking time: 40 minutes*

Peel the celeriac and cut into quarters, then slice each quarter into strips.
Cut a few of these into matchsticks and set aside to add before serving.
Peel and roughly chop the potatoes.

Melt the butter in a heavy-bottomed saucepan until it foams, add the strips
of celeriac and gently sauté until they begin to brown. Add the potatoes
and cook until lightly golden. Cover with water, season with salt and bring
to a boil. Cover and cook for about 30 minutes; test the celeriac with the
point of a knife to make sure it is tender.

While the soup is cooking, grill the slices of bread and then cut them into
little croutons. Fill a soup tureen with boiling water to keep it hot.

Drain the vegetables, reserving the cooking liquid, then mince in a food
mill or purée in a blender. Dilute the mixture with some of the cooking
liquid until it has a velvety consistency, making it as thick or as thin as you
like. Briefly reheat. Meanwhile, empty the water from the tureen and place
the matchsticks of celeriac in the bottom.

Pour the soup over these, season with pepper and serve immediately with
the croutons.

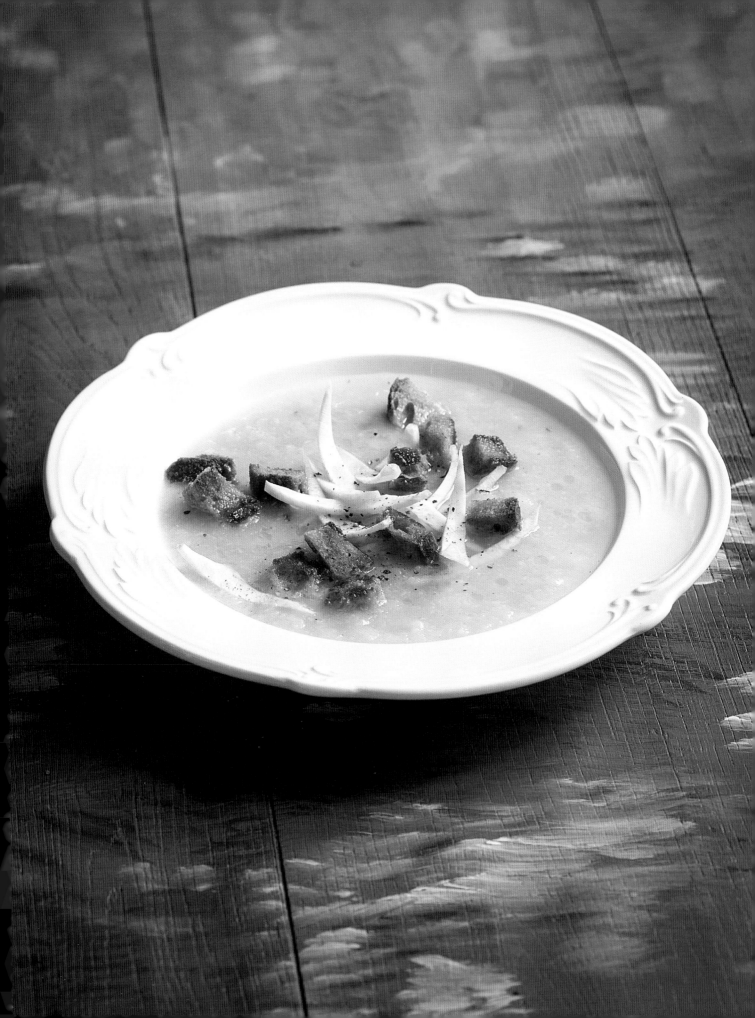

Herb and Lettuce Soup

❖

1 small bunch sorrel
1 bunch chervil
1 medium-sized lettuce
100 g (3 oz) round or short-grained rice

3 tbsp butter
1 pinch coarse salt
Freshly ground pepper to taste

❖ *Serves 4 Preparation time: 20 minutes Cooking time: 50 minutes*

Carefully wash, drain and dice the herbs and lettuce.

Melt about 1 tablespoon of butter in a saucepan. When it begins to foam, throw
in the chopped herbs and lettuce and stir briskly. Add a pinch of coarse salt and
a grind of pepper and wilt for 5 minutes. Pour in 1 liter (6 cups) of hot water and
simmer for 15 minutes.

Rinse the rice in cold water to remove the starch (the water should run clear
when you drain it), then pour it into the pan. Stir well to combine with the
herbs and lettuce and then bring to a gentle boil for 30 minutes.

Mix well and pour the boiling soup into a soup tureen with 2 tablespoons of
butter. Serve immediately.

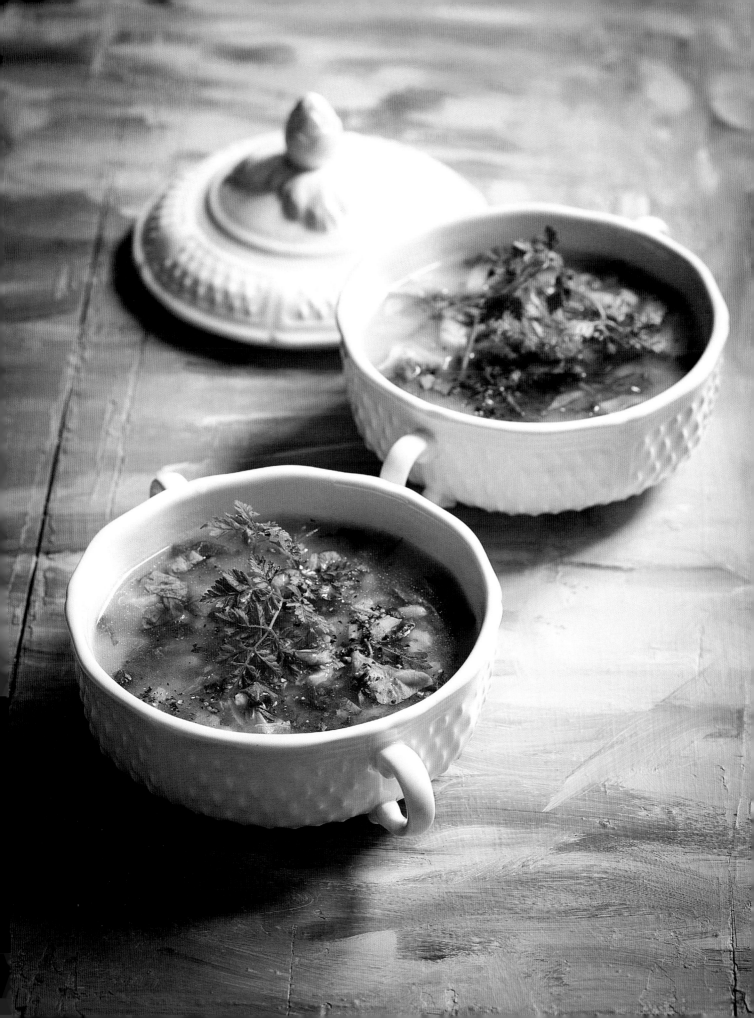

Baked Eggs with Tomato Sauce

For the eggs
8 free range eggs
1 liter (4 cups) skim milk
100 g (3 oz) grated Emmental
1 tbsp butter
Salt + freshly ground pepper to taste

For the tomato sauce
12 small ripe tomatoes
1 slice ham
1 medium-sized sprig thyme
1 bay leaf
1 tbsp butter
Salt + freshly ground pepper to taste

❖ *Serves 8 Preparation time: 20 minutes Cooking time: 45 minutes*

Fill a roasting pan halfway with water and carefully place in the oven. Find a rectangular dish that is small enough to fit in the roasting pan and grease the base and sides well.

Preheat the oven to 150°C (gas mark 2 or 300°F).

Pour the milk into a saucepan, add a little salt, and bring to a boil. Turn off the heat as soon as the milk begins to bubble.

Break the eggs into a bowl and beat them as you would for an omelette. Continue to beat the eggs and stir in the hot milk one tablespoon at a time until the eggs are hot. Pour in the rest of the milk and the grated cheese and stir briskly. Pour the mixture into the buttered dish and spread it out evenly. Carefully place the dish in the roasting pan; the water should be barely simmering, with just a few bubbles on the surface. Cook the eggs in the bain-marie for 30 minutes.

Meanwhile, make the tomato sauce: scald the tomatoes, then run them under cold water and peel them. Roughly chop and gently squeeze them to get rid of the juice and seeds. Put the tomatoes in a saucepan with the sprig of thyme and the bay leaf. Season with salt and pepper and add the diced ham. When the tomatoes begin to boil, turn down the heat and gently simmer for 20 minutes. Strain through a fine sieve and extract as much pulp as possible. Keep the sauce warm.

Check if the eggs are done by inserting the point of a knife into the middle of the dish: the blade should come out dry. Remove the dish from the oven and let the egg mixture rest for 5 minutes before turning it out onto a warm dish. Add a generous piece of butter to the hot tomato sauce, stir briskly and pour the sauce over the eggs.

Poached Eggs à la Lyonnaise

8 very fresh free range eggs
12 small white onions
100 ml (¹/₂ cup) clarified stock (or 1 stock cube
dissolved in 100 ml or ¹/₂ cup hot water)
100 ml (¹/₂ cup) skim milk

40 g (1 ¹/₂ oz) grated Emmental
80 ml (5 tbsp) white wine vinegar
1 tbsp butter + butter for greasing the dish
Salt + freshly ground pepper to taste

❖ *Serves 8 Preparation time: 20 minutes Cooking time: 45 minutes*

Heat a large saucepan of water and bring to a boil. Add the white wine vinegar. Break an egg into a cup and carefully tip it into the center of the pan where the water is boiling the hardest. Lower the heat and poach the egg for 3 minutes. Remove with a slotted spoon and drain on a clean paper towel. Repeat the process with the rest of the eggs, making sure to skim the water and bring it back to a boil each time.

Preheat the grill.

Dice the onions, blanch them in boiling water and drain. Melt a tablespoon of butter in a saucepan, add the onions and gently sauté without letting them brown: they should be barely golden. Add the flour and stir briskly until the mixture forms a light paste. Gradually add the milk and stock, whisking vigorously to make sure there are no lumps. You should end up with a smooth, thick sauce. Season with a pinch of salt and plenty of pepper.

Grease a gratin dish and pour in half of the sauce. Lay the poached eggs on top of this and cover with the remaining sauce. Sprinkle with grated cheese and cook under a very hot grill for 15 minutes until crispy and golden.

TIP

This is not a difficult recipe to make once you have mastered how to poach the eggs. Whatever you do, do not try and save time by poaching them all at once.

"Mme Monet's room has blue woodwork, while those of Mlles Blanche and Germaine have violet. We did not see Mlle Marthe's room. Mlle Blanche showed us some of her paintings. They were prettily coloured and two, of trees reflected in the Epte, were like M. Monet's painting."

Julie Manet, *Diary*, October 30, 1893.

Above: Claude Monet, *Water Lilies and Agapanthus*, 1914-17. Monet was deeply attached to his house at Giverny and finally, after buying it in 1890, he was able to realize his dream and create a water garden. The water lilies in his pond were to engross him for more than thirty years.

Alice Hoschedé in 1879, aged thirty-five. She would soon have to make the decision to throw in her lot with Monet, who was widowed and desperate as he wrote to Pissarro in September 1879: "I am overwhelmed, with no idea how to pick myself up or organise my life with my two children."

Right: Claude Monet, *Portrait of Blanche Hoschedé as a Young Girl*, c. 1880. Monet was particularly fond of Blanche, who was a painter in her own right, and often went off with him painting en plein air.

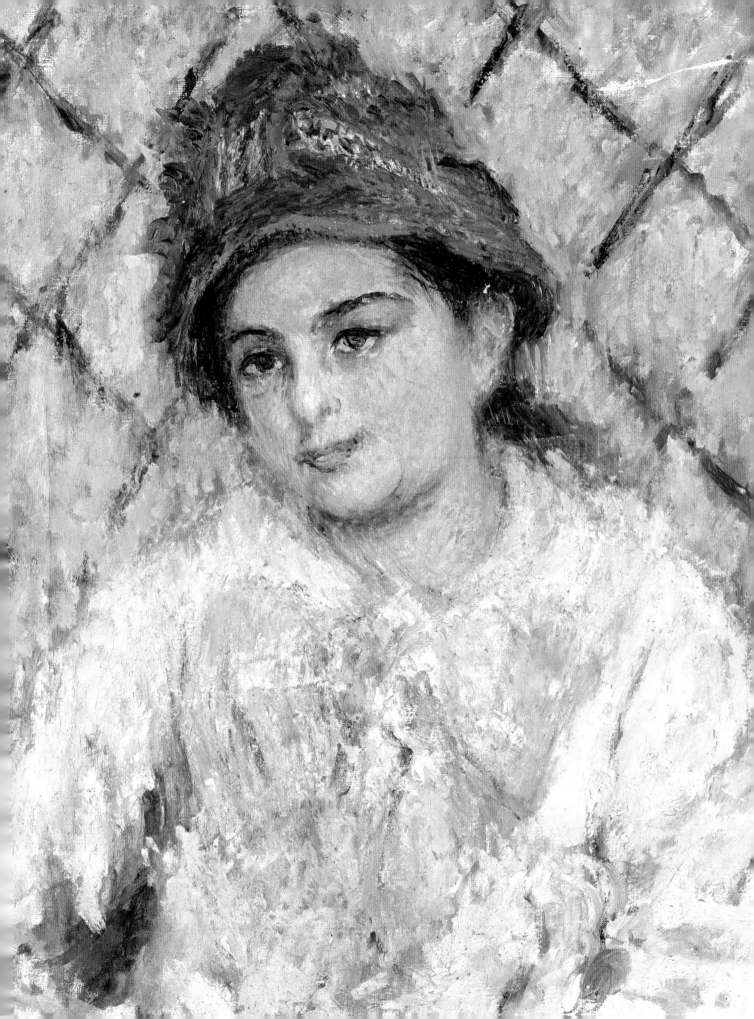

Stuffed Tomatoes

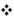

12 small ripe tomatoes
1 bouquet garni (1 sprig thyme, 1 bay leaf
and 1 sprig parsley)
2 medium-sized slices *pain de champagne*
(sourdough bread), crusts removed
100 ml (½ cup) stock (or 1 stock cube dis-
solved in 100 ml or ½ cup hot water)
50 g (2 oz) smoked bacon

50 g (¾ cup) button mushrooms,
stems removed
1 bunch flat-leaf parsley
2 medium-sized garlic cloves
6 medium-sized shallots
2 egg yolks
1 tbsp butter
Oil
Salt + freshly ground pepper to taste

❖ *Serves 6 Preparation time: 30 minutes Cooking time: 1 hour*

Carefully cut around the stem of each tomato with the point of a knife, cutting in towards the core at an angle to remove the tough part under the stem. Carefully remove the pulp from the tomatoes with a small spoon and place in a saucepan. Briefly bring to a boil and then strain through a fine sieve to get rid of the seeds. Return to the pan with the bouquet garni, season with salt and pepper and cook for at least 20 minutes until reduced to a purée. Remove the bouquet garni.

Soak the bread in the stock.

Preheat the oven to 200°C (gas mark 5 or 400°F).

Dice the bacon and the mushroom caps. Dice the parsley. Peel and dice the garlic and the shallots. Melt a tablespoon of butter in a pan and gently sauté the chopped ingredients. When the mixture is golden, add the bread and the tomato purée. Mix well and then bind with the egg yolks. Check for seasoning, adding a pinch of salt and pepper if the stuffing tastes bland.

Lightly brush a ceramic baking dish with oil. Fill the tomatoes with stuffing and lay them in the dish. Cook in the oven for 30 minutes. Serve hot or cold.

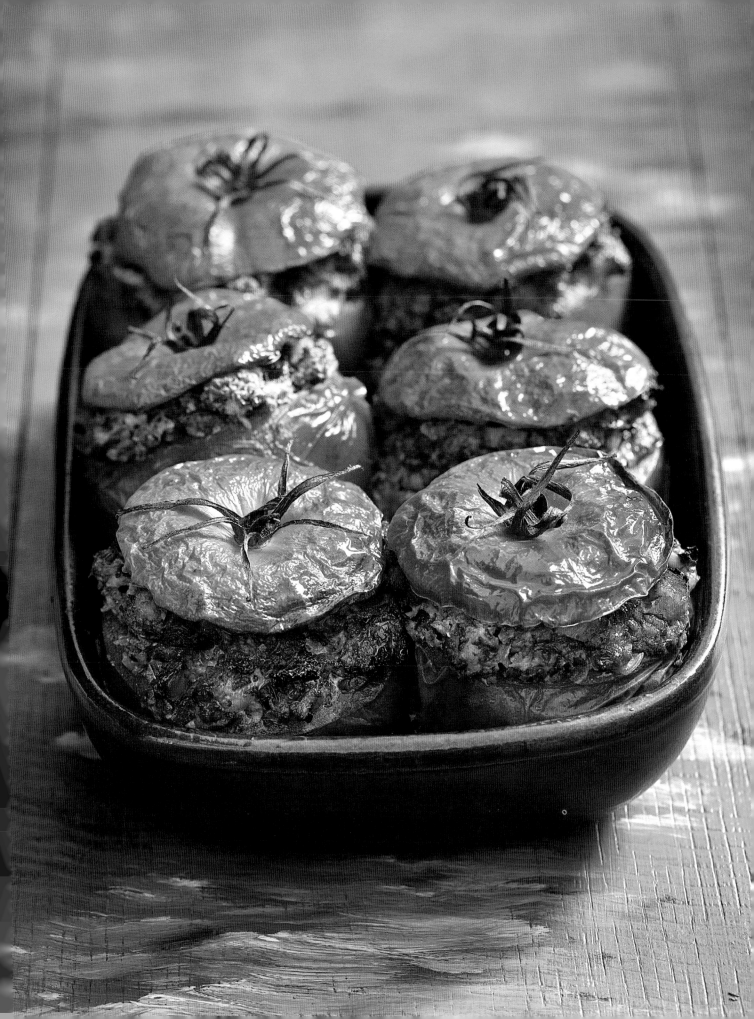

Stuffed Aubergines

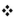

For the aubergines

3 firm-fleshed aubergines (eggplants)
1 pinch coarse salt
2 tbsp flour
300 ml (1 ½ cups) olive oil + oil for brushing
the dish
2 tbsp breadcrumbs
Salt + freshly ground pepper to taste

For the tomato sauce

4 ripe tomatoes
1 bouquet garni (1 sprig thyme, 1 bay leaf
and 1 sprig parsley)

2 shallots
1 garlic clove
1 tbsp olive oil
Salt + freshly ground pepper
to taste

For the stuffing

100 g (2 cups) button mush-
rooms, stems removed
1 handful flat-leaf parsley
3 shallots
2 garlic cloves
2 tbsp olive oil

❖ *Serves 6 Salting time: 1 hour Cooling time: 20–30 minutes Preparation time: 40 minutes Cooking time: 1 hour*

Cut the eggplants in half lengthwise. Pierce the skin in a few places and
sprinkle with coarse salt. Place flat on a large dish and leave to drain for
about 1 hour.

Meanwhile, make the sauce: scald the tomatoes for 1 or 2 minutes and then
run them under cold water and peel them. Roughly chop the flesh and
put in a saucepan. Briefly bring to a boil and then strain through a fine
sieve to get rid of the seeds. Return the purée to the pan with the bouquet
garni, season with salt and pepper and cook for about 10 minutes to reduce.
Remove the bouquet garni. Peel and dice the shallots and garlic, place in a
frying pan with the olive oil and sauté until they begin to brown. Add the
reduced tomato purée and cook for another 10 minutes. Season with salt
and pepper and set aside.

Now fry the eggplants: heat the olive oil in a large frying pan. Flour the cut
sides of the eggplants and carefully drop them into the hot oil, watching
out in case it spits. Fry for 10 to 15 minutes: the flesh should be tender but
not mushy. Drain on paper towels and leave to cool.

...|...

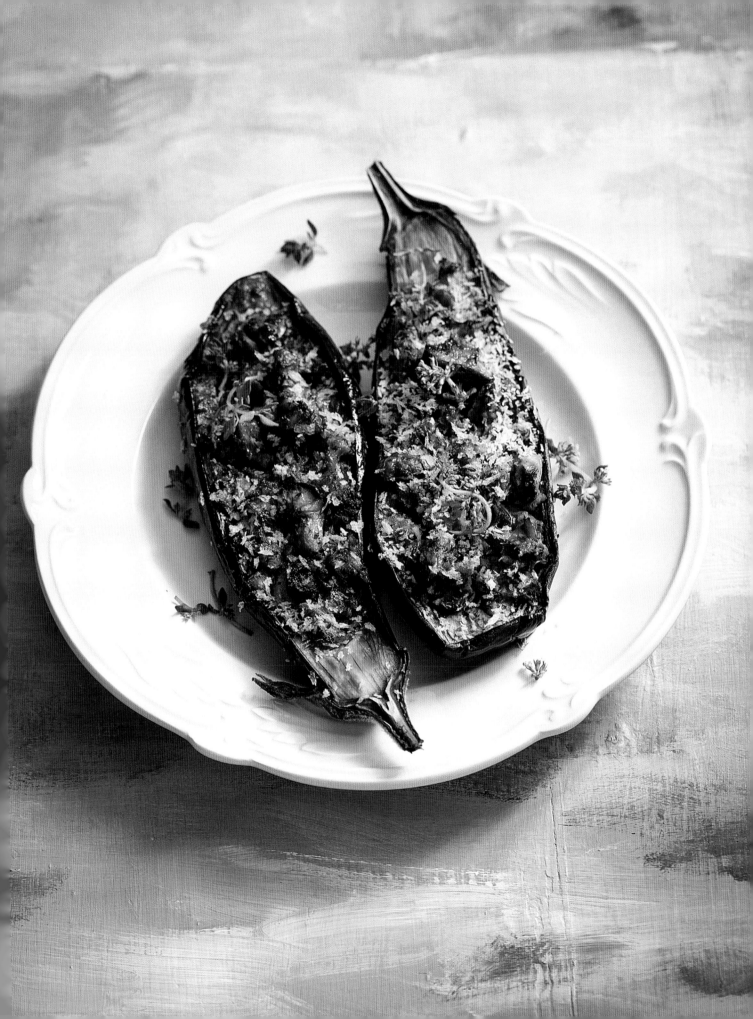

Make the stuffing: carefully wipe the mushrooms clean with a paper towel (do not wash them) and dice. Dice the parsley. Peel and dice the garlic and the shallots. Heat the olive oil in a frying pan and gently sauté all of the chopped ingredients. Cook for about 15 minutes until they begin to brown and smell sweet.

Carefully scoop out the flesh of the eggplants, leaving a depth of 5 mm (1/$_2$ cm) and making sure the skins remain unbroken. Chop the flesh and add to the frying pan. Cook for about 10 minutes, stirring carefully until the stuffing is well mixed. Season to taste with salt and pepper. To finish, mix in a good-sized spoonful of tomato sauce.

Preheat the oven to 200°C (gas mark 5 or 400°F). Brush a large gratin dish with oil, fill the eggplant skins with stuffing and place in the dish. Sprinkle with breadcrumbs, drizzle with oil, and bake in the oven for 20 minutes until crisp and golden. Reheat the tomato sauce. Serve the eggplants hot, warm or at room temperature, with the hot tomato sauce either alongside or poured over them.

"Meals had to be served exactly on time [...]. Because the family was generally scattered about the house, the gong was sounded once and then a second time, after which everyone had to be seated at the table."

Jean-Pierre Hoschedé, *The Little-Known Claude Monet*, 1960.

Right: Claude Monet, *Branch of the Seine near Giverny*, 1897.

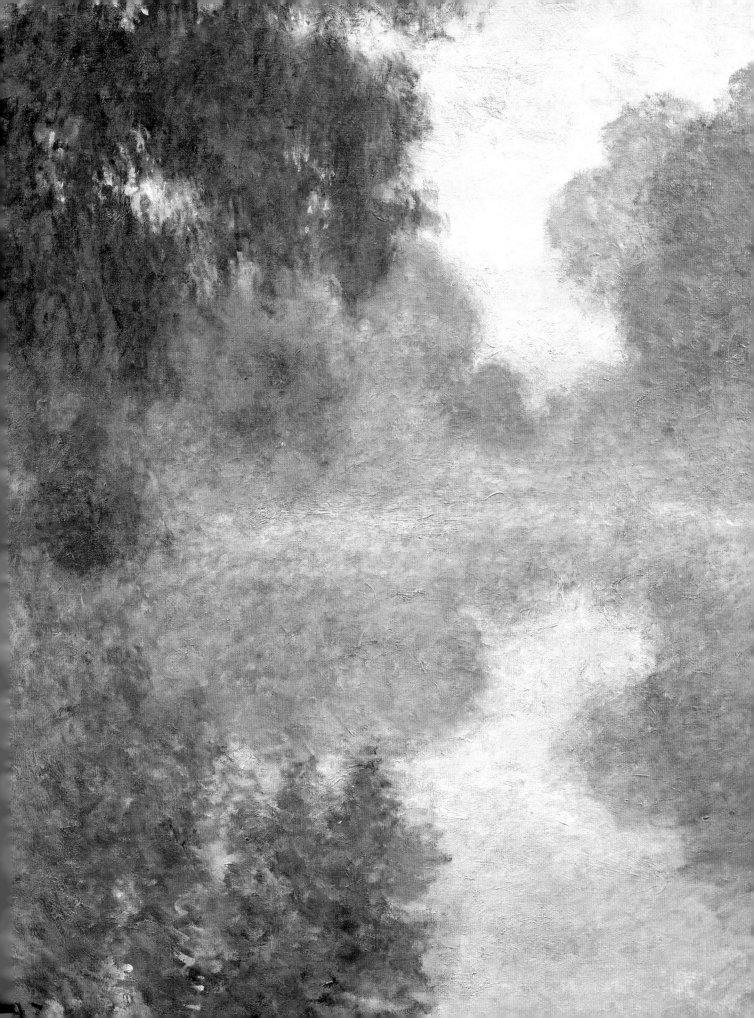

Gastronome's Fried Chicken

1 medium-sized free range chicken,
cut into pieces
4 artichokes
1 small truffle

30 g (2 tbsp) butter
1 tsp concentrated tomato purée
200 ml (1 cup) dry white wine
Salt + freshly ground pepper to taste

❖ *Serves 4 Preparation time: 15 minutes Cooking time: 40 minutes*

Blanch the artichokes in boiling salted water until the leaves drop off.
Remove all the leaves and the choke. Make sure the hearts are completely
clean and undamaged and cut them into quarters.

Carefully scrape the truffle clean with a paper towel (do not wash it) and
then dice it.

Preheat the oven to 180°C (gas mark 4 or 350°F). Heat the butter in a
casserole dish and brown the chicken. When it turns golden, add the
tomato purée and half of the white wine and season with salt and pepper.

Put the casserole dish in the oven and leave the chicken uncovered to finish
cooking for about 30 minutes. Pour in the rest of the wine and reduce the
sauce by briefly bringing it to a boil over a high heat. Put the artichoke
hearts and sliced truffle around the chicken and return the casserole dish
to the oven for 10 minutes. Serve hot.

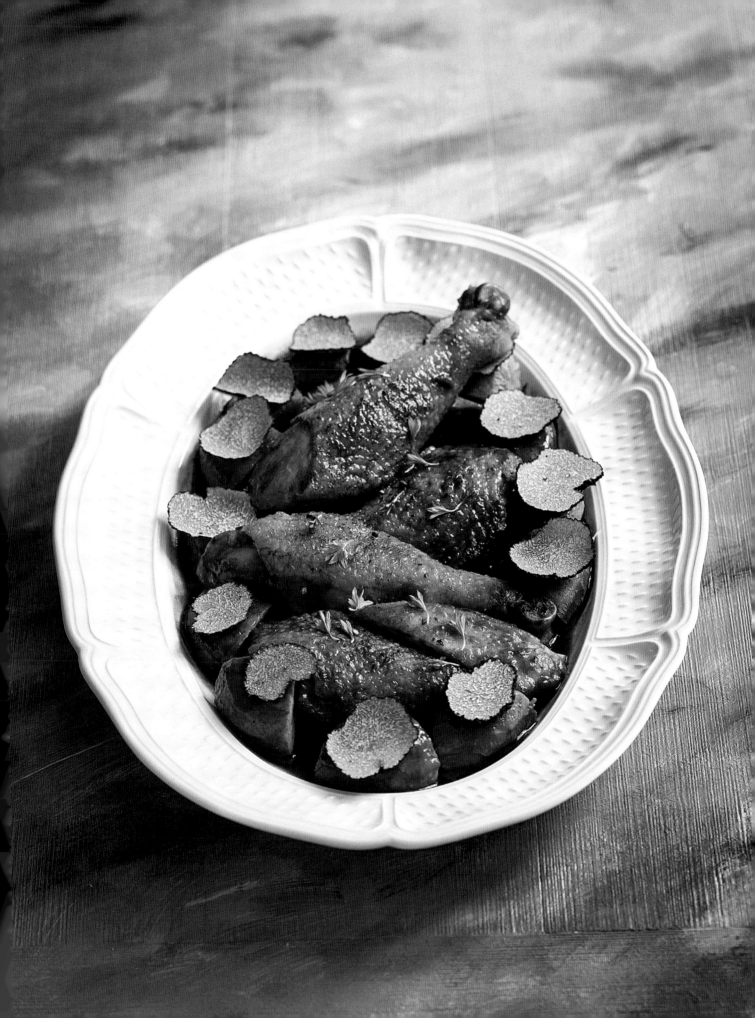

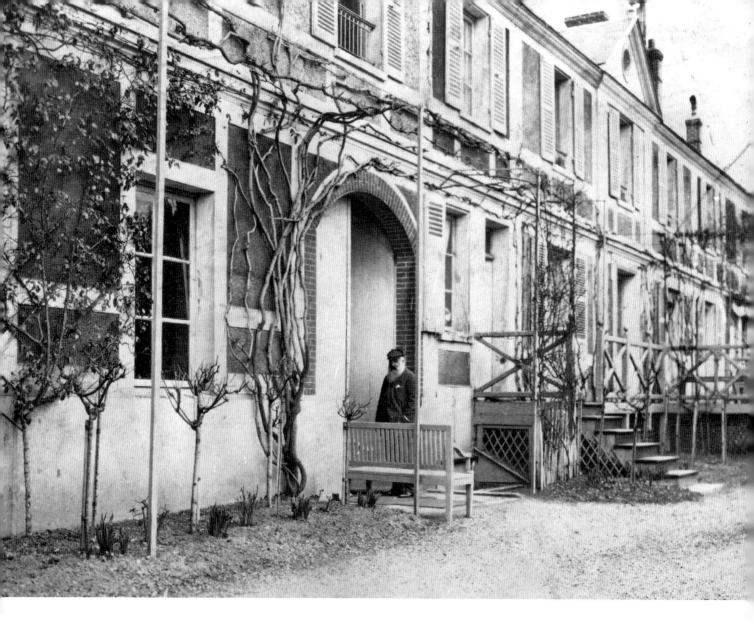

"There are two studios, one at each end of the garden. Between them sits the red and green house, laden with climbing roses, with all the ease of an unruffled spectator."

Marc Elder, *At Giverny with Monet*, 1924.

Above: Monet at Giverny in about 1915; he put his heart and soul into creating his garden and enlarged it several times. Claude Monet, *Effect of Spring*, Giverny, 1890.

Right: Monet was entranced by the countryside around Giverny. Monet is seen here, with his hands in his pockets, devoting himself to his other passion: gardening.

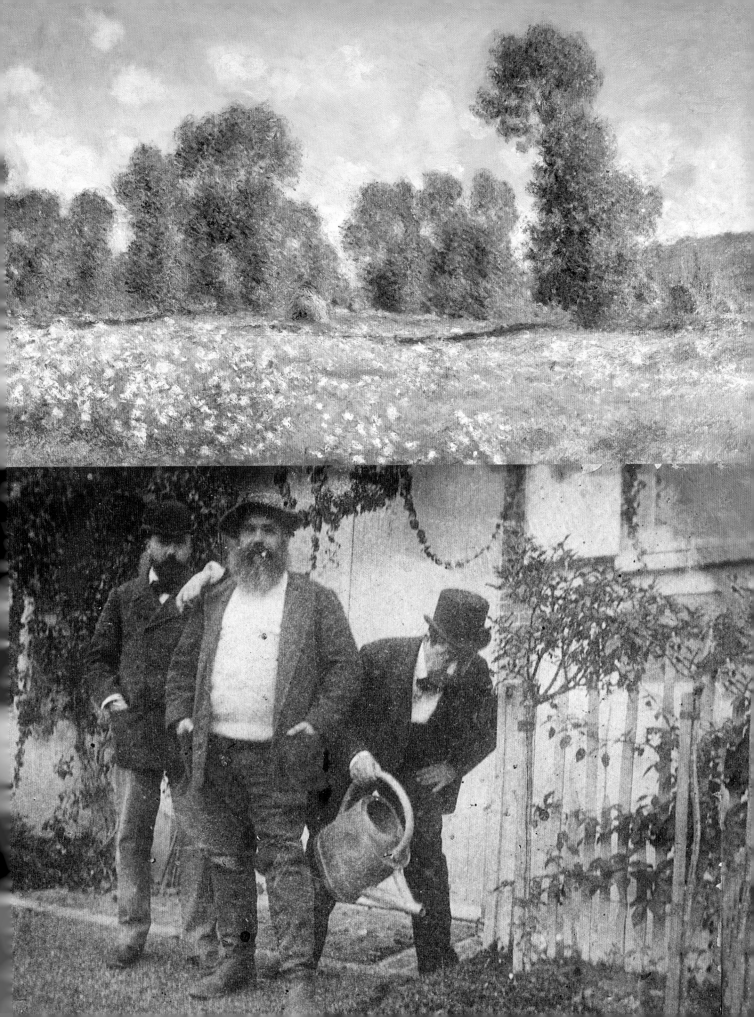

Tarragon Chicken

For the chicken

1 medium-sized free range chicken
1 slice fatty bacon
1 bunch tarragon
1 tsp cornflour
Salt + freshly ground pepper to taste

For the stock

2 onions
1 bouquet garni (2 sprigs thyme, 2 bay leaves,
2 sprigs flat-leaf parsley)
2 medium-sized carrots
2 sprigs tarragon
Cloves
Coarse salt
Peppercorns

❖ *Serves 4 Preparation time: 15 minutes Cooking time: 1 hour 15 minutes*

Make the stock: peel the onions and stud with cloves and then peel
the carrots and cut into rounds. Put the onions and carrots in a large
stew pot with the bouquet garni, tarragon, a good pinch of coarse salt,
a few peppercorns and 2 liters (8 to 8 $^1/_2$ cups) of cold water. Bring to a
boil, skim and remove from the heat.

Meanwhile, put the sprigs of tarragon inside the bird (reserving a few
leaves for later), truss it and lay the bacon over the breast.

Put the stock back on to heat and then lower the chicken into the pan and
bring back to a gentle boil. Cover and simmer for 55 minutes, then remove
from the heat. Leave the chicken in the stock while you make the sauce.

Mix the cornflour with a little water in a small saucepan and then add a
ladleful of stock. Dice the tarragon leaves, add to the saucepan and leave
the sauce to thicken. Season with salt and pepper. Pour into a gravy boat
and keep warm.

Remove the chicken from the stock, carve it and arrange on a serving dish.
Serve immediately with the sauce on the side.

Veal Cutlets
à la Milanaise

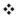

For the cutlets
4 veal cutlets on the bone (2 cm thick)
300 g (³/₄ lb) macaroni or fresh spaghetti
2 eggs
3 tbsp breadcrumbs
40 g (3 tbsp or a bit less than ¹/₂ stick) butter
2 tbsp olive oil
Freshly grated Parmesan
Salt + freshly ground pepper to taste

For the tomato sauce
3 ripe tomatoes
100 g (3 ¹/₂ oz) lean ham
5 button mushrooms
Butter
50 ml (¹/₄ cup) meat juices (or ¹/₄ stock
cube dissolved in 50 ml or ¹/₄ cup water
to make a very concentrated stock)

❖ Serves 4 Preparation time: 15 minutes Cooking time: 20 minutes

Start by making the sauce: scald the tomatoes to make it easier to remove
their skins, remove the seeds and then roughly chop the flesh. Gently sauté
the chopped tomatoes in a tablespoon of butter, add the meat juices or
stock and leave to thicken for about 10 minutes. Cut the ham into strips
and add to the tomato mixture (do not add any onions, shallots or garlic).
Keep warm.

Clean the mushrooms with a paper towel (do not wash), cut off most of
the stems and dice the caps. Gently fry these in a tablespoon of butter.

Coat the cutlets: break the eggs into a bowl, season with salt and pep-
per, add half of the olive oil and beat with a fork. Put a thick layer of
breadcrumbs in another bowl. Dip the cutlets into the beaten egg one
by one, shake off any drips and then turn them over in the breadcrumbs
several times.

.... /...

Melt the butter in a pan and then quickly sear the cutlets for about 5 minutes on each side over a medium heat. While they are browning, put on a large pan of water to boil and cook the pasta until it is al dente (the meat and pasta should be ready at the same time).

Reheat the tomato sauce at the same time, adding the mushrooms.

Drain the pasta, drizzle with oil and pour the sauce over it.

Serve with the cutlets and grated Parmesan on the side.

Above: Claude Monet, *Haystacks at Giverny*, 1884.

Right: Claude Monet, *Meadows at Giverny*, 1888.

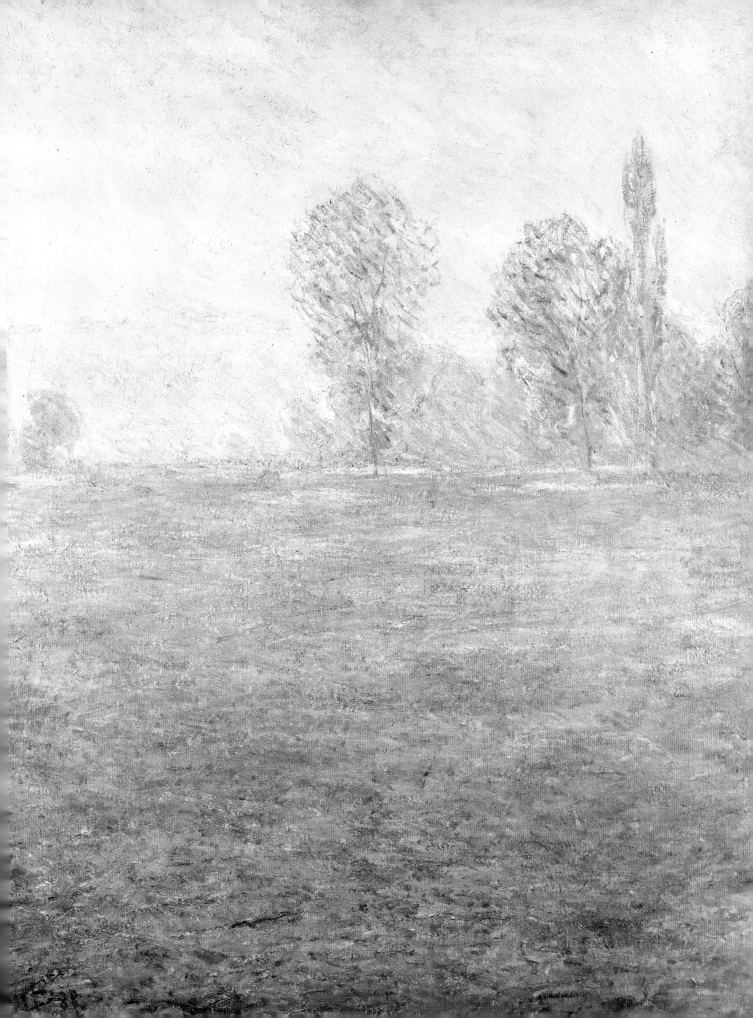

Veal Escalopes à la Viennoise

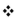

For the escalopes
4 medium-sized veal escalopes
2 eggs
3 tbsp breadcrumbs
40 g (3 tbsp or a bit less than $^1/_2$ stick) butter
+ 2 tsp melted butter
Oil for frying
Salt + freshly ground pepper to taste

For garnish
2 eggs
1 small bunch parsley
2 lemons

Serves 4 Preparation time: 20 minutes Cooking time: 20 minutes

Start by making the garnish: hardboil the eggs for 10 minutes and then peel and chop them into small pieces. Dice the parsley and keep cool.

The escalopes should be thin so they will cook quickly. Flatten them out one at a time: place between two sheets of plastic wrap on a chopping board and flatten with a rolling pin or meat mallet.

Break the eggs into a bowl, season with salt and pepper, add a drizzle of oil and beat with a fork. Put a thick layer of breadcrumbs in another bowl. Dip the escalopes into the beaten egg one by one, shake off any drips and then turn them over several times in the breadcrumbs. Lay them on a large serving dish without overlapping until you are ready to cook them.

Get two frying pans ready so that you can cook all four escalopes at the same time. Melt a tablespoon of butter in each, then add 1 cm of oil. When the butter begins to smoke, put in the escalopes. Cook them for about 4 minutes on each side, making sure that the breadcrumbs do not brown too fast (turn down the heat if necessary).

Arrange the escalopes on a serving dish and drizzle with melted butter (not too much). Arrange the chopped egg and parsley around them in a ring. Serve hot with quarters of lemon.

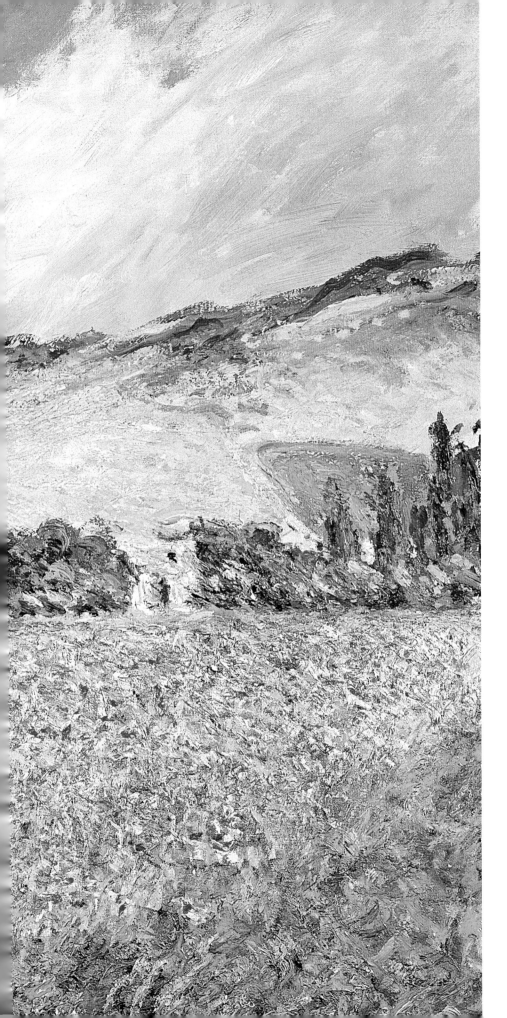

Claude Monet, *Poppy Field Near Giverny*, 1885.

In an earlier picture painted in 1871 and entitled *Poppies*, Monet had depicted two young women walking peacefully with children through a field full of these delicate flowers.

Page 155 : Claude Monet, *Water Lilies at Giverny*, 1908.

Partridges with Cabbage

❖

2 partridges, dressed and trussed

1 medium-sized savoy cabbage

1 slice bacon

3 carrots

2 small onions

1 bouquet garni (2 sprigs thyme, 2 bay
leaves, 3 sprigs flat-leaf parsley)

125 g (between 4 to 4 ¹/₂ oz) lean smoked bacon

1 saveloy

1 tbsp lard

30 g (2 tbsp or ¹/₄ stick) butter, cut into
shavings

500 ml (2 ¹/₂ cups) stock

1 egg white

300 g (2 ¹/₂ cups) flour

Salt ı freshly ground pepper to taste

❖ *Serves 4 Preparation time: 40 minutes Cooking time: 2 hours 15 minutes*

Heat the lard and brown the partridges on all sides, then leave them to cool on a
large dish. Meanwhile, cut the core from the cabbage, separate the leaves and and
blanch them for 5 minutes or until soft. Drain the leaves, run them under cold
water to refresh and then thoroughly dry them with a clean paper towel folded
in half.

Line the base of a cast iron casserole dish with the slice of bacon and then spread
out half of the dry cabbage leaves in a layer on top. Peel the onions and carrots,
slice them into rounds and place on top of the cabbage. Lay the partridges on this
bed of vegetables, cover them with the remaining cabbage leaves, the chopped
bacon and the saveloy. Pour the stock over the top, add the bouquet garni and
scatter a few shavings of butter over the partridges. Cover.

Combine the flour and egg white and then gradually add water to form a soft
dough that is easy to shape. Roll into a long sausage shape and place this around
the rim of the casserole dish to tightly seal the lid. Cook over a medium heat for
2 hours.

By the time you take the lid off, you should have a rich, concentrated gravy. If it
is too light, using a slotted spoon, take everything out of the casserole dish and
keep it warm, and then reduce the sauce over a high heat. Carve the partridges,
arrange on a serving dish with the vegetables and saveloy, drizzle with a little
of the gravy and serve the rest in a gravy boat.

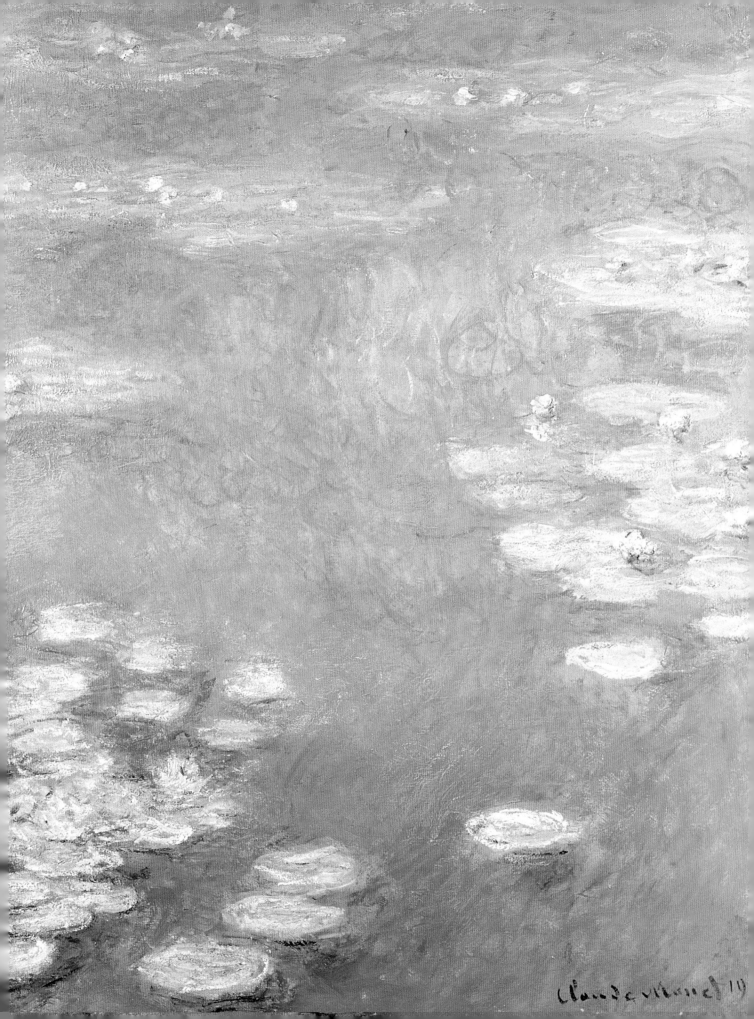

Pigeons à la Forestière

❖

2 medium-sized pigeons	100 ml (¹/₂ cup) stock
2 carrots	50 ml (¹/₄ cup) cognac
2 small onions	1 tbsp lard (or 1 tbsp butter + dash
150 g (2 cups) button mushrooms	of oil)
1 stalk celery	Salt + freshly ground pepper to taste

❖ *Serves 4 Preparation time: 20 minutes Cooking time: 1 hour 20 minutes – 1 hour 50 minutes*

Preheat the oven to 160°C (gas mark 3 or 320°F).

Peel the carrots and onions and cut them into rounds. Clean the mushrooms with a paper towel (do not wash), discard the stems, and dice the caps. Dice the celery.

Heat a tablespoon of lard (or a tablespoon of butter with a dash of oil) in a casserole pan and sear the pigeons, turning them so they brown all over. Cook them until they turn a deep brown and then remove them from the pan.

Put the vegetables in the casserole pan and sauté for about 10 minutes. Push some of the vegetables to the sides with a wooden spoon, leaving the remainder of the vegetables in a bed in the center of the pan. Lay the pigeons on top of this and cover with a few of the vegetables from the sides. Season with salt and pepper and pour in the stock and the cognac.

Combine the flour and water into a sticky dough to seal the pan. Put the lid on the pan, roll the dough into a sausage shape and lay over the lid to form a tight seal. Cook for between 1 hour and 1 hour 30 minutes depending on the size of the pigeons. Serve in the casserole pan.

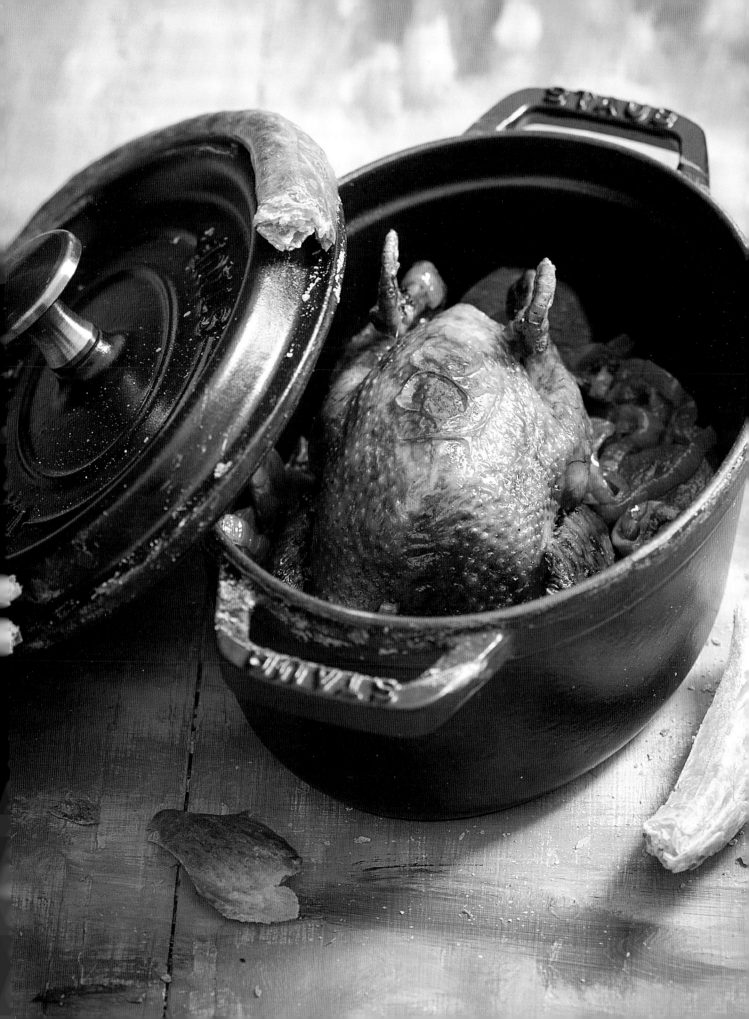

Pike with Butter Sauce

1 pike, weighing 1.5 kg (3–4 lbs)

For the butter sauce
5 or 6 medium-sized grey shallots
80 ml (5 ¹/₂ tbsp) dry white wine
250 g (a bit more than 9 oz or a bit more than
2 sticks) butter
Salt + freshly ground pepper

For the broth
2 onions
2 carrots
1 bouquet garni (2 sprigs thyme,
2 bay leaves, 5 sprigs parsley)
1 bottle dry white wine
Salt, peppercorns

❖ *Serves 6 Preparation time: 40 minutes Cooling time: at least 2 hours Cooking time: 1 hour 15 minutes*

Start by making the broth: peel the carrots and cut into rounds, peel the onions and chop into quarters, then put everything into a fish kettle (fish poacher) with the bouquet garni. Pour in the water and wine, adding 100 ml (¹/₂ cup) of wine for every liter of water: there should be enough broth to cover the fish when it goes in later. Season with salt and throw in 10 peppercorns. Put the lid on the fish kettle, bring the broth to a boil and then simmer for 30 minutes. Leave until completely cool.

Gut and clean the fish (but do not scale it), then place it carefully in the cold broth. The broth should cover the pike completely. Bring to a boil and then lower the heat so that the broth barely simmers; if it is on too high, the flesh will break up. A pike weighing 1.5 kg (3–4 lbs) will take 30 minutes.

When the fish is almost cooked, make the butter sauce (see recipe on p. 159).

Take the pike out of the broth. Fold a tea towel in half and place on a large dish and arrange the fish on top. Serve with the warm butter sauce in a gravy boat on the side.

Butter Sauce

5 or 6 medium-sized grey shallots
80 ml (5 ¹/₂ tbsp) dry white wine

250 g (a bit more than 8 tbsp or a bit
more than 2 sticks) butter
Salt + freshly ground pepper to taste

❖ *Serves 4 Preparation time: 5 minutes Cooking time: 15 minutes*

Peel and dice the shallots. Put them in a saucepan with the white wine, stir, and cook over a low heat to reduce. While the shallots are cooking, dice the butter.

When the wine has reduced by half, add a few cubes of butter to the pan and whisk over a low heat without boiling. Keep adding the butter in this way until it is all incorporated, whisking to form a creamy sauce. Season with salt and pepper to taste.

"You take a beautiful fish, a pike if you can, cook it in a broth, season with salt and pepper to taste, and serve very hot with beurre blanc, a creamy butter sauce flavoured with shallots ..." – "Blanche," he said, "we must try it."

Marc Elder, *At Giverny with Monet*, 1924.

Crème au Thé

❖

1 liter (4 cups) milk
250 g (1 cup + a pinch) superfine sugar
3 tsp green tea

3 tsp Ceylon tea
6 egg yolks

❖ *Serves 6 Preparation time: 15 minutes Infusion time: 1 hour Cooking time: 50 minutes*

Preheat the oven to 150°C (gas mark 2 or 300°F).

Make a bain-marie: pour boiling water into a roasting pan and carefully put it in the oven.

Pour the milk into a saucepan and bring to a boil, then add both kinds of tea and the sugar. Stir well to dissolve the sugar, cover and leave to cool for 1 hour. When the milk is almost cold, add the beaten egg yolks. Whisk together, then strain through a sieve.

Pour the cream into a dish and cook it in the oven in the bain-marie for 50 minutes. Take the dish out of the oven and leave to cool at room temperature. Serve cold.

"In a rush as always, my darling, because I have a very busy day. I have to put the brandy in the cellar, get out the wine, etc."

Claude Monet, letter to Alice Monet, February 24, 1902.

Chocolate Cake

2 eggs
The eggs weight in dark chocolate
The eggs weight in butter + a tbsp for
greasing the pan

The eggs weight in superfine sugar
1 tbsp flour + a few pinches for flouring
the pan
Salt

❖ *Serves 4 Preparation time: 15 minutes Cooking time: 20 minutes*

Preheat the oven to 180°C (gas mark 4 or 350°F).

Melt the butter with a little water over a low heat. Take off of the heat, add the chocolate and stir until it is completely melted. Cool.

Separate the eggs. Fold the yolks into the chocolate mixture and stir. Add the sugar and flour and mix well.

Whip the egg whites into stiff peaks with a pinch of salt. Add half of the egg whites to the chocolate mixture, folding in carefully and lifting up from the bottom to make sure that everything is combined, and then add the other half of the egg whites. Pour into a well greased and floured pan. Bake in the oven for 20 minutes until cooked with a slightly runny center.

"Our banter did not stop the master from doing justice to a second piece of cake amid his laughter."

Marc Elder, *At Giverny with Monet*, 1924.

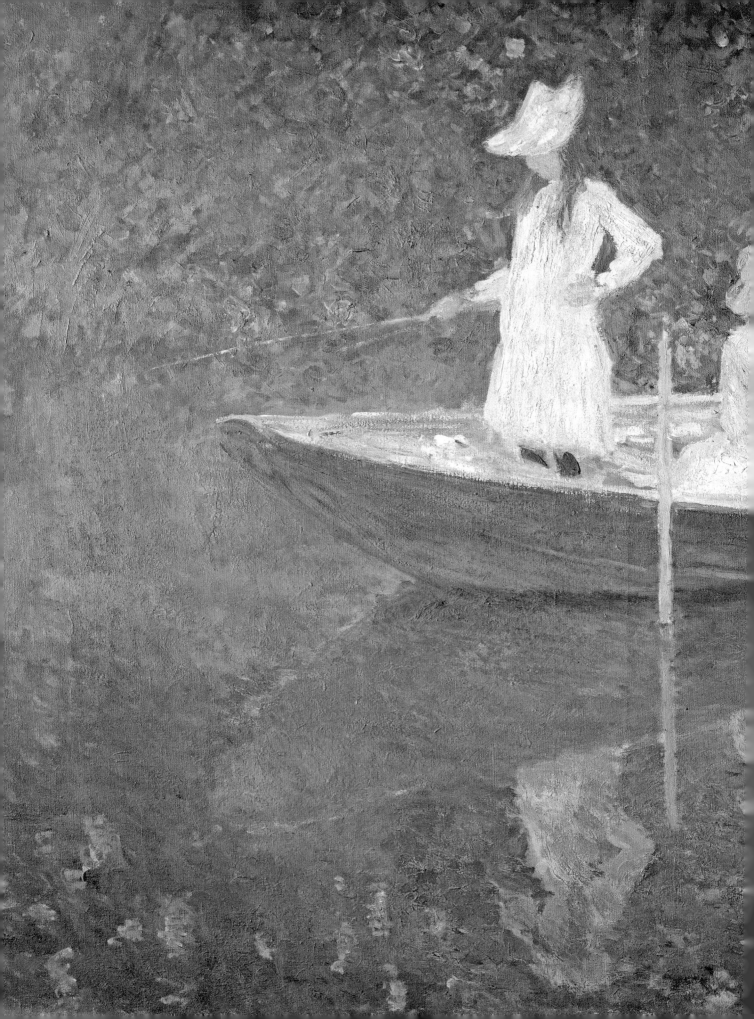

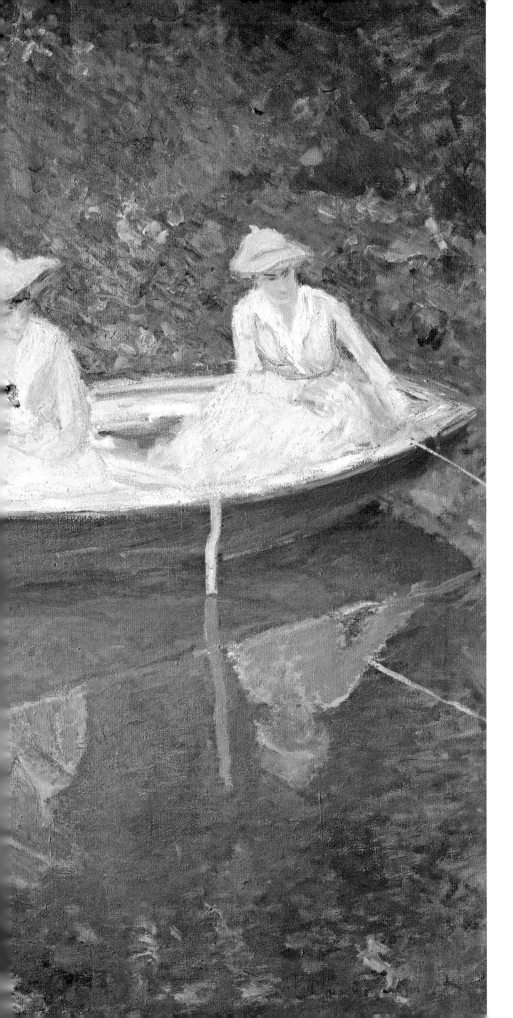

Claude Monet, *The Boat at Giverny*, 1887.

Monet had four boats moored near Giverny: two skiffs built of mahogany, his studio-boat and the rowing boat pictured here with Suzanne, Blanche and Germaine Hoschedé on board. Monet wrote to Gustave Geffroy on June 22, 1890: "I have gone back to some things that cannot possibly be done: water, with weeds waving at the bottom. [...]. It's a wonderful sight, but it drives one to crazy to try to paint it."

Vert-Vert Cake

For the cake
4 eggs
150 g (2/$_3$ cup) superfine sugar
125 g (1 cup) flour
60 g (4 tbsp or 1/$_2$ stick) butter + 20 g (3/$_4$ tbsp)
for greasing the pan
50 g (1/$_2$ cup) pistachios
4 tbsp kirsch
Lemon

For the spinach coloring
3 handfuls spinach

For the pistachio buttercream
100 g (1 cup) pistachios, shelled and finely
chopped
2 tbsp kirsch
100 g (7 tbsp or a bit less than 1 stick) softened
butter
100 g (1/$_2$ cup) superfine sugar
2 whole eggs + 2 egg yolks
2 tsp flour
100 ml (1/$_2$ cup) milk

For the fondant icing
600 g (3 cups) superfine sugar
2 tbsp simple syrup
1 lemon

❖ *Serves 8 Preparation time: 40 minutes Cooking time: 50 minutes*

Preheat the oven to 150°C (gas mark 2 or 300°F).

Start by making the cake: break the eggs into a saucepan and slowly whisk
with the sugar over a low heat until the mixture has doubled in volume. Sift
the flour and add to the eggs with the softened butter, crushed pistachios,
kirsch and the grated zest of half of a lemon. Mix well with a wooden spatula.
Pour the mixture into a greased spring-form pan and bake in the oven for about
30 minutes. Insert the point of a knife into the middle of the cake to check if it
is cooked: the blade should come out dry. Take the cake out of the oven, leave
it to cool for about 10 minutes before turning it out onto a board. Leave until
completely cool.

Next make the spinach purée, which you will use to color the pistachio butter-
cream and the icing. Blanch the spinach in boiling water for 1 minute and then
pass it through some muslin to make a green purée.

..../...

Now make the pistachio buttercream: mix the crushed pistachios into a paste with the kirsch and 50 g (3 ½ tbsp or a bit less than ½ stick) of softened butter, then color with 2 teaspoons of the spinach purée. In a pan, beat the whole eggs and egg yolks together with the sugar. Stirring constantly, gradually add the flour and milk. Heat the mixture to thicken it and then mix in the pistachio paste. Bind it all together with 50 g (3 ½ tbsp or a bit less than ½ stick) of softened butter.

Cut the cooled cake into three layers: a bottom, middle and top layer. Spread the bottom and middle layers with the pistachio buttercream (not the top layer). Assemble the cake and keep it to cool while you make the icing.

To make the fondant icing: dissolve the sugar in a saucepan with 200 ml (1 cup) of water over a fairly high heat. Check the syrup periodically as it boils to see what stage it has reached. It needs to reach the "large thread" stage, when a large thread forms when a little of the syrup is dropped into cold water. When the syrup is almost cooked, add the simple syrup and color it as green as you want with the spinach purée.

Place the cake on a lightly oiled marble surface. Pour the syrup over it and smooth it out with a wooden spatula. To finish, sprinkle with lemon juice. Cover with a damp cloth and keep cool until ready to serve.

Right: Claude Monet, *Still Life with Melon*, 1872. Monet sold a number of paintings that year, and enjoyed a spell of relative, but short-lived, financial comfort as a result. He was in Paris for a while, staying in the rue de L'Isly in Paris, and perhaps painted this picture there.

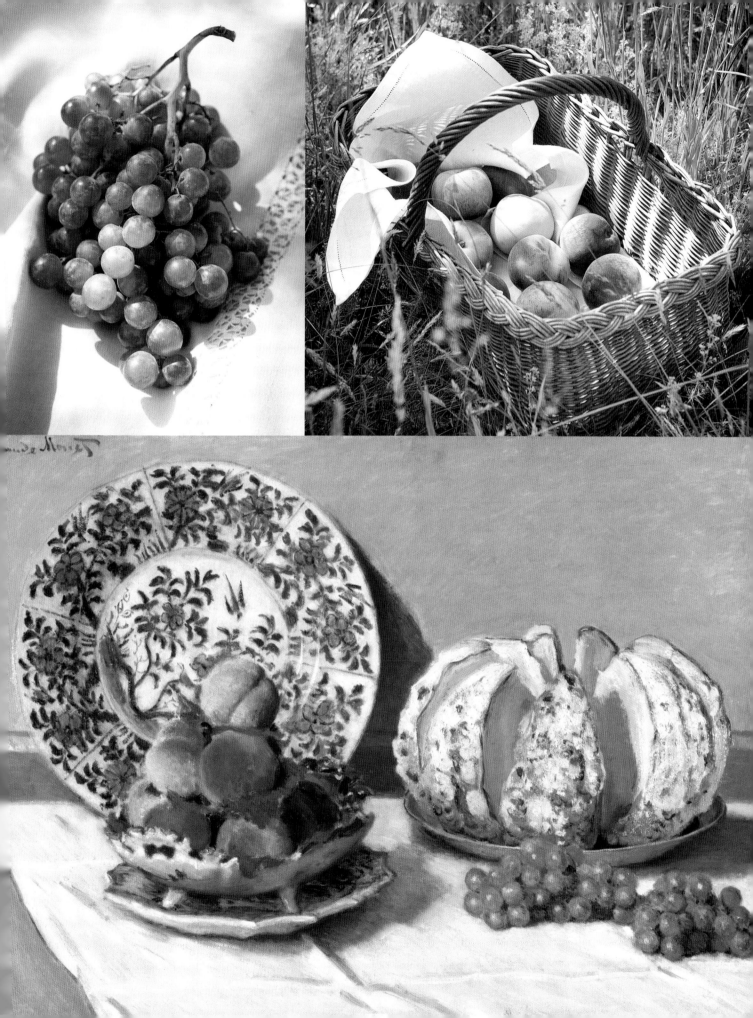

Peaches à la Bourdaloue

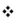

6 medium-sized peaches
400 g (2 cups) superfine sugar
1 vanilla pod
6 egg yolks
1 tbsp flour

500 ml (2 ¹/₂ cups) milk
4 almond macaroons
1 tbsp butter for greasing the dish
+ a bit for the top

❖ *Serves 6 Preparation and cooling time: 25 minutes Cooking time: 10 minutes*

Quickly scald the peaches to make them easier to peel, then cut them in half
and remove the pits.

Make a syrup with 300 g (1 ¹/₂ cups) of sugar and 500 ml (2 ¹/₂ cups) of water.
Split the vanilla pod in two, scrape out the seeds into the syrup, throw in
the pod and bring to a boil. Marinate the peach halves in the boiling syrup.

Make a *crème pâtissière*: in a saucepan, beat the egg yolks with 50 g (4 tbsp)
of sugar and the flour. Bring the milk to a boil and pour it gradually onto
the egg mixture, whisking all the time. Stirring constantly, let the mixture
thicken as it begins to boil and then remove from the heat and leave to cool.

Heat the grill.

Grease a gratin dish. When the *crème pâtissière* is cool, take the peaches out of
the marinade, shaking off any drips. Spread a layer of *crème pâtissière* in the
bottom of the dish, follow with a layer of peaches and a final layer of *crème
pâtissière.*

Crush the macaroons with a rolling pin and mix with the remaining sugar
to make a praliné. Cover the final layer of crème *pâtissière* with the *praliné.*
Dot with butter. Cook under the grill until golden and crisp. Serve hot,
but not boiling.

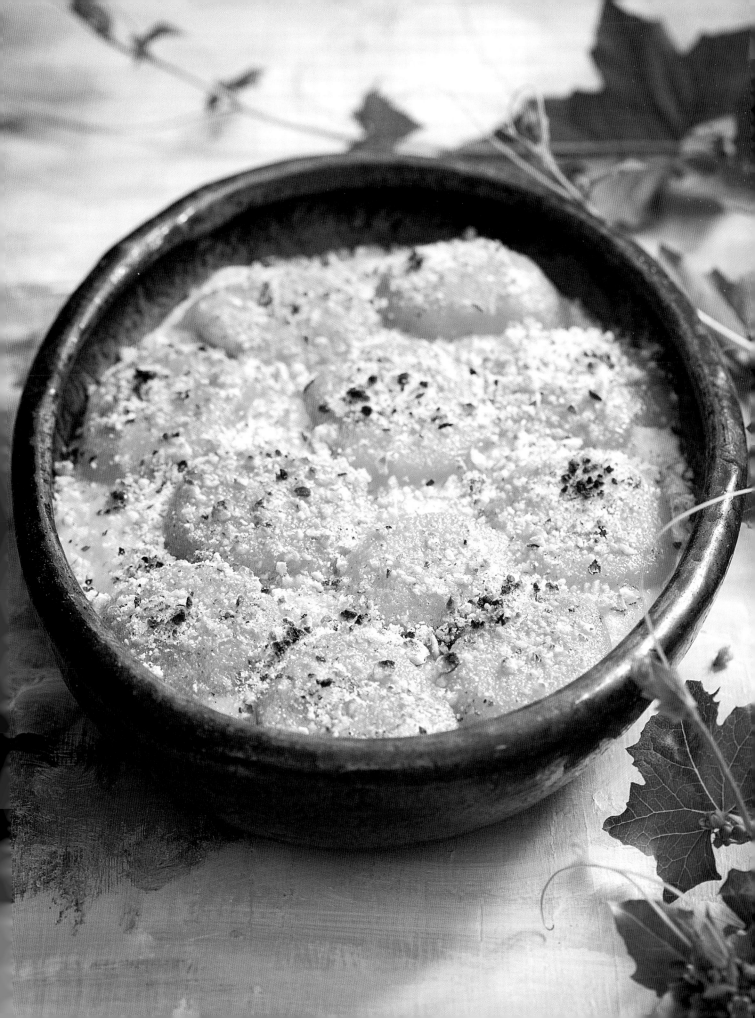

Plum Jam

❖

2 kg (4 lbs) plums
1.5 kg (3 lbs) granulated sugar
1 preserving pan

1 sugar and jam cooking thermo-
meter
8–10 jam jars

❖ *Makes 8–10 jars Preparation time: 20 minutes Cooking time: about 25 minutes*

Choose good looking plums that are ripe, but not over-ripe. Cut them in half and remove the pits before weighing them. Allow 600 g (1 lb or 3 cups) of sugar per 500 g (1 lb) of plums (add 60 g or 2 oz of sugar for every additional 100 g or 3 $^1/_2$ oz of plums).

Boil the sugar with a "grand boulé" in a copper preserving pan (between 125°C or 255°F and 130°C or 270°F). When it reaches a roiling boil, add enough plums to cover the bottom of the pan. When the plums are soft to the touch, take the pan off of the heat and lift out the plums with a fork and put them into the jars.

Return the pan to the heat, bring the syrup back to a roiling boil and repeat the process until all of the plums are cooked and put into the jars. Then put the pan back on the heat and bring the syrup to another boil and pour it into the jars. Carefully lift up the plums at the top to make sure that the syrup is evenly spread throughout the jar.

TIP

You can make apricot jam in the same way.

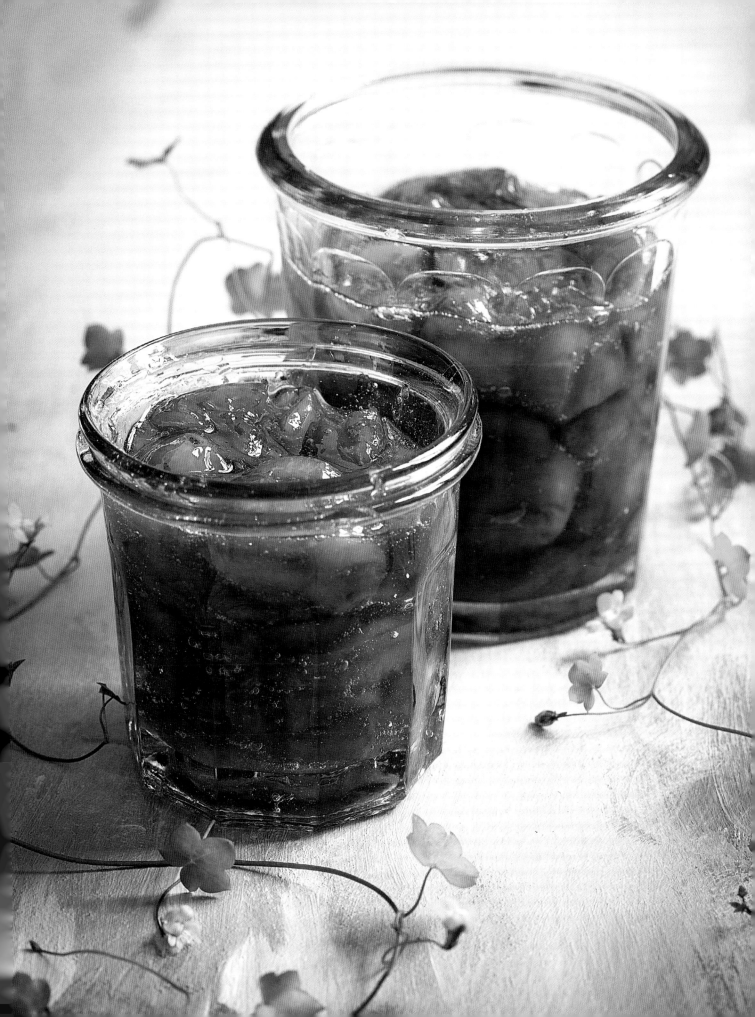

Preserved Cherries

❖

2 kg (4 lbs) fleshy cherries
50 g (4 tbsp) superfine sugar

❖ *Makes 4 jars Preparation time: 30 minutes Cooking time: 20 minutes*

Clean the preserving jars and scald the (new) rubber seals. Carefully take the cherries off their stems and sift through them, discarding any that are blemished. Since the cherries generate a great deal of juice, pack the jars so the cherries fill them right up to the line at the top of the jar.

Make a light syrup by boiling the sugar in 1 liter (4 cups) of water. Pour the syrup into the preserving jars so that it comes up to the line at the top. Put the seals around the lids and close the jars.

Fold a dish towel in fourths, place it in the bottom of a large pan, and set the jars on top (the cloth will cushion the shock when the water begins to boil). Fill the pan with cold water so that it comes up to the neck of the jars, cover, and bring to a boil. Simmer for 20 minutes. It is important not to simmer for longer than this or the jars may break. Then remove from the heat and leave the jars to cool in the water. If the cooking has been adequate, the jars will be hermetically sealed.

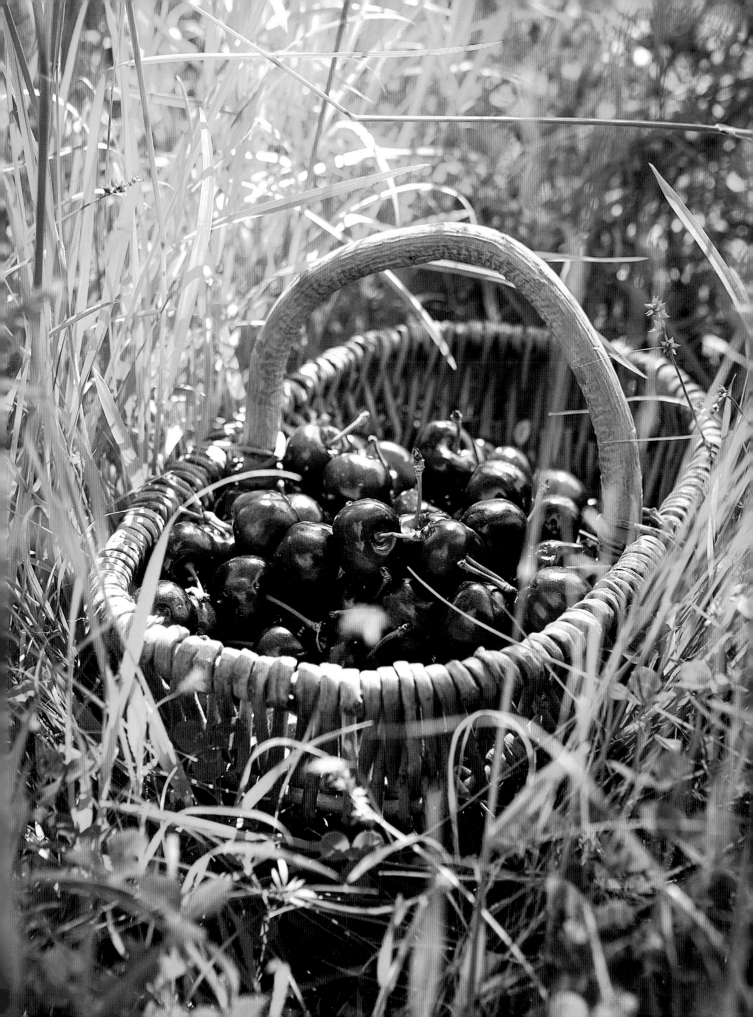

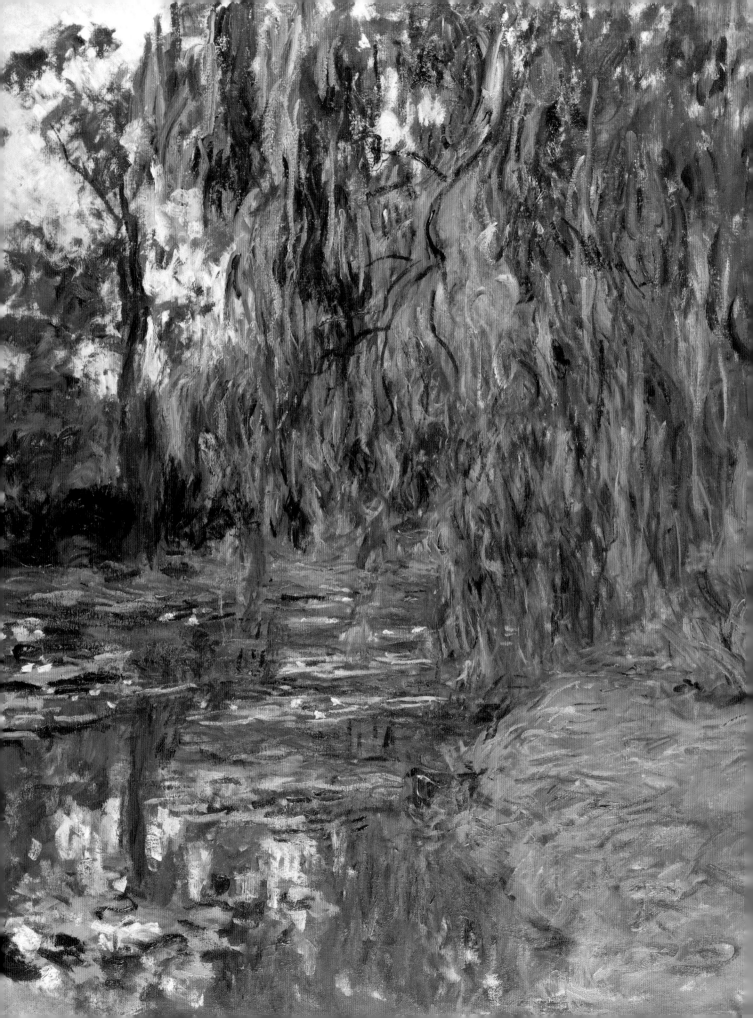

GOURMANDS
and
Gourmets

"Luncheon is served!"

❖

"Come on everybody, sit down and let's eat this young pigeon which will not be any good unless it's eaten hot!"[1] When he was in a good mood, Monet would urge his family to sit down and eat together. In his memoirs, Jean-Pierre Hoschedé gives insight into some of Monet's meal-time rituals at Giverny. We learn that he liked his asparagus underdone and his woodcocks well hung. We know that he had a distinctive way of making salad dressing: "he would load the salad spoon with crushed peppercorns, coarse salt, quantities of olive oil and a little wine vinegar, mix these together in situ so that the spoon overflowed, and then liberally dress the salad until the lettuce leaves were more or less black with pepper." Hoschedé adds that the only people who would eat a salad dressed by Monet were Monet himself and his daughter-in-law, Blanche: "She liked everything he liked."[2] This was perhaps not surprising: she was the only one in the household to paint alongside Monet and she was a talented painter in her own right.

We also have accounts from people who were invited to share a meal with Monet. "Monet has always loved eating,"[3] René Gimpel recorded before going on to describe the generous meal to which he was treated: "'Luncheon is served!' announces the butler dressed in white from head to toe … Lunch at Claude Monet's is wonderful. A few hors-d'oeuvres to start, served with the best Norman butter, succulent sweetbreads with spinach, two chickens between five people: a roast one nobody would touch, and a second extraordinary one, cooked with black olives, then a tart, a pure delight and fruit as beautiful as flowers […]. Then we move into his studio-sitting room where he nurses a little tot, a huge little tot."[4]

Jacques Salomon described another occasion during which Monet complimented Mme Salomon on her ultramarine dress that looked "so good against his walls" and during which he impressed his guests with "truly aristocratic straight-forwardness" as he attended to them. "He poured drinks, watched to see that everyone helped themselves to the food, noticing if anyone did not and saying, 'But you are not eating.' A servant came in with some duck's wings and presented them to Monet, who seasoned them with salt, pepper and nutmeg and sent them back to be roasted 'in the fires of hell.' A minute later, the duck was brought back burning on a plate."[5]

Thadée Natanson remembers what Monet would talk about at the table: "it would often be recipes, memories, the flavour of particular fruit, flesh of a specific fish, quantities of meat, all of which he would discuss as ever with the most delicious precision. He would talk as naturally about cooking as Voltaire did in his letters about hazel grouse and trout in the Gex region. Monet had a healthy appetite until he was a ripe old age and he was not frightened of drinking, however, as long as it was with food and there was never more than one sort of wine on offer at a meal." In Natanson's case, it was raw duck's thighs that Monet seasoned liberally "before sending them back to the kitchen to be grilled."[6]

Gifts of Food and Drink

Many of Monet's guests at Giverny were regular visitors. Paul Durand-Ruel would come with his family, and while he and his sons looked through Monet's latest paintings and made their selection, his daughters-in-law would join the Monet family for meals in

the garden or in the house, as some beautiful photographs testify. Monet also regularly hosted Gustave Geffroy, Sacha Guitry and his wife Charlotte Lysès whom Monet found entertaining, the composer Chabrier, the singer Faure, writers Maupassant and Natanson, art dealers Josse and Gaston Bernheim, the collector René Gimpel, horticulturalists Truffaut and Vilmorin, and a host of painters. Among these were Renoir, Cézanne, Pissarro, Mary Cassatt, Berthe Morisot and her daughter Julie Manet, Caillebotte, Sargent, Signac, Vuillard, Bonnard, and of course Georges Clemenceau, who came to lunch at Giverny every fortnight in the final years of Monet's life. All Monet's regular visitors were people whose company he enjoyed. Some stayed at the Baudy Hotel. After the meal, they were all treated to a tour of his studio and a stroll in his marvelous garden, which they all found, in Octave Mirbeau's words, "a perpetual feast for the eyes."[7]

For Monet, a meal in the dining room at Giverny provided the perfect situation in which to develop the bonds of friendship he held so dear. That said, he also maintained his relationships with his friends between their visits. In his letters to Octave Mirbeau, Gustave Caillebotte and Georges Clemenceau, he would talk a great deal about flowers and gardening, but there were also frequent references to good food. Naturally, the friendships between the men manifested themselves in gifts of food. Mirbeau and Monet exchanged dahlias and chrysanthemums, but Mirbeau gave Monet equal pleasure when he had a basket of pears sent to him from his estate at Les Damps or lobsters from Belle-Île. The business of creating caused Mirbeau moments of real anguish as it did Monet ("I am

working like a labourer on my stupid *Abbé Jules*. And the agonies and the anguish I suffer at not being able to write it! I am driven almost to distraction"[8]). However, when Monet wrote back and told him of the similar torments he was going through, Mirbeau immediately suggested an excellent remedy: "for a start, come and spend a couple of days in Paris. We will wander about. We will go here and there … from the Jardin des Plantes, which is a wonderful place, to the Théâtre-Français. We will eat well, we will talk rubbish, and we will not look at pictures."[9]

Monet sent plums from his orchard to his friend Caillebotte while Caillebotte sent him baskets of prawns. In 1907, Monet thanked the Bernheim brothers for sending him pàté; in 1922, Marc Elder sent him a case of Muscadet. These gifts of food and drink were often accompanied by messages referring to the good times the friends had together. To commemorate a pleasant stay he had in the Creuse with Maurice Rollinat, once again Monet sent plums to the poet in exchange for some *vin gris*. Gustave Geffroy and Monet frequently recalled the circsumstances of their first meeting at Belle-Île in 1886, which Geffroy described as follows: "I came back to the inn, Monet had a room there […], and he ate at the bar there: lobster, meat, fruit, all for 4 francs a day, board and lodging …"[10] Shortly afterwards, Geffroy suggested that they meet up in Paris: "We could eat together in memory of Kervilllaouen. […] we could drink a toast in cognac."[11] It was a habit they kept up: on a visit to Paris is 1899, Monet suggested to Geffroy that they meet up at the Floury restaurant.[12]

It was the same with Monet's painter friends. Among Monet's oldest friends, those who had also

lived through the struggles and hard times of the very early days of Impressionism, Camille Pissarro was a stalwart. He took it upon himself to regularly supply Monet with cider and Burgundy. Renoir too, of course, was just as loyal a friend, having lived through dark days with Monet when the two shared a studio in Paris and "a sack of haricot beans lasted for about a month." Renoir told his son, Jean: "I was never so happy in my whole life. I should say, though, that Monet would wangle an invitation to dinner from time to time and we would gorge ourselves on turkey and truffle stuffing and Chambertin!"[13] When Monet and Renoir met up again much later – at Giverny where Renoir would stay at the Baudy Hotel, or at Renoir's house in Cagnes-sur-Mer – they carried on their good old ways. Monet and Alice stopped off on their way back from Venice to visit Renoir at Les Collettes, the estate where he continued to paint in spite of his debilitating illness, and Monet was very taken with Mme Renoir's famous bouillabaisse.

Gastronomic Jaunts and Get-Togethers

The advent of the motor car transformed life for the family at Giverny. There are photographs of Monet and Alice wrapped up in furs, about to set off on various excursions. In 1906, there were trips to the hill at Gaillon where they would stand at the side of the road and watch as motorized thunderbolts hurled themselves down hills with a 10 percent gradient at 40 meters a second. On another occasion Monet, Alice and Michel took off to Spain. When their car broke down at Biarritz, they left it there to be repaired and continued on by train to Madrid and Toledo. On their return, the Panhard Levassor had been duly repaired

and carried them valiantly back from Biarritz to Giverny. Their expeditions did not always have a sporting or cultural goal; they could be spontaneous trips simply prompted by a passion for food. Jean-Pierre Hoschedé described one such occasion when the family suddenly decided to set off for Lamotte-Beuvron, home of the celebrated *Tarte Tatin*: "It was a mad caper organised in a few minutes flat following a conversation we had about the tart. The entire family piled into the two cars, children, grandchildren and all. We came back the next day after a visit to the Château de Chambord and a second *Tarte Tatin*."[14]

The Impressionists and their friends often had an opportunity to meet up in Paris. They saw each other at special events organized to mark specific occasions. For example, there was the banquet held in 1888 in honor of Rodin, which Monet was unable to attend, and the one in 1894 in honor of Puvis de Chavannes, which he attended a few weeks before leaving for Norway. There were also other regular dinners, such as the Good Cossacks dinner held once a month in Paris since 1886, where Monet would meet up with Mirbeau among others. Lastly, inspired perhaps by the happy get-togethers they used to have at the Café Guerbois or the Nouvelle-Athènes, there were monthly gatherings at the Café Riche, instigated by Monet himself. Caillebotte wrote to Monet about this in 1886: "Duret writes to me that at our dinner tomorrow there will be him, Deudon, Bérard, Huysmans, Moore, Mallarmé."[15]

Gustave Geffroy gave a vivid description of the atmosphere at these social events: "When they got together over a meal, the Impressionists were rather a wild bunch, [...] in relaxation mode, away from

worries and work, they were like happy schoolboys let out of school. Discussions sometimes became heated, particularly between Renoir and Caillebotte. [...]They would voice their opinions not just about art and painting, but on everything to do with literature, politics and philosophy, subjects in which Caillebotte, as a great reader of books, journals and newspapers, was well versed. Renoir was determined to keep up with the latest in everything and had equipped himself with an encyclopaedic dictionary so that he could drum up arguments to 'catch Caillebotte out.' Pissarro and Monet were also devotees of literature and both had good and reliable taste. I remember a veritable contest they had about Victor Hugo, with passions running high for and against, and everyone venting their feelings and asserting their opinions, and they all came away friends at the end of it and went off to sit outside a café and watch the eternally magical spectacle of Paris at night."[16]

Close as he was to all of his good friends, Monet felt their deaths acutely: Berthe Morisot in 1896, Sisley in 1899 (a few days before Suzanne Hoschedé), Pissarro in 1903, Cézanne in 1906. When Alice fell ill and died in 1911, Monet's suffering was immense. His friends rallied round and came to visit him: Gustave Geffroy, Clemenceau, Degas, Renoir, Mirbeau, Julie Manet ... Then came the harrowing period of the war, and in 1914, his son Jean died after a long illness.

From then on Monet lived at Giverny alone, apart from his daughter-in-law Blanche, Jean's widow. The only thing that could lift his sad spirits was a visit from the Butlers who came to lunch every day, or from Jean-Pierre and Geneviève Hoschedé who also lived in Giverny. He also had the support of the loyal Clemenceau, of course, who encouraged him to have cataract surgery so he could paint again. Monet had the operation in 1923. Afterwards, he was able to finish the monumental project he had been working on since 1918, *Water Lilies*. This was Monet's final, magnificent homage to his water-lily pond and also his special tribute to France and her victory.

Monet died on December 5, 1926. *The Water Lilies* were installed according to his wishes in the Orangerie. The beautiful oval rooms that housed them were officially opened by Clemenceau on May 17, 1927. The devoted Blanche continued to look after the house in Giverny. Although the yellow dining room no longer rang with joyful conversation, Monet's house forever captured a charming way of life with food and warmth at its center.

1. J.-P. Hoschedé, *op. cit.*

2. *Ibid.*

3. R. Gimpel, *op. cit.*

4. *Ibid.*

5. Jacques Salomon, "Giverny, June 14, 1926, Lunch today with the Monets," Arts, 337, December 14, 1951.

6. T. Natanson, *op. cit.*

7. Octave Mirbeau, "Claude Monet and Giverny," *L'Art dans les deux mondes*, March 7, 1891.

8. O. Mirbeau, letter to C. Monet, January 1888, Claude Monet archives, artists' correspondence, Artcurial catalalogue, Paris, 2006.

9. O. Mirbeau, letter to C. Monet, June 1903, *ibid.*

10. G. Geffroy, *op. cit.*

11. G. Geffroy, letter to C. Monet, December 10, 1886, Claude Monet archives, *op. cit.*

12. C. Monet, letter to G. Geffroy, March 6, 1899, quoted by D. Wildenstein, *op. cit.*, vol. IV.

13. J. Renoir, *op. cit.*

14. J.-P. Hoschedé, *op. cit.*

15. Gustave Caillebotte, letter to C. Monet, May 15, 1886, Claude Monet archives, *op. cit.*

16. G. Geffroy, *Claude Monet, His Life and Work, op. cit.*

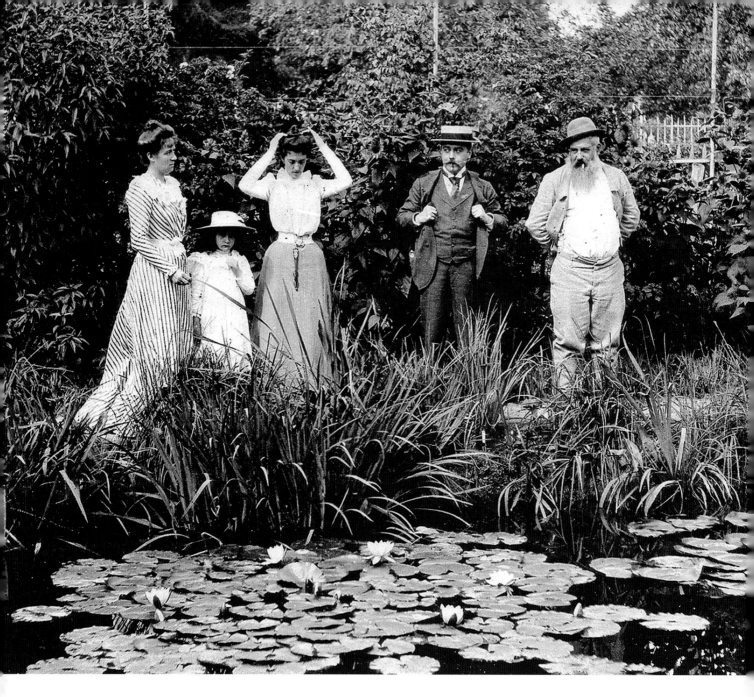

"My dear friend, I am still waiting for your promised visit. It is really the moment for it, you will see a splendid garden ..."

Claude Monet, letter to Georges Clemenceau, Giverny, May 29, 1900.

Above: Germaine Hoschedé, Madame Joseph Durand-Ruel, Lily Butler, Georges Durand-Ruel and Claude Monet, September 1900.

Right: Claude Monet, *In the Woods at Giverny, Blanche Hoschedé at Her Easel with Suzanne Hoschedé Reading,* 1887.
Marthe and Jimmy in front of Suzanne, Lily Butler and Alice Monet at Giverny, 1910. Jimmy and Lily were the children of Suzanne Hoschedé and the American painter Theodore Butler. After Suzanne's premature death, her sister Marthe looked after the children and later married their father.

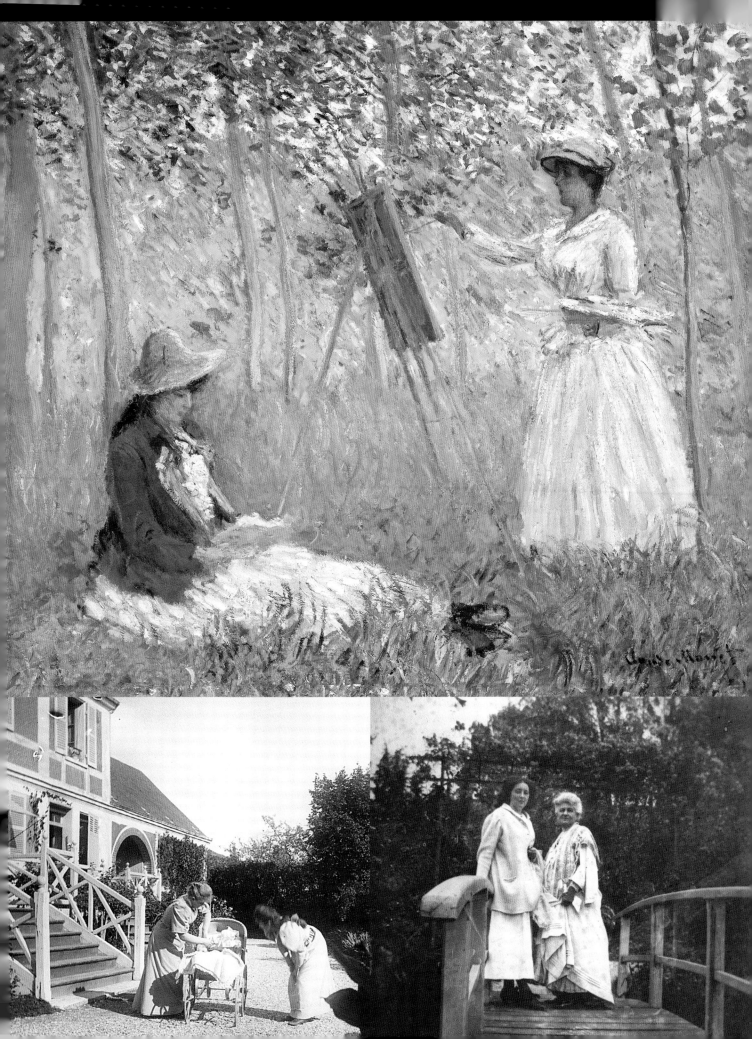

Fontanges Soup

❖

300 g (1 ¹/₂ cups) split peas
1 onion
2 leeks, white parts only
1 handful sorrel
1 lettuce
2 medium floury potatoes (250 g or ¹/₂ lb)
5 sprigs chervil, finely chopped

1 tbsp butter
1.5 liters (6 cups) chicken stock (or water, for a thinner soup)
2 egg yolks
250 ml (1 cup) heavy cream
pain de champagne (sourdough bread)
Salt + freshly ground pepper to taste

❖ *Serves 6 Soaking time: 1 hour Preparation time: 40 minutes Cooking time: 2 hours 30 minutes*

Start by washing the split peas in plenty of water and then leave them to soak for 1 hour in twice their volume of cold water.

Meanwhile, prepare the vegetables: peel and dice the onion. Wash the white parts of the leeks and cut them into rounds. Wash the sorrel and remove any stringy stalks. Wash and drain the lettuce leaves. Chop the chervil. Peel and dice the potatoes.

Melt the butter in a casserole pan. When it begins to foam, throw in the chopped onion, the white parts of the leeks, sorrel and lettuce leaves and finally the chervil. Stir for a few minutes. The vegetables should be coated in butter but should not brown. Drain the split peas and add to the vegetables with the potatoes. Pour in the stock or water.

Season with salt and pepper, cover and cook over a low heat for at least 2 hours. Taste to make sure the split peas are tender.

Strain the soup through a fine sieve and keep it warm. Heat a soup tureen by filling it with boiling water. In a bowl, beat the cream and egg yolks together (keep the egg whites for another recipe). Tip this mixture into the hot soup tureen. Immediately pour the boiling soup over it and serve with very thin slices of sourdough bread.

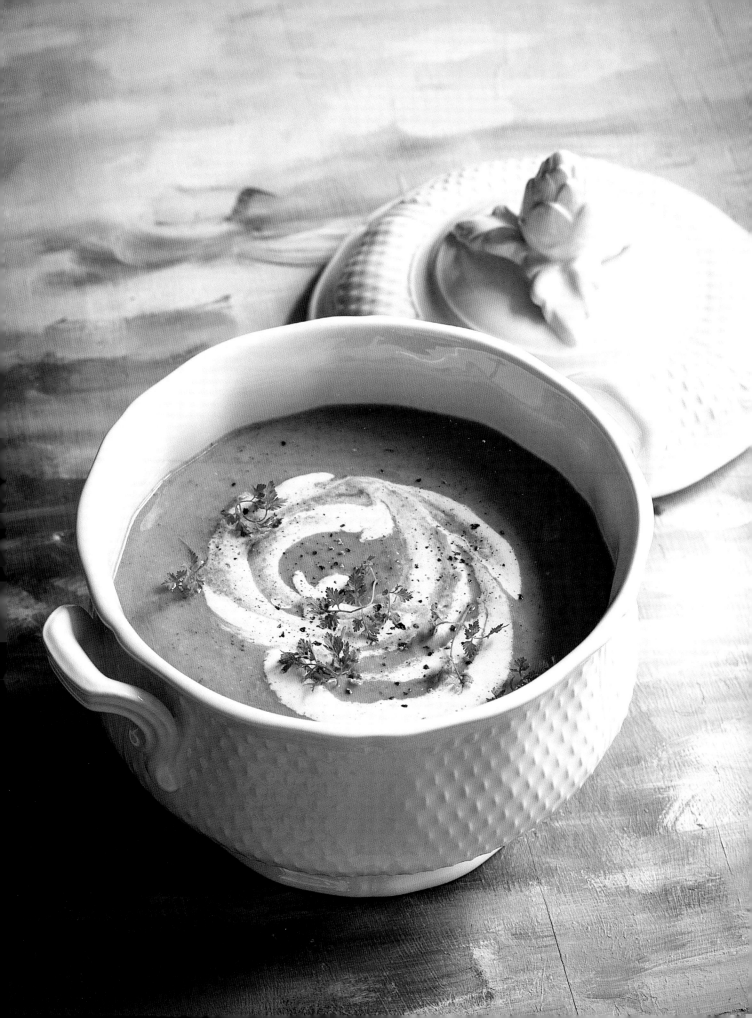

Scrambled Eggs

❖

8 very fresh eggs
Choice of garnish (optional): 1 bunch chives,
10 g fresh truffle, 250 g (3 cups) small girolle
(chanterelle) mushrooms

4 slices stale bread
60 g (4 tbsp or $^1/_2$ stick) butter + a little melted
butter for greasing the saucepan
Salt + freshly ground pepper to taste

❖ *Serves 4 Preparation time: 5 minutes Cooking time: 25 minutes*

Start by preparing your garnish if you decide to have one: chop the chives into a small bowl; grate the truffle into shavings in another bowl; wipe the chanterelle mushrooms clean, then fry them gently in a tablespoon of foaming butter for 10 minutes.

Toast the slices of bread and cut them in half.

Fill a large saucepan halfway with water and put on to heat to make a bain-marie. Brush the bottom of a smaller pan with a little melted butter. Cut the remaining butter into small cubes and put to one side.

Break the eggs into a bowl with a little salt. Beat them lightly with a fork to mix the yolks and whites. The mixture should not be foamy.

Lower the smaller pan into the simmering bain-marie and tip in the eggs and stir them well with a wooden spoon. Season generously with pepper. When the eggs begin to thicken, lay the cubes of butter on top. As soon as they start to look grainy, take the pan out of the bain-marie and immediately serve the eggs with the toast. If you want to add a garnish, mix it into the eggs when they are nearly cooked.

TIP

Making scrambled eggs requires some care because they need to cook slowly: it will take about 10 minutes for them to begin to set. Stir them constantly to prevent them from sticking to the bottom of the pan, and keep the bain-marie barely simmering.

Stuffed White Onions
(Charlotte Lysès)

12 medium-sized white onions

250 g ($^1/_2$ lb) leftover cooked meat (roast pork or roast chicken) or 250 g ($^1/_2$ lb) fresh calf's liver

60 g (1 $^1/_2$ cups) mixed herbs (parsley, chives)

1 slice stale bread

1 egg

100 g (a bit less than 1 cup) grated Emmental

Oil

Butter for greasing the dish

Salt + freshly ground pepper to taste

❖ *Serves 6 Preparation time: 25 minutes Cooking time: 40 minutes*

Preheat the oven to 200°C (gas mark 5 or 400°F). Peel the onions, taking care to keep the first white layer intact and then scald them for about 10 minutes (they should stay firm). Cut off the top of each onion to make a lid, then carefully hollow out the bottom halves until you are left with an outer wall 2 layers thick. Put the tops to one side and keep the parts you have removed to use later.

With a sharp knife, chop the leftover meat into very small pieces. If you are using fresh calf's liver, chop it into very small pieces and fry it quickly in a dash of hot oil.

Dice the herbs. Toast the bread to dry it out even more and then crumble it into breadcrumbs. Lower the egg into a pan of boiling water and cook until hardboiled. Peel and roughly chop the egg.

Mix the leftover meat or calf's liver with the chopped herbs, breadcrumbs and chopped hard-boiled egg. Add half of the grated cheese. Season with salt and pepper. Stuff the onions carefully with the mixture and put the onion tops back on.

Butter a small gratin dish and lay the onions in it, packing them in tightly. Cook in the oven for 15 minutes. Next, take off the tops and set them aside. Sprinkle the rest of the cheese over the onions, return the onions to the oven for 10 minutes and bake until they are crispy and golden. Put the onion tops back on the onions to serve. Eat hot or cold.

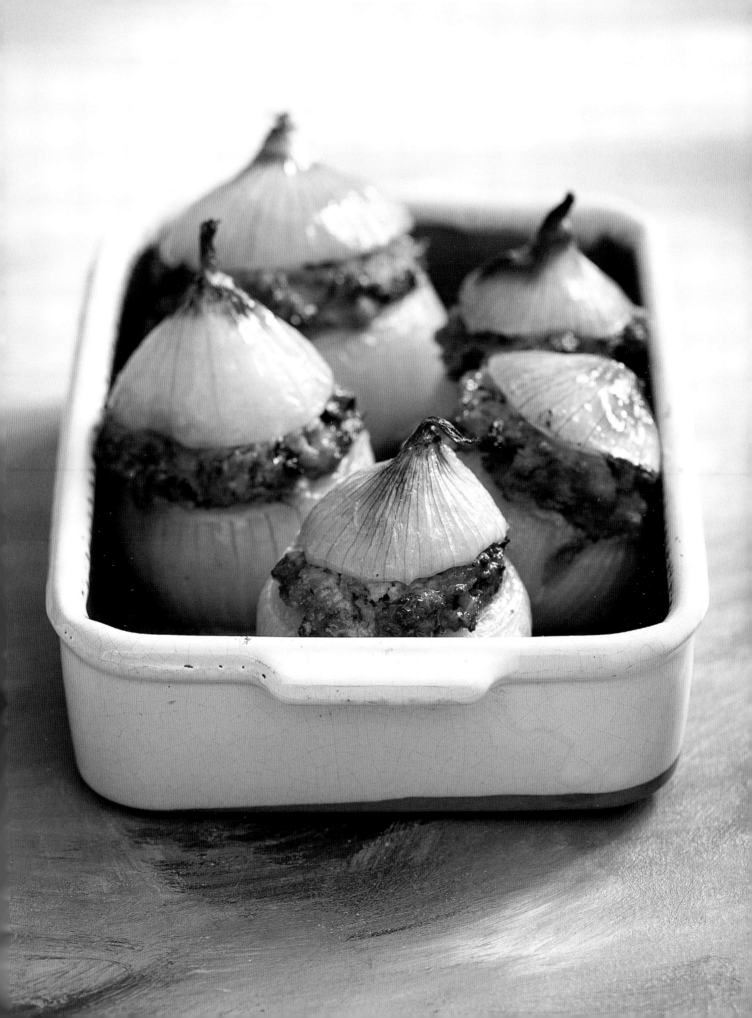

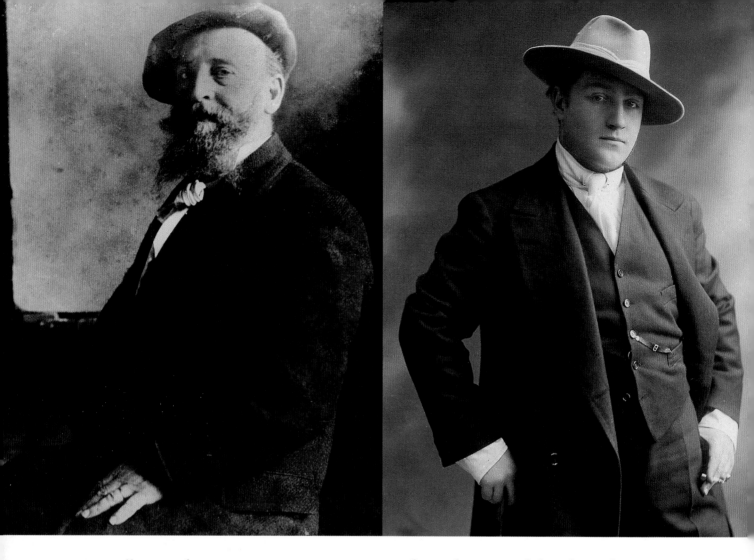

"Wearing an enormous straw hat, he would take Clemenceau off to the garden to see his irises or water flowers in full bloom. He would sit down near him under a willow or against the tall clumps of reeds and watch the water lilies slowly close."

Thadée Natanson, *Painted in their Turn*, 1948.

Above: Alfred Sisley was one of his oldest friends. On the right is Sacha Guitry, another close friend, who would come and see Monet with his wife, Charlotte Lysès.

Right: The art dealer Paul Durand-Ruel was Monet's benefactor and supported him throughout his life. Gustave Caillebotte, seen in the *Self-Portrait* (1875–6 bottom left), shared Monet's passion for gardening. Julie Manet, bottom right, was Berthe Morisot's daughter and according to Thadée Natanson: "[Monet] extended to Julie the profound affection he had for Berthe Morisot" (*Painted in their Turn*, 1948).

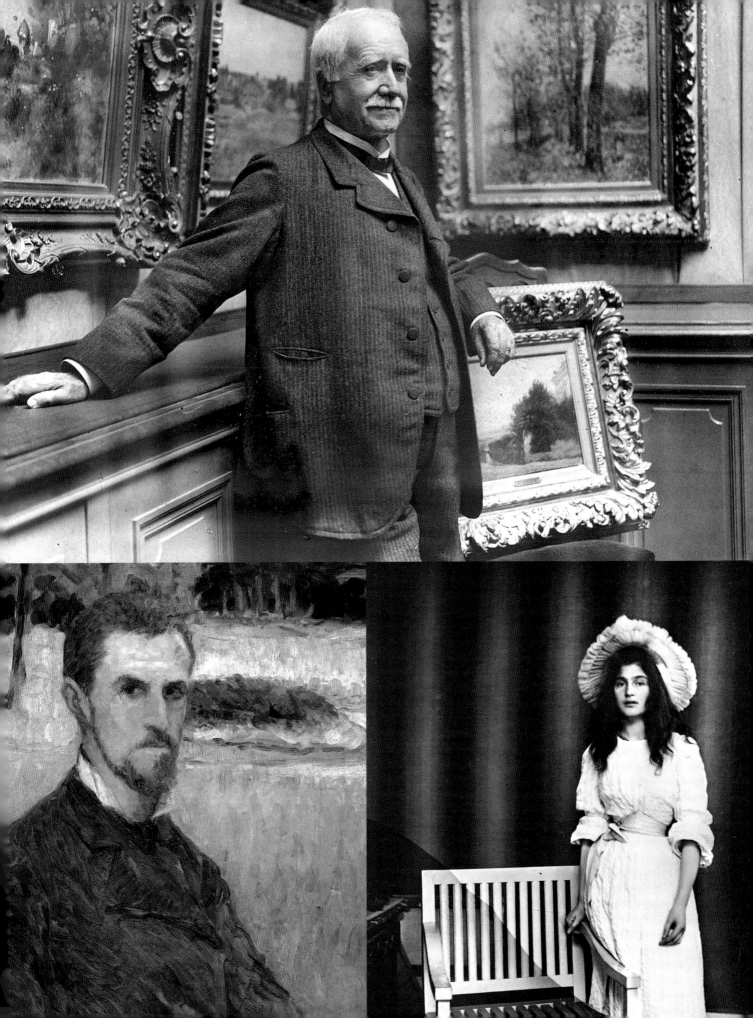

Girolle Mushrooms
(*Stéphane Mallarmé*)

❖

1 kg (2.2 lbs) girolle (chanterelle) mushrooms, preferably with very firm caps and stems
125 g (4 oz) smoked bacon
100 g (3.5 oz) lard

1 garlic clove
1 handful flat-leaf parsley
Salt + freshly ground pepper to taste

❖ *Serves 6 Preparation time: 40 minutes Cooking time: 1 hour 30 minutes*

Trim off and discard the muddy bases of the mushroom stems. Clean the mushrooms one at a time: do not wash them under the tap or they will lose all of their flavor; wipe them carefully or scrape them lightly with the point of a knife. Cut any large mushrooms in half.

Dicc the bacon. Melt the lard in a cast-iron frying pan. When it is good and hot, throw in the chopped bacon and sauté for a few minutes. Add the mushrooms. Season generously with pepper, but be careful not to add too much salt because of the bacon. Cook over a low heat for about 1 hour 15 minutes, until the mushrooms have emitted all of their natural liquid. When they begin to brown, add the peeled and crushed garlic. Serve the mushrooms hot, with finely chopped parsley sprinkled on top.

TIP

The mushrooms are as good, if not better, reheated in a bain-marie.

Cèpes à la Bordelaise

❖

1 kg (2.2 lbs) cèpes (porcini), preferably
with small, fleshy caps with light undersides
2 garlic cloves
1 handful flat-leaf parsley

1 medium-sized slice stale bread
4 tbsp olive oil
Salt + freshly ground pepper to taste

❖ *Serves 6 Preparation time: 20 minutes Cooking time: 1 hour*

Start by cleaning the porcini, wiping them carefully with a dry paper
towel; do not wash them under the tap. Scrape the base of the stems to
remove any loose dirt, discarding any that you cannot scrape clean. Slice
the caps and stems into pieces 1 cm thick.

Heat the oil in a cast-iron frying pan. As soon as it is hot, throw in the
porcini, season with salt and pepper, and stir briskly so that all of the
mushrooms are coated in oil. Cook over a low heat, uncovered, for 1 hour.

Toast the bread if it is not dry enough and then crumble into breadcrumbs.
Pass the breadcrumbs through a fine sieve to get rid of any large pieces.

Peel and dice the garlic. Chop the parsley. Mix the garlic and parsley with
the breadcrumbs.

When the porcini are almost cooked, scald a serving dish and put it in the
oven (at about 150°C or gas mark 2 or 300°F) to keep warm. Check that the
porcini are cooked and beginning to brown. Increase the heat to firm them
up a little bit, then transfer them to the serving dish and keep them hot.

Discard half of the oil the mushrooms have been cooking in and
put the herb and breadcrumb mixture in the frying pan with the rest.
Fry quickly for 30 seconds, stirring very briskly so the mixture does
not brown. Sprinkle over the porcini and serve immediately. This dish
should be eaten while it is piping hot.

Stuffed Artichoke Hearts

❖

6 medium-sized artichokes

1 lemon

250 g ($^1/_2$ lb) button mushrooms

250 g ($^1/_2$ lb) onions

4 to 6 shallots

1 garlic clove

1 tsp concentrated tomato purée

150 ml (5 fl oz) stock (or 1 stock cube dissolved in 150 ml or 5 fl oz water)

12 thin slices smoked bacon

2 tbsp butter

1 tsp oil

2 tbsp breadcrumbs

Salt + freshly ground pepper to taste

❖ *Serves 6 Preparation time: 20 minutes Cooking time: 1 hour*

Cut the artichoke stalks evenly right down to the base so that they sit upright. Remove all of the tough, little outer leaves. With a sharp knife, cut off the tops of the artichokes so that you are left with the fleshy bottom halves of the leaves and the hearts. Remove any hard or stringy bits from the artichoke hearts with a knife and then rub them with one half of the lemon. Place them in a saucepan with cold, salted water and a dash of vinegar.

Scald the artichoke hearts for 10 minutes. Drain them and leave them face down in a colander.

Meanwhile, make the stuffing: carefully wipe the mushrooms clean with paper towels, trim off and discard the muddy bases of the stems, then dice the stems and caps. Peel and dice the onions, shallots and garlic and sauté over a medium heat in a frying pan with a tablespoon of foaming butter. As soon as the mixture begins to brown, add the mushrooms and turn up the heat so they fry right away. Season with salt and pepper and then stir in the tomato purée.

…|…

Preheat the oven to 150°C (gas mark 2 or 300°F). When the artichokes are cool enough to handle, carefully pull out the little clump of purple leaves in the middle and then use a small spoon to remove the choke.

Fill the centers of the artichokes with the stuffing, packing it in so that it comes up a bit higher than the leaves. Lay two slices of bacon on top of each artichoke, tying them in place with kitchen string as if you were tying a package and knotting the string at the top.

Melt a tablespoon of butter with the oil in a cast iron casserole dish that is just big enough to hold the artichokes side by side and keep them upright. Sauté the artichokes for 10 minutes, then pour in the stock. Cover and cook in the oven for 45 minutes. Check regularly to make sure the artichokes are not sticking and baste periodically with their cooking liquid.

Take the dish out of the oven and turn on the grill. Take the lid off of the dish and check that there is still a little liquid left in the bottom; if there is not, add 50 ml ($^1/_4$ cup) of water. Carefully untie the string, sprinkle the artichokes with breadcrumbs and cook under the grill until crispy and golden.

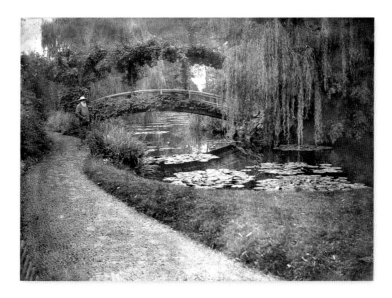

Above: Claude Monet in front of the Japanese bridge over his pond, about 1915–20.

Page 199: Claude Monet, *Water Lilies with Weeping Willows*, 1907.

Salt Cod Croquettes

❖

500 g (1 lb) salt cod
5 floury potatoes (800 g or about 1 ¹/₂ lbs
in all)
300 ml (a bit more than 1 ¹/₂ cups) milk
40 g (5 tbsp) flour + a few spoonfuls

40 g (a bit less than 3 tbsp) butter
2 eggs, beaten
2 lemons
Freshly ground pepper
Oil for frying

❖ *Serves 4 Soaking time: 24 hours Preparation time: 25 minutes Cooking time: 30 minutes*

Prepare a day ahead: put the salt cod in a colander with the skin-side up, and set
in a large bowl of cold water to remove the salt. Leave for 24 hours, changing the
water several times.

The following day: Rinse the cod, put in a saucepan, cover with water and heat.
Time it from the moment the water begins to simmer: it will take 15 minutes.
Remove from the heat and leave to cool in its cooking liquid.

Meanwhile, peel and cut the potatoes into chunks and cook for about 15 minutes,
then mash them with a third of the milk. Keep warm. Take the cod out of its
cooking liquid, remove the skin and bones, flake the flesh with your fingers,
then mash with a fork.

Make a thick béchamel sauce: melt the butter and then whisk in the flour. When
the mixture begins to foam, gradually add the milk, stirring constantly to get
rid of any lumps. Thicken over a low heat for 5 minutes and then mix in the cod
and mashed potato. Add the beaten eggs and season generously with pepper (it
will not need any salt because of the cod).

Fill a saucepan halfway with oil and put on to heat. Meanwhile, shape the cod
and potato mixture into walnut-sized balls and roll in flour. Drop them into the
hot oil and fry for 3 minutes, turning them so that they become golden all over.
Drain them on paper towels and serve very hot with quarters of lemon.

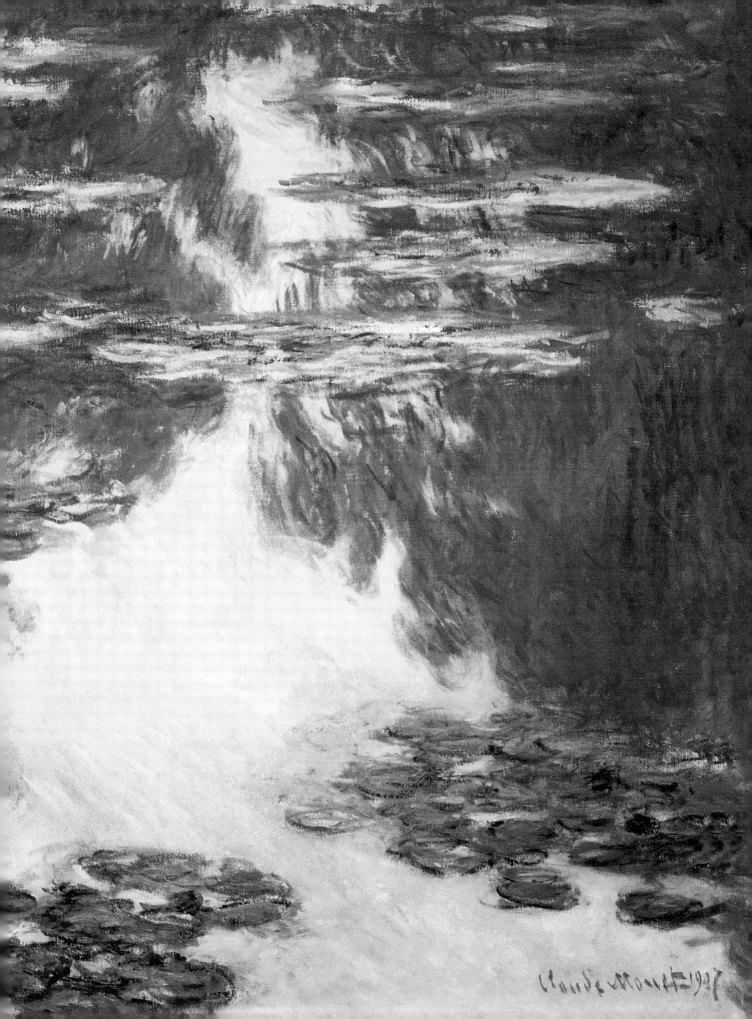

Monkfish à l'Américaine

❖

4 medium-sized pieces monkfish tail
1 tbsp flour
100 ml (¹/₂ cup) olive oil
4 shallots, finely chopped
1 bouquet garni (2 sprigs thyme, 1 bay leaf, 3 sprigs flat-leaf parsley)

1 or 2 pinches chili powder
100 ml (¹/₂ cup) dry white wine
250 g (1 cup) rice
50 ml (¹/₄ cup) Madeira
1 tbsp concentrated tomato purée
Salt + freshly ground pepper to taste

❖ *Serves 4 Preparation time: 5 minutes Cooking time: 30 minutes*

Wipe down and flour the pieces of fish. In a frying pan, heat the oil and quickly sear the slices of monkfish for about 2 minutes on each side. Add the chopped shallots, bouquet garni, chili powder (the dish should be quite spicy) and white wine. Season with salt and pepper to taste. Cook over a low heat for 15 minutes.

Meanwhile, cook the rice in plenty of boiling, salted water.

Mix the tomato purée with a little of the cooking juices from the fish and then pour it into the frying pan with the Madeira. Cook for another 5 minutes.

Lay the fish on a serving dish and arrange the rice in a ring around it and pour the sauce on top. Serve immediately.

TIP

To give the sauce a richer flavor, you can pour a glass of brandy over the fish immediately after searing it and flambé.

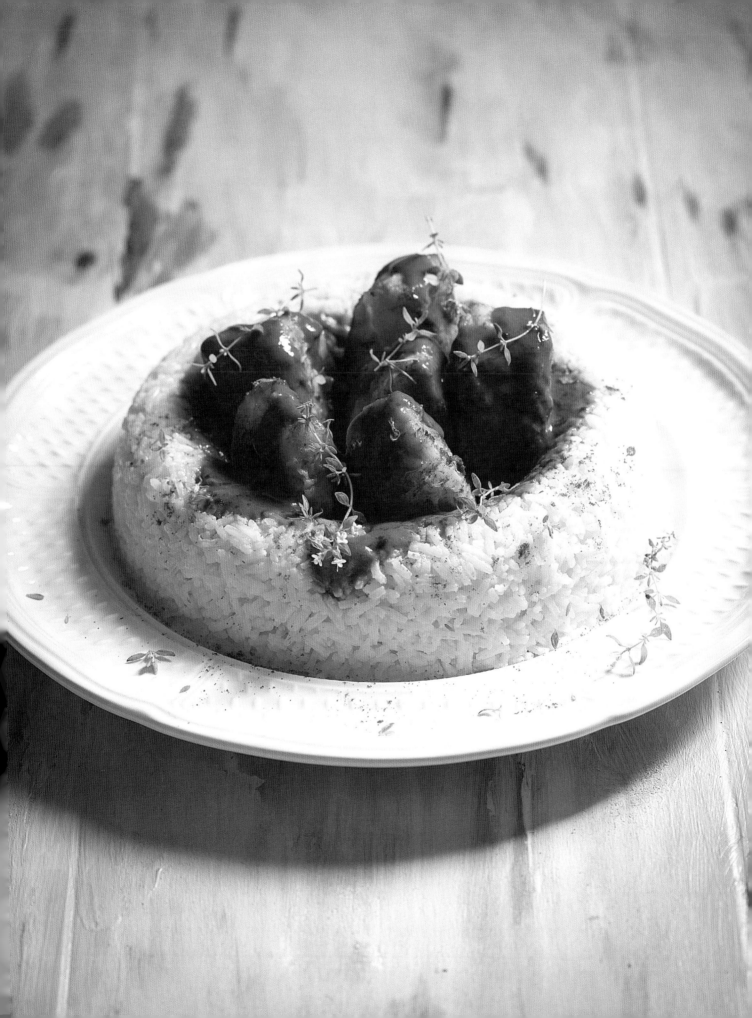

Salt Cod Bouillabaisse
(Paul Cézanne)

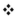

For the bouillabaisse

1 medium-sized piece salt cod, 800 g (1.8 lbs)

6 potatoes

4 leeks

300 ml (a bit more than 1 ½ cups) olive oil

30 g (2 tbsp) butter

30 g (4 tbsp) flour

For the seasoning

2 garlic cloves

10 sprigs parsley

1 good pinch saffron threads

1 bay leaf

Peppercorns

Cloves

❖ Serves 4 Soaking time: 24 hours Preparation time: 20 minutes Cooking time: 50 minutes

Prepare a day ahead: soak the cod in cold water to remove the salt. Leave for 24 hours, changing the water several times.

The following day, drain and dry the cod. Peel the potatoes and cut them into rounds. Wash the leeks and cut into small chunks. Fry the potatoes in 2 tablespoons of hot olive oil until they are three-quarters of the way cooked. Put the leeks in a saucepan with 2 tablespoons of hot oil and fry the same. Lastly, fry the cod in 100 ml (½ cup) of hot oil, removing it from the pan before it gets crispy.

Melt the butter in a casserole pan, stir in the flour and then add 400 ml (about 1 ½ cups) of water. Add the seasonings to the *Bouillabaisse*, boil for 10 to 15 minutes and then carefully add the cod and the potatoes to the pan. Cook everything together for another 15 minutes and then add the chunks of leek. Heat for about 5 minutes and serve immediately.

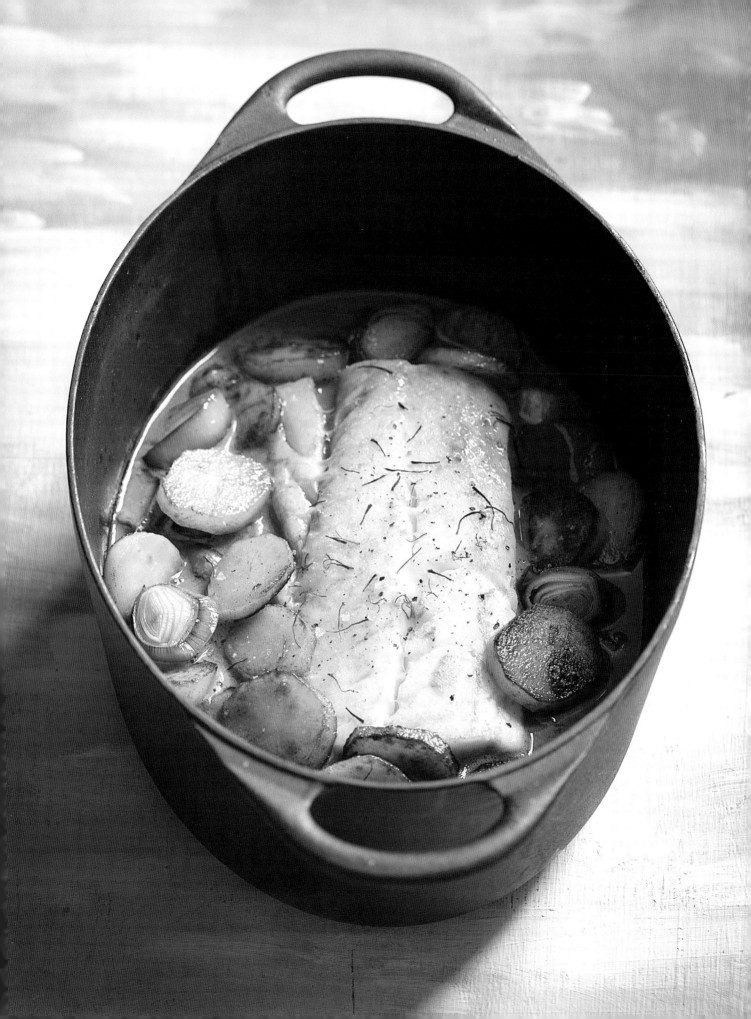

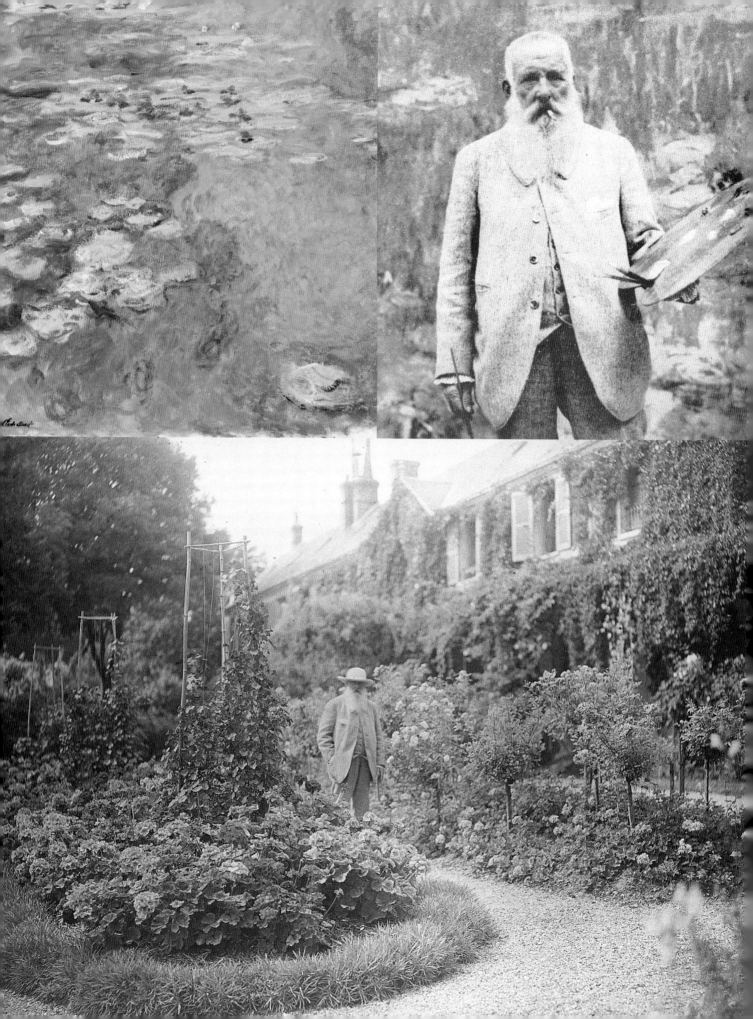

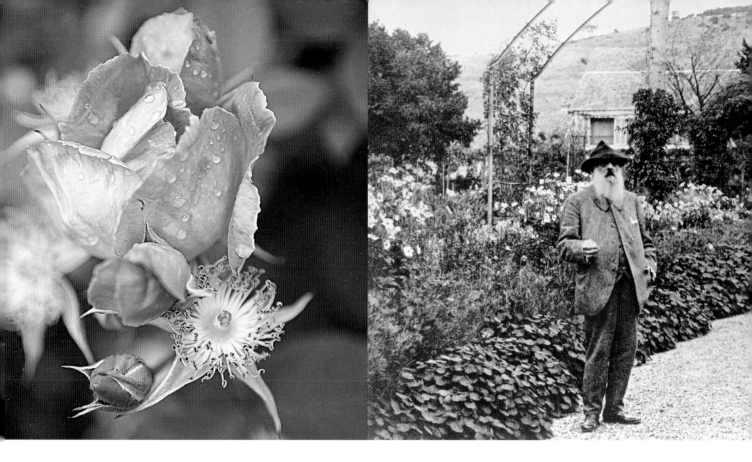

"Giverny, 11 November 1912,

Dear Sir,

I would be grateful if you could dispatch the enclosed order as soon as possible to Giverny station (in the Eure).

Yours faithfully"

Claude Monet to E. Thiébault, seedsman, 30 place de la Madeleine, Paris.

Left: Claude Monet, *Water Lily Pond*, 1917-19; Claude Monet in front of his house, 1921.

Above: Monet in his garden, 1925.

Stuffed Capon

❖

1 medium-sized free range capon weighing at least 3 kg (6 ½ lbs) plucked and dressed (but with the liver and gizzard)
1 thick slice ham
2 onions + 1 large onion to cook with the capon
100 g (3 ½ oz) field mushrooms
4 small morel mushrooms
3 carrots

2 egg yolks
2 tbsp heavy cream
100 ml (½ cup) Madeira
1 slice stale bread + 100 ml (½ cup) milk (optional)
1 tbsp butter + 2 tbsp melted butter
About 500 ml (2 cups) chicken stock
Salt + freshly ground pepper to taste

❖ *Serves 10 Preparation time: 30 minutes Cooking time: 4 hours 30 minutes*

Preheat the oven to 150°C (gas mark 2 or 300°F). Peel 2 onions and wrap each in a piece of foil. Put the onions in a small roasting pan and bake in the oven for 1 hour 10 minutes until quite tender.

Take the onions out of the oven when they are cooked and leave them to cool.

Meanwhile, prepare the mushrooms: wipe the field mushrooms carefully and remove the stems; trim the bases off of the morel mushrooms and discard them, then scrub the caps well with a small brush, cleaning all of the cavities. Do not wash the mushrooms under the tap. Dice all of the stuffing ingredients: the baked onions, ham, liver and gizzard from the capon, field mushrooms and morels. Season with salt and pepper. Add the cream and gently sauté in a tablespoon of melted butter for about 10 minutes. Leave to cool, then bind with the egg yolks and flavor with the Madeira. If the mixture is too thin, soak the stale bread in milk, squeeze out any liquid and then mix it into the stuffing to thicken.

Preheat the oven to 180°C (gas mark 4 or 350°F).

Stuff the capon and tightly truss the legs so that the stuffing does not escape. Peel the carrots and the remaining onion, cut into julienne strips and lay these in the bottom of a large roasting pan. Lay the capon on top and baste it with melted butter. Put the pan in the oven, cover the capon with foil and roast for about 2 hours 30 minutes, basting it regularly with small ladlefuls of hot chicken stock. Remove the foil and let the top brown for 30 minutes. Remove the capon from the oven and let it rest for 10 minutes before carving.

Coq au vin

❖

1 cockerel weighing about 2 kg (4 ¹/₂ lbs),
plucked and dressed
1 medium-sized piece lean smoked bacon
(about 200 g or 7 oz)
12 small grelot (pearl) onions
200 g (7 oz or a bit less than ¹/₂ cup) small
button mushrooms

1 tbsp butter + 2 tbsp butter for the sauce
50 ml (¹/₄ cup) brandy
500 ml (2 cups) burgundy
1 bouquet garni (2 sprigs thyme, 2 bay leaves,
3 sprigs tarragon)
2 tbsp flour
Salt + freshly ground pepper to taste

❖ *Serves 4 Preparation time: 20 minutes Cooking time: 1 hour*

Cut the cockerel into pieces. Peel the onions, but keep them whole. Clean the mushrooms: cut off the muddy bases and a good part of the stems, carefully wipe the caps with a clean paper towel and cut them in half. Dice the bacon.

Melt the butter in a casserole pan and sauté the bacon with the small onions. When they start to brown, remove them from the pan and put in the pieces of cockerel. Brown for about 10 minutes, turning several times. Add the bouquet garni and mushrooms and a grind of pepper. Cover and cook for 15 minutes.

With a spoon, skim off any fat from the cooking juices, pour the brandy over the bird and flambé. Add the wine, cover and cook for another 30 to 35 minutes. Test the chicken pieces with a fork to check if they are done (the juice should run clear). Remove them from the pan, shaking them well to remove any liquid, and keep warm. Using a wooden spoon, over a low heat, stir the softened butter and flour into the sauce to thicken it. Cook until the sauce is thick and smooth and coats the back of the spoon. Season with salt and pepper and then put the pieces of chicken back in the pan to reheat. Serve immediately.

TIP

Coq au vin can also be served with fried croutons. It is even better the day after it is cooked, slowly reheated in a bain-marie.

Boeuf à la Mode
(Marthe Butler)

❖

1 piece boned beef weighing 1.5 kg (3 to
3 $^1/_2$ lbs), preferably rump
4 to 5 thin pieces smoked bacon
1 calf's foot (optional)
5 carrots
1 large onion
400 ml (2 cups) white wine

500 ml (a bit more than 2 cups) meat juices (or
concentrated beef stock made from 2 stock
cubes dissolved in 500 ml or a bit more than
2 cups water)
50 ml (3 tbsp) brandy
1 tbsp butter
Salt + freshly ground pepper to taste

❖ Serves 6 Preparation time: 20 minutes Cooking time: 7 hours Setting time: at least 3 hours

Trim the meat of any gristle and securely tie into a roll with 4 or 5 pieces of
string to hold it in shape.

Peel the carrots and cut into rounds. Peel the onions and chop into thick
chunks.

Sauté the bacon in the butter in a large cast iron casserole pan over high
heat. When it is sizzling, add the piece of beef and sear it on all sides.
Remove it from the pan.

Pour in 100 ml ($^1/_2$ cup) of the wine and the same quantity of meat juices
or concentrated stock. Stir briskly with a wooden spoon and then put the
beef back in the pan. Cook until the liquid has reduced by half, turning the
meat over several times.

…/…

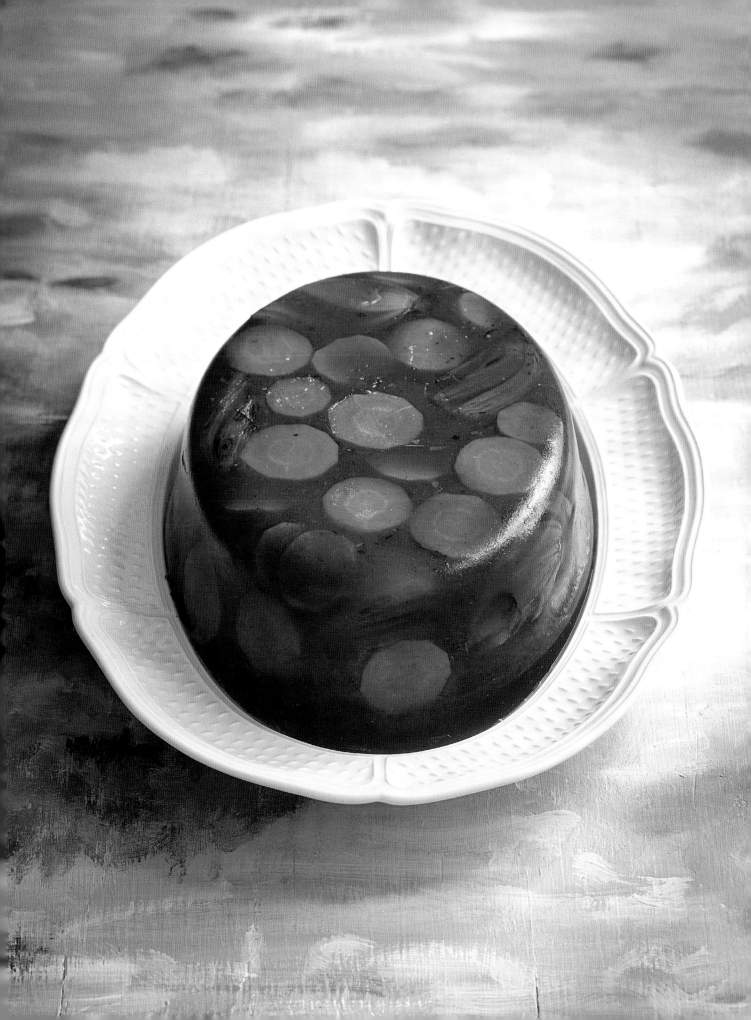

When the sauce has thickened, turn down to the lowest possible heat. Season with salt and pepper, arrange the rounds of carrot and chunks of onion around the piece of beef, add the calf's foot (optional), and then gently pour in the rest of the wine and the stock.

Cover with a close-fitting lid and cook over a very low heat for a total of 7 hours. Turn the meat over three or four times and add a little water if necessary if it begins to stick to the pan. About 1 hour before the end of the cooking time, pour in the brandy.

When the beef is perfectly cooked and tender, remove it from the pan to take off the string, and then return it to the pan and allow the juices to set into jelly before serving.

"He would stride energetically off to paint en plein air clutching armfuls of pens, canvases, easels, boxes of paints, brushes and the like, often with his daughter-in-law Blanche to help him …, and he would stride as energetically back to his studio along the paths in his garden across which he trained nasturtiums to creep. He had six men at his command to help him in this garden, and while he was alive, they worked there from dawn to night."

Thadée Natanson, *Painted in their Turn*, 1948.

Right: Claude Monet on the Japanese bridge in his garden at Giverny, 1920.

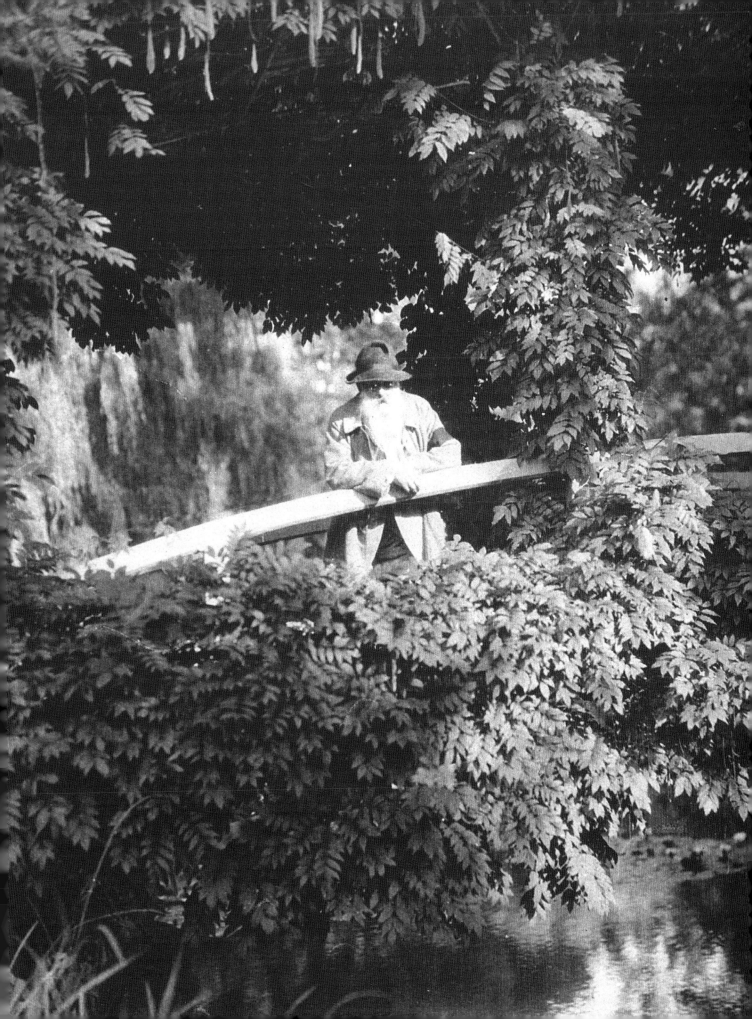

Oxtail Hochepot
(Marguery)

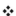

For the hochepot

1 oxtail cut into 6 cm (2 in) chunks
4 pieces bacon rind
2 sprigs thyme
3 bay leaves
300 ml (1 ½ cups) brown stock (or concentrat-
ed beef stock made from 1 stock cube dissolved
in 300 ml or 1 ½ cups water)
100 ml (½ cup) white wine

For the garnish

6 chipolatas
12 small onions
250 g (4 cups) button mushrooms
1 kg (2.2 lbs) chestnuts, in water or
vacuum-packed
2 tbsp butter
1 tsp superfine sugar
1 tsp olive oil
Salt + freshly ground pepper to taste

❖ *Serves 6 Preparation time: 40 minutes Cooking time: 3 hours 15 minutes*

Preheat the oven to 180°C (gas mark 4 or 350°F).

Line the base of a large cast iron casserole dish with the bacon rind. Lay the
herbs on top and then the chunks of oxtail, packing them in tightly to keep
them upright. Put in the oven and sweat for 15 minutes, then turn them
over and repeat on the other side. Remove the dish from the oven. Lower
the temperature to 150°C (gas mark 2 or 300°F).

Pour in 100 ml (½ cup) of brown or concentrated stock and all of the wine.
Briefly boil to reduce the liquid and then add the rest of the stock to the
casserole dish. Top with a little water so that the liquid covers the chunks
of oxtail, cover the casserole dish and return to the oven for about 3 hours
or until the meat comes off the bone.

Meanwhile, make the garnish: peel the onions and put them in a small
saucepan with a tablespoon of butter, the sugar, a pinch of salt and a little
pepper. Fill the saucepan halfway with water, place a circle of greaseproof
paper on top of the onions and simmer.

… / …

Remove the greaseproof paper and cook for another 10 minutes: all of the liquid should have evaporated. Carefully caramelize the onions, moving the pan around so that they brown evenly: they should be shiny and lightly golden. Keep them warm.

Clean the mushrooms with paper towels and trim off the muddy bases. Without removing the stems, slice the mushrooms from top to bottom and sauté in a frying pan in the rest of the butter. When they are golden and all their natural liquid has evaporated, remove the frying pan from the heat.

In a frying pan, heat the chestnuts in the olive oil.

When the oxtail is cooked, transfer the chunks of meat into a frying pan. Using a sieve, strain the cooking juices from the casserole, skimming off any fat, and pour over the oxtail. Add the glazed onions, sautéed mushrooms, chestnuts and chipolatas. Cook for 15 minutes and serve hot.

Above: Claude Monet in the sitting-room at Giverny, about 1915–20.

Right: The nasturtium alley in the garden at Giverny, about 1920.

Venison with Rosehips

❖

1 piece of venison, weighing 1.5 kg (a bit more than 3 lbs)
60 g (4 tbsp or ½ stick) butter
1 tbsp oil
300 ml (1 ½ cups) white wine vinegar
250 g (8 oz) rosehips
250 g (8 oz or 1 ½ cups) blanched almonds

200 ml (1 cup) white wine (approx.)
40 g (5 tbsp) flour
1 tsp superfine sugar
4 cloves
Lemon
Coarse salt, peppercorns

❖ *Serves 8 Preparation time: 30 minutes Cooking time: 1 hour 30 minutes*

Preheat the oven to 180°C (gas mark 4 or 350°F).

Melt 1 tablespoon of butter with 1 tablespoon of oil in a large casserole dish, sear the venison on all sides, and then pour in 1 liter of water mixed with the white wine vinegar. Add a good pinch of coarse salt and ten peppercorns.

Put the lid on the casserole dish and put it in the oven for 1 hour 30 minutes: check that the meat is tender (it can take longer depending on the age of the meat).

Meanwhile, make the sauce: clean the rosehips and snip off both ends with a pair of scissors. Wash and dry them, then crush them with a mortar and pestle. Weigh the pulp and add the same weight of white wine. Cook for 30 minutes. Add 2 or 3 spoonfuls of the cooking liquid from the meat and strain through a fine sieve (this step is necessary to separate out the seeds and fine hairs that can cause terrible itchiness).

Grate the almonds. Heat 40 g (3 tablespoons) of butter in a small saucepan, take the pan off the heat and whisk in the flour. Add a little of the venison's cooking liquid to the roux, then tip in the rosehip pulp. Cooking constantly, add the grated almonds, sugar, cloves and the finely chopped zest of half of a lemon. Continue cooking until the sauce is thickened. Season to taste.

Arrange the meat on a serving platter with the sauce in a gravy boat on the side.

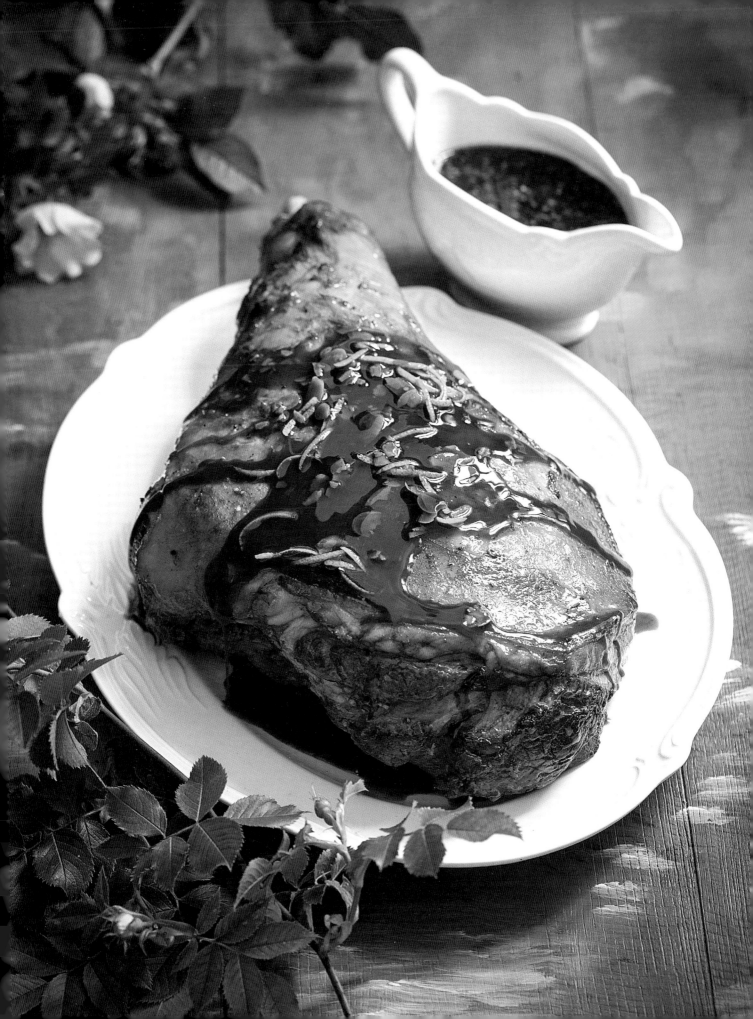

Sacha's Pork Shoulder
(Sacha Guitry)

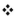

1 pork shoulder, cured
1 large smoked sausage (or 1 large Morteau
sausage), to cook
1 medium-sized savoy cabbage

8 medium-sized potatoes
2 sprigs thyme
2 bay leaves
Peppercorns

Serves 4 Preparation time: 20 minutes Cooking time: 2 hours 30 minutes

Place the pork shoulder in a casserole pan. Tie the thyme and bay leaves together in a bouquet garni and toss into the pan. Cover with cold water and add 10 peppercorns (but no salt because the cured meat is already salty). Gently bring to a boil.

Meanwhile, strip away the outer leaves from the cabbage and cut the cabbage into quarters. Peel the potatoes.

Once the water in the casserole begins to boil, skim off any froth and keep the water at a gentle boil. Add the quartered cabbage, cover and simmer for 1 hour 30 minutes. Drop the potatoes into the pan and continue cooking for 15 minutes. Lastly, add the sausage without pricking it. Cook for another 30 minutes.

Warm a serving dish with boiling water and place the pork shoulder on it, surrounded by the vegetables. Cut the sausage into thick slices and lay these on top of the vegetables. Pour a ladleful of stock over the top and serve while hot.

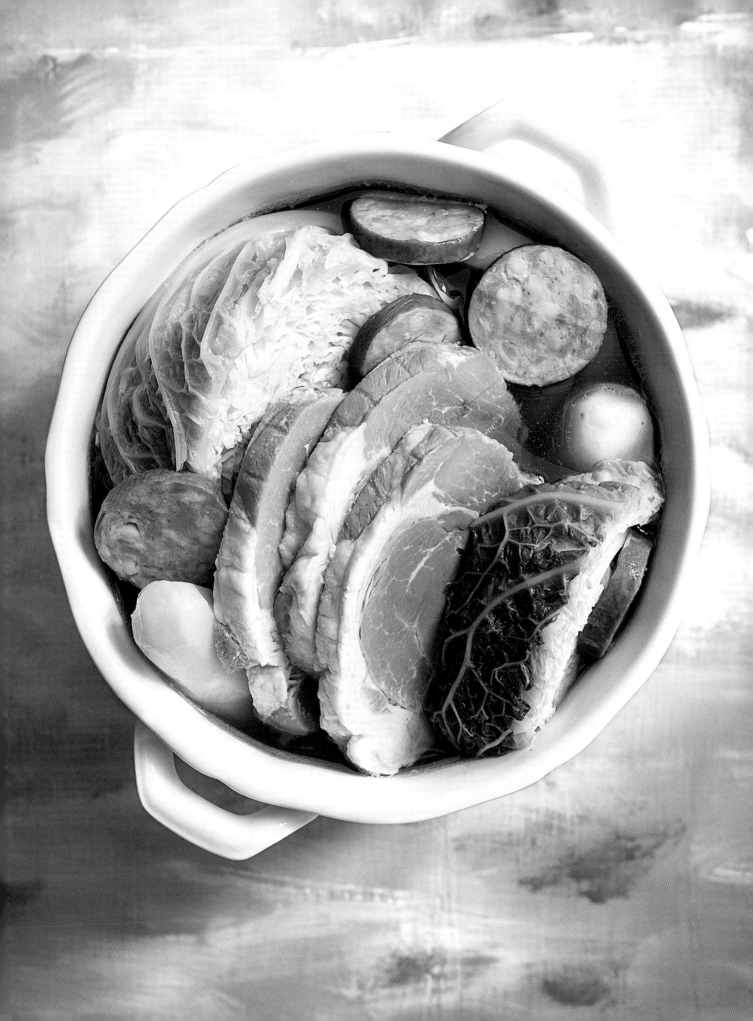

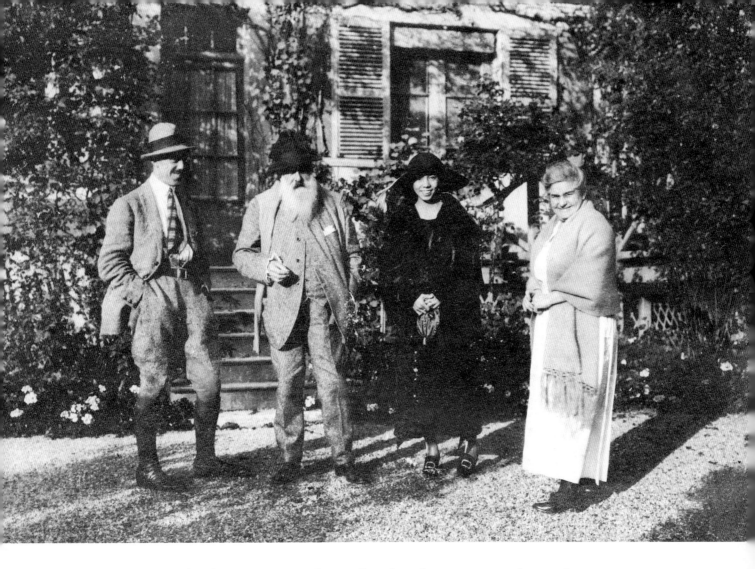

"Lunch draws to a close [...]. The somewhat riotous exuberance of the garden is muted in the cool intimacy of the house. The atmosphere at the table is more than cordial, paternal. In the master's company, one feels at ease, light of heart, brimming with affectionate tranquillity."

Marc Elder, *At Giverny with Monet*, 1924.

Above: Claude and Blanche Monet, Shoichi and Fukuko Naruse at Giverny.
Right: Claude Monet, *The Lily Pond*, 1899.

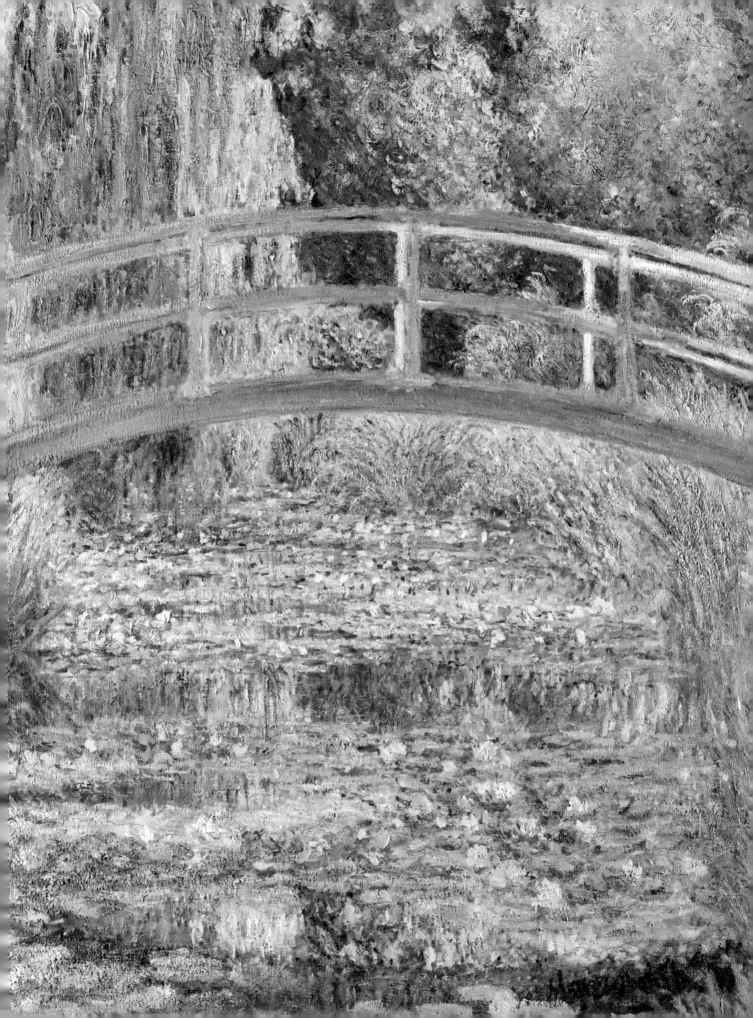

Beignets Soufflés or Nun's Farts (*Mélanie*)

❖

250 ml (1 cup) milk
100 g (7 tbsp or a bit less than ¹/₂ stick) butter
1 tbsp brandy
1 large pinch salt

1 large pinch superfine sugar
150 g (a bit more than 1 cup) flour
4 eggs
Oil for frying
Powdered sugar

❖ *Makes about 30 beignets Preparation time: 20 minutes Resting time for the pastry: 1 hour Cooking time: 10 minutes*

Put the milk, butter, brandy, salt and sugar in a saucepan and heat while stirring with a spatula. As soon as the mixture begins to boil, toss in all of the flour. Lower the heat and stir in the flour with a wooden spoon, at first slowly and then briskly until the mixture is very smooth and does not stick to the spoon. Take the pan off of the heat, add the eggs one at a time, mixing in each one before adding the next, until the pastry is blended and smooth, but not runny. Leave the pastry to rest for 1 hour.

Heat the oil in a deep frying pan to a temperature of 170°C (325°F).

Drop spoonfuls of the mixture into the oil. As the beignets begin to expand, turn up the heat. When they have inflated nicely, take them out and drain them on a towel. Sprinkle with powdered sugar.

Crème Somptueuse

❖

3 bars dark semi-sweet chocolate weighing
250 g (8.8 oz)
100 g (7 tbsp or a bit less than 1 stick) butter
3 egg yolks

❖ *Serves 8 Preparation time: 20 minutes Resting time: 24 hours*

Make the cream 24 hours in advance so that it sets well.

Break the chocolate into squares and melt over a low heat, adding a little water to the bottom of the saucepan and stirring constantly.

When the chocolate has a creamy consistency, take it off the heat and add the butter bit by bit, stirring constantly to mix it in.

Beat the egg yolks in a bowl, then carefully pour the chocolate over them and mix with a wooden spoon until blended into a cream. Pour into a serving bowl. The cream can keep for 2 or 3 days in the fridge.

"Every day, Monet would have coffee served in the studio, followed by a tumbler of plum brandy made from plums from the garden."

Jean-Pierre Hoschedé, *The Little-Known Claude Monet*, 1960.

Apricot Charlotte

❖

About 24 sponge finger biscuits
(Lady Fingers)

3 tbsp superfine sugar

3 tbsp kirsch

1 medium-sized jar apricot jam

Butter for greasing the mould

❖ Serves 8 Preparation time: 20 minutes Resting time: 12 hours

Make syrup by bringing the sugar, kirsch and 100 ml ($\frac{1}{2}$ cup) of water to a boil. Line the base of a greased charlotte mould with Lady Fingers dipped in syrup, filling any gaps with bits of broken biscuit.

Spread a layer of apricot jam on top of this, then a layer of biscuits dipped in syrup, then a layer of apricot jam and another layer of biscuits (laying them at right angles to the first layer), and repeat until all the biscuits are used up. Cover with a plate slightly smaller in diameter than the mould, put a weight on top and leave it to rest in the fridge for 12 hours.

TIP

This charlotte can be served with vanilla crème anglaise.

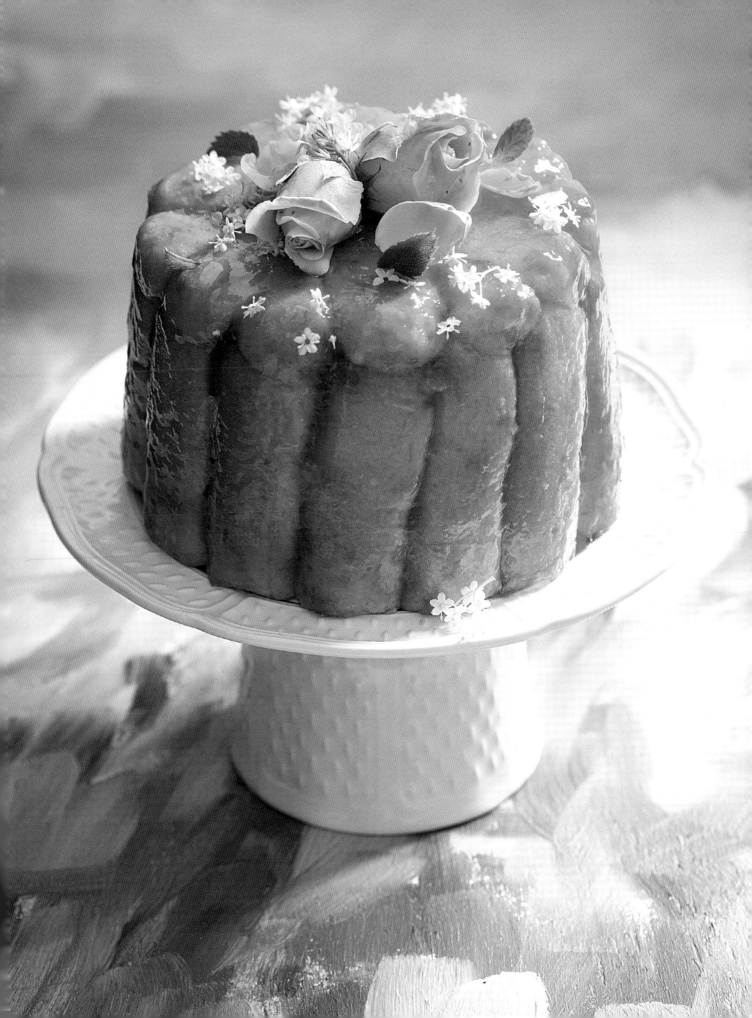

Banana Ice Cream

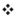

500 ml (2 cups) milk
5 egg yolks
250 g (a bit more than 1 cup) superfine sugar

1 tsp cornflour
150 g (5 oz) heavy cream
4 bananas
Salt

❖ *Serves 8 Preparation time: 25 minutes Freezing time: at least 4 hours*

Bring the milk to a boil with a pinch of salt.

Put the egg yolks, sugar and cornflour in a bowl and mix with a wooden spoon until the mixture is pale and airy. Slowly stir in a bit of the boiling milk. Pour into a copper saucepan, add the rest of the milk and thicken over a low heat without letting it boil, stirring constantly. As soon the cream sticks to the spoon, take it off the heat. Leave to cool.

Peel the bananas, mash them to a purée with a fork and pass through a fine sieve. Add the purée to the cooled cream and then mix carefully, blending everything together. Whisk.

Pour the ice cream mixture into a mould and put it in the freezer until it forms ice crystals. Every 40 minutes to 1 hour, take out the ice cream, blend it and then pour it back into the mould. Repeat the process until the ice cream has completely set. Blend one last time and then pour it into an ice mould or a mould with a rounded base.

Chestnut Galettes

❖

250 g (1 cup) chesnut purée
125 g (a bit more than 8 tbsp or a bit more than
1 stick) butter + 1 tbsp for greasing the tins

125 g (a bit more than $^1/_2$ cup) superfine sugar
3 eggs
Salt

❖ *Makes about 10 galettes Preparation time: 20 minutes Cooking time: 20 minutes*

Preheat the oven to 160°C (gas mark 3 or 320°F).

Separate the eggs. Slowly melt the butter and then mix it with the chestnut purée, sugar and egg yolks. Whip the egg whites into stiff peaks with a pinch of salt and then gently fold them into the chestnut mixture, mixing them carefully together.

Grease small, shallow, round tins. Fill with the galette mixture and bake for 20 minutes. Take tins out of the oven, immediately turn out the *galettes* and leave to cool.

"He is filled with elation and joy in the presence of all nature, be it in the form of vaporous willows or vibrating lilies, or a fruit bowl full of strawberries or a trout cooked in jelly."

Marc Elder, *At Giverny with Monet*, 1924.

Scones

❖

250 g (2 cups) flour
10 g (2 ¹/₂ tsp) baking powder
40 g (a bit less than 3 tbsp) butter + 1 tbsp
for greasing the parchment paper

100 ml (¹/₂ cup) milk (approx)
1 egg
Salt

❖ *Makes about 10 scones Preparation time: 15 minutes Cooking time: 15 minutes*

Preheat the oven to 200°C (gas mark 5 or 400°F). Mix together the flour, baking powder and a pinch of salt. Add the softened butter and knead well. Gradually add the beaten egg and the milk until you have formed a softened dough. Roll it out with a floured rolling pin and cut into small rounds using a thin-rimmed glass.

Place the scones on a baking tray lined with greased parchment paper. Bake in the oven for 15 minutes and eat hot, cut in half, with butter.

"Dear Madame,

All my apologies for arriving at your house

in such a sorry state, and thank you for the

excellent tisane you gave me; thanks to it

and the rest, I am able to return home quite

restored."

Claude Monet, letter to Berthe Morisot, January 7, 1888.

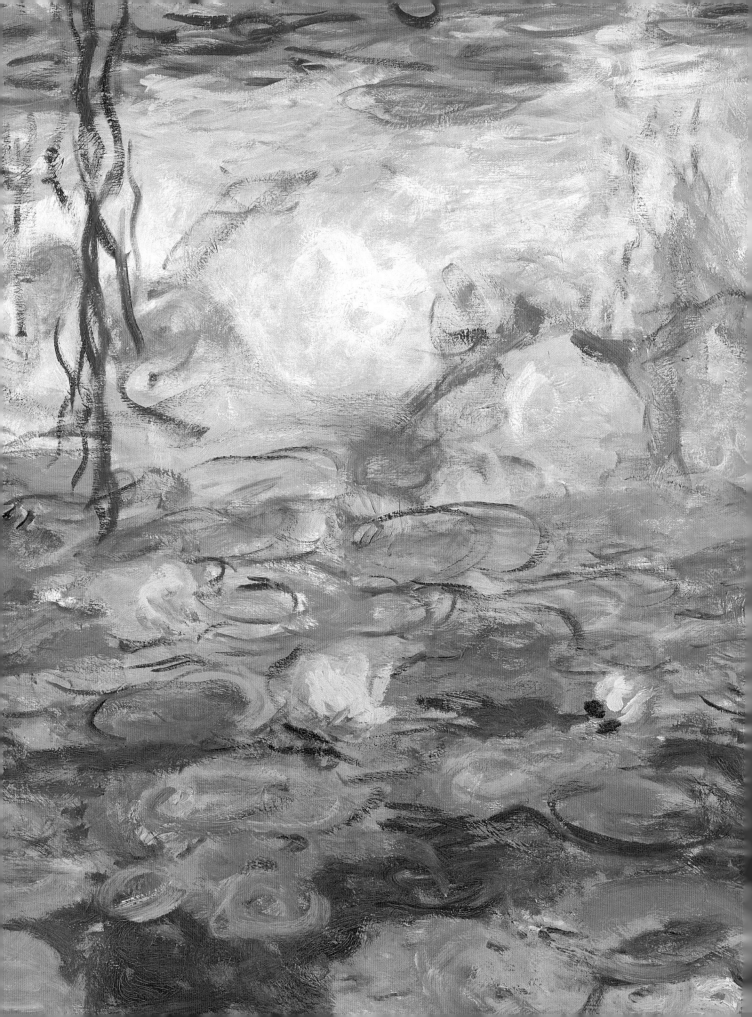

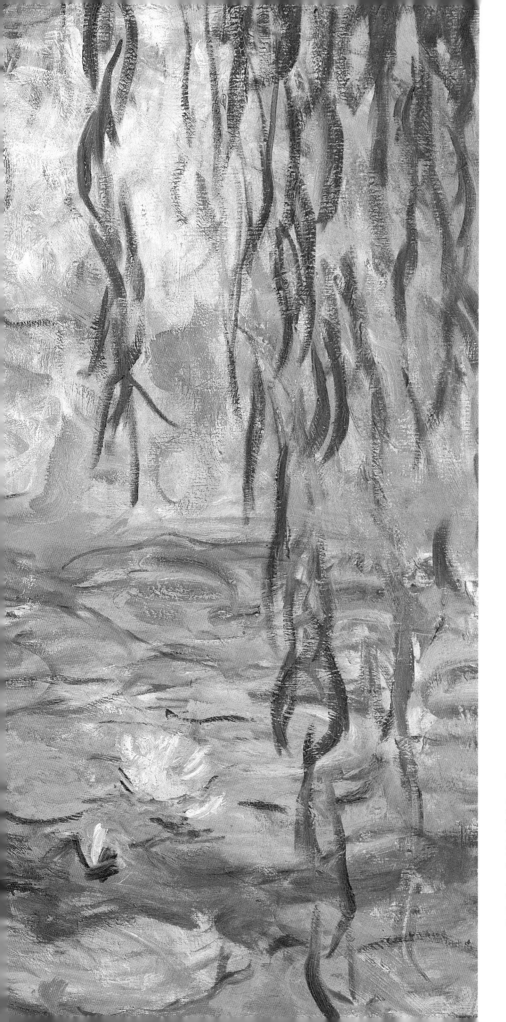

Claude Monet, *Water Lilies* (detail), 1916–19.

Claude Monet wrote to Georges Bernheim Jeune on November 16, 1920: "It took me a long time to understand my water lilies ... I planted them for pleasure, and grew them without thinking of painting them [...] You don't absorb a landscape in a day [...] And then, all of a sudden, I had a revelation and saw the magic of my pond. I took up my palette [...] Since then, I have painted scarcely anything else."

Index of Recipes

❖

❖ Paintings which have been cropped are shown below not cropped ❖

p. 6 Claude Monet, *Garden in Bloom, Sainte-Adresse*, c. 1866. Paris, Musée d'Orsay.

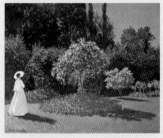

p. 7 Claude Monet, *Woman in the Garden, Sainte-Adresse*, 1867. Saint-Petersburg, State Hermitage Museum.

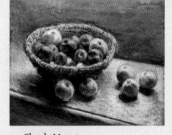

p. 7 Claude Monet, *Un bol de pommes*, 1880. Private collection.

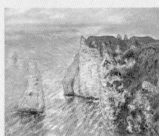

p. 7 Claude Monet, *The Rock Needle and Porte d'Aval Étretat*, 1886. Private collection.

p. 27 Gilbert Alexandre de Séverac, *Portrait of Claude Monet*, 1865. Paris, Musée Marmottan Monet.

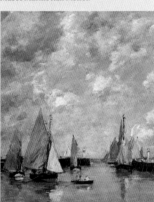

p. 39 Eugène Louis Boudin, *The Jetty at High Tide, Trouville*, c. 1888-1895. Caen, Association Peindre en Normandie.

p. 63 Claude Monet, *The Luncheon, Monet's Garden at Argenteuil*, 1873. Paris, Musée d'Orsay.

p. 63 Claude Monet, *In the Meadow*, 1876. Private collection.

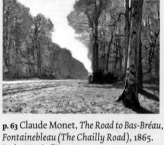

p. 63 Claude Monet, *The Road to Bas-Bréau, Fontainebleau (The Chailly Road)*, 1865. Paris, Musée d'Orsay.

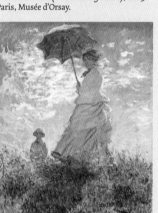
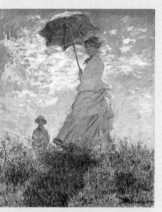

p. 84 Claude Monet, *Woman with a Parasol, Madame Monet and her Son*, 1875. Washington DC, National Gallery of Art.

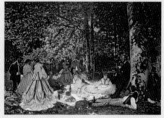

p. 116–117 Claude Monet, *Le Déjeuner sur l'herbe*, 1865-1866. Moscow, Pushkin Museum.

p. 119 Claude Monet, *Spring at Giverny*, 1903. Private collection.

p. 119 Claude Monet, *Garden at Giverny*, 1895. Zurich, Bührle Collection.

p. 132 Claude Monet, *Water Lilies and Agapanthus*, 1914–1917. Paris, Musée Marmottan Monet.

p. 133 Claude Monet, *Portrait of Blanche Hoschedé as a Young Girl*, c. 1880. Rouen, Musée des Beaux-Arts.

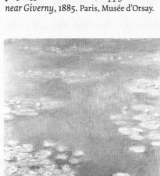

p. 152-153 Claude Monet, *Poppy Field near Giverny*, 1885. Paris, Musée d'Orsay.

p. 177 Claude Monet, *A Pathway in Monet's Garden, Giverny*, 1902. Vienna, Ostrerreichische Galerie Belvedere.

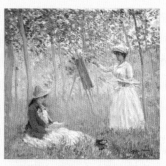

p. 183 Claude Monet, *In the Woods at Giverny, Blanche Hoschedé at her Easel with Suzanne Hoschedé Reading*, 1887. Los Angeles, Los Angeles County Museum.

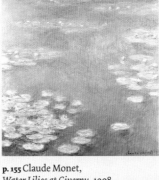

p. 155 Claude Monet, *Water Lilies at Giverny*, 1908. Private collection.

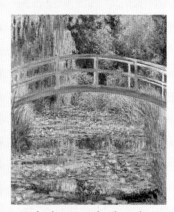

p. 139 Claude Monet, *Branch of the Seine near Giverny*, 1897. Paris, Musée Marmottan Monet.

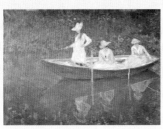

p. 164–165 Claude Monet, *The Boat at Giverny*, 1887. Paris, Musée d'Orsay.

p. 176 Claude Monet, *Weeping Willows the Water Lily Pond at Giverny*, 1918. Private collection.

p. 221 Claude Monet, *The Lily Pond*, 1899. London, National Gallery.

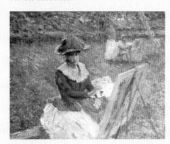

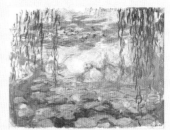

p. 149 Claude Monet, *Meadows at Giverny*, 1888. Saint-Petersburg, State Hermitage Museum.

p. 177 Claude Monet, *Blanche Hoschedé peignant*, 1892. Private collection.

p. 232–233 Claude Monet, *Nymphéas*, 1916–1919. Paris, Musée Marmottan Monet.

The following paintings also appear in this book:

p. 63 (center) Claude Monet, *Water Lilies: Morning with Willows*, 1915–1926. Paris, Musée de l'Orangerie.

p. 118 Claude Monet, *The House at Giverny Under the Roses*, 1925. Private collection.

Credits

All the photographs in this book were taken by Francis Hammond, with the exception of the following:

Bridgeman Images

p. 6: Claude Monet / Musée d'Orsay, Paris, France © Bridgeman Images ; p. 7 (top right): Claude Monet / Hermitage, St. Petersburg, Russia / Bridgeman Images ; p. 7 (center): © Bridgeman Images ; p. 7 (bottom left): Claude Monet / Private Collection / Photo © Christie's Images / Bridgeman Images ; p. 7 (bottom right): Claude Monet / Private Collection / Photo © Christie's Images / Bridgeman Images ; p. 12: Gustave Le Gray / Private Collection / The Stapleton Collection © Bridgeman Images ; p.13 (bottom): Claude Monet / Private Collection © Bridgeman Images ; 23 (bottom): Claude Monet / Metropolitan Museum of Art, New York, USA © Bridgeman Images ; p. 26 (left): Claude Monet / Musée Marmottan Monet, Paris, France © Bridgeman Images ; p. 26 (center): Claude Monet / Musée Marmottan Monet, Paris, France © Bridgeman Images ; p. 26 (right): Claude Monet / Musée Marmottan Monet, Paris, France © Bridgeman Images ; p. 27: Gilbert Alexandre de Séverac / Musée Marmottan Monet, Paris, France © Bridgeman Images ; p. 31: Claude Monet / Musée d'Orsay, Paris, France © Bridgeman Images ; p. 38 (left): Eugène Louis Boudin / Musée des Beaux-Arts André Malraux, Le Havre, France © Bridgeman Images ; p. 39: Eugène Louis Boudin / Association Peindre en Normandie, Caen, France © Bridgeman Images ; p. 44-45: Claude Monet / Pushkin Museum, Moscow, Russia © Bridgeman Images ; p. 48: Johan Barthold Jongkind / Private Collection © Bridgeman Images ; p. 54-55: Claude Monet / Private Collection © Bridgeman Images ; p. 63 (top left): Claude Monet / Musée d'Orsay, Paris, France © Bridgeman Images ; p. 63 (top right) and on the cover: Claude Monet / Private Collection / Photo © Christie's Images / Bridgeman Images ; p. 63 (center): Claude Monet / Musée de l'Orangerie, Paris, France / Bridgeman Images ; p. 63 (bottom right): Claude Monet / Musée d'Orsay, Paris, France © Bridgeman Images ; p. 68: Jean Frédéric Bazille / Musée d'Orsay, Paris, France © Bridgeman Images ; p. 69 (top left): Pierre Auguste Renoir / Musée Marmottan Monet, Paris, France © Bridgeman Images ; p. 69 (top right): French School (19th century) / Musée Marmottan Monet, France © Bridgeman Images ; p. 69 (bottom): Ignace Henri Jean de Fantin-Latour / Musée d'Orsay, Paris, France © Bridgeman Images ; p. 2: Claude Monet / The Barnes Foundation, Philadelphia, Pennsylvania, USA © Bridgeman Images ; p. 84: Claude Monet / National Gallery of Art, Washington DC, USA © Bridgeman Images ; p. 85 (left): Nadar (Gaspard Félix Tournachon) / Private Collection / Archives Charmet © Bridgeman Images ; p. 85 (right): Claude Monet / Musée d'Orsay, Paris, France © Bridgeman Images ; p. 102: Pierre Auguste Renoir / Musée d'Orsay, Paris, France © Bridgeman Images ; p.

103 (top): Claude Monet / Metropolitan Museum of Art, New York, USA © Bridgeman Images ; p. 103 (bottom left): Eugène Atget / Archives Larousse, Paris, France © Bridgeman Images ; p. 110: Claude Monet / Musée d'Orsay, Paris, France © Bridgeman Images ; p. 112: Claude Monet / Mondadori Portfolio/Walter Mori © Bridgeman Images ; p. 116-117: Claude Monet / Pushkin Museum, Moscow, Russia © Bridgeman Images ; p. 118: Claude Monet / Private Collection / Bridgeman Images ; p. 119 (top left): French Photographer / Musée Marmottan Monet, Paris, France © Bridgeman Images ; p. 119 (top right): Claude Monet / Private Collection © Bridgeman Images ; p. 119 (center): French School (20th century) / Musée Marmottan Monet, Paris, France / Bridgeman Images ; p. 119 (bottom left): French School (19th century) / Musée Marmottan Monet, Paris, France © Bridgeman Images ; p. 119 (bottom right): Claude Monet / Bührle Collection, Zurich, Switzerland © Bridgeman Images ; p. 124 (left): Claude Monet / Musée Marmottan Monet, Paris, France © Bridgeman Images ; p. 124 (right): Claude Monet / Musée Marmottan Monet, Paris, France © Bridgeman Images ; p. 125: Greiner, A. Studio (19th century) / Musée Marmottan Monet, Paris, France © Bridgeman Images ; p. 132 (left): Claude Monet / Musée Marmottan Monet, Paris, France © Bridgeman Images ; p. 132 (right): Ferdinand Mulnier / Musée Marmottan Monet, Paris, France © Bridgeman ; p. 133: Claude Monet / Musée des Beaux-Arts, Rouen, France © Bridgeman Images ; p. 139: Claude Monet / Musée Marmottan Monet, Paris, France © Bridgeman Images ; p. 143 (top): Claude Monet / Private Collection / Photo © Lefevre Fine Art Ltd., London / Bridgeman Images ; p. 143 (bottom): French Photographer (19th century) / Musée Marmottan Monet, Paris, France © Bridgeman Images ; p. 148: Claude Monet / Private Collection / Peter Willi © Bridgeman Images ; p. 149: Claude Monet / Hermitage, St. Petersburg, Russia © Bridgeman Images ; p. 152-153: Claude Monet / Musée des Beaux-Arts, Rouen, France © Bridgeman Images ; p. 155: Claude Monet / Private Collection © Bridgeman Images ; p. 164-165: Claude Monet / Musée d'Orsay, Paris, France © Bridgeman Images ; p. 169 (bottom): Claude Monet / Museu Calouste Gulbenkian, Lisbon, Portugal © Bridgeman Images ; p. 176: Claude Monet / Private Collection © Bridgeman Images ; p. 177 (top left): Claude Monet, / Osterreichische Galerie Belvedere, Vienna, Austria / Bridgeman Images ; p. 177 (top right): French Photographer (20th century) © Musée Marmottan Monet, Paris, France / Bridgeman Images ; p. 177 (center): Claude Monet / Musée Marmottan Monet, Paris, France © Bridgeman Images ; p. 177 (bottom right): Claude Monet / Private Collection / Photo © Christie's Images / Bridgeman Images ; p. 183 (top): Claude Monet / Los Angeles County Museum of Art, CA, USA © Bridgeman Images ; p. 183 (bottom right): French Photographer (20th century) / Musée Marmottan Monet, Paris, France © Bridgeman Images ; p. 190 (left): French Photographer

(19th century) / Private Collection / Archives Charmet © Bridgeman Images ; p. 191 (top): French Photographer / Photo © PVDE / Bridgeman Images ; p. 191 (bottom left): Gustave Caillebotte / Private Collection © Bridgeman Images ; p. 191 (bottom right): French Photographer (19th century) / Musée Marmottan Monet, Paris, France © Bridgeman Images ; p. 199: Claude Monet / Bridgestone Museum of Art, Tokyo, Japan / Peter Willi © Bridgeman Images ; p. 204 (top left): Claude Monet / Musée Marmottan Monet, Paris, France © Bridgeman Images ; p. 205 (right): French Photographer (20th century) / Musée Marmottan Monet, Paris, France © Bridgeman Images ; p. 211: French Photographer (20th century) / Musée Clemenceau, Paris, France / Archives Charmet © Bridgeman Images ; p. 215: French Photographer (20th century) / Musée Marmottan Monet, Paris, France © Bridgeman Images ; p. 220: French Photographer (20th century) / Musée Marmottan Monet, Paris, France © Bridgeman Images ; p. 221: Claude Monet / National Gallery, London, UK © Bridgeman Images ; p. 232-233: Claude Monet / Musée Marmottan Monet, Paris, France © Bridgeman Images.

Private Collections

p. 13 (top right): © Collection Prince Xavier Beguin Billecocq ; p. 23 (top left): © Collection Prince Xavier Beguin Billecocq ; p. 183 (bottom left): Archives Durand-Ruel © Archives Durand-Ruel & Cie.

Photothèque Hachette

p. 38 (right): F. Mulnier © Photothèque Hachette ; p. 182: Archives Durand-Ruel © Photothèque Hachette ; p. 190 (right): © Photothèque Hachette.

Réunion des Musées Nationaux

p. 63 (bottom right): © Musée d'Orsay, dist. RMN-Grand Palais / Patrice Schmidt ; p. 177 (bottom left): © RMN-Grand Palais (Musée d'Orsay) / Rights reserved ; p. 204 (bottom) and on the cover: © Musée d'Orsay, dist. RMN-Grand Palais / Patrice Schmidt.

Roger-Viollet

p. 13 (top left): Charles Marville © Roger-Viollet; p. 22: © UB / Roger-Viollet ; p. 103 (bottom right): © Roger-Viollet ; p. 111 (top): © BHdV / Roger-Viollet ; p. 197: © Pierre Choumoff / Roger-Viollet ; p. 214: © Pierre Choumoff / Roger-Viollet ; p. 204 (top right): © Roger-Viollet.

Rue des Archives

p. 2: Claude Monet photographié par Nickolas Muray © Granger NYC / Rue des Archives ; p. 142: © Rue des Archives / Collection Grégoire.

Acknowledgements

We would like to extend our profound thanks to all of those who have given their time, skill and energy to the production of this book:

Aude de la Rivière at Gien; Nicolas Pastot and Jérôme Rioux for their cooking; Virginie Graire and Françoise Ménez for their expert knowledge of painting; Anne Berthold for handling all of the logistical challenges; la Faïencerie de Gien (www.gien.com) for supplying all of the china; Defrise (www.defrise.fr) for supplying the period objects; Le Comptoir du Perreux for supplying the period bottles; Les Délices de Fred and Le Perreux-sur-Marne for supplying the bread for the *Déjeuner sur l'herbe*.

© Prestel Verlag, Munich · London · New York, 2016, reprinted 2020
A member of Verlagsgruppe Random House GmbH
Neumarkter Strasse 28 · 81673 Munich

The original edition was published under the title *Recevoir selon Monet. Les recettes d'un maître* at Les Editions du Chêne – Hachette Livre, 2015. Text: Florence Gentner. Photographs: Francis Hammond. Food Styling: Garlone Bardel.

© 2015, Editions du Chêne – Hachette Livre

Front cover: Herb and Lettuce Soup (see p. 128); Strawberry Mousse (see p. 112); Claude Monet, *Water Lilies* (detail), 1916–19 (see pp. 212/13)

Back cover: Claude Monet, *Iris Bed in Monet's Garden* (detail), 1900, Musée d'Orsay, Paris; Vert-Vert Cake (see p. 166); Oxtail Hochepot (see p. 212); Claude Monet, *The Lily Pond* (detail), 1899 (see p. 221)

Prestel Publishing Ltd.
14–17 Wells Street
London W1T 3PD

Prestel Publishing
900 Broadway, Suite 603
New York, NY 10003

Library of Congress Control Number is available; a CIP catalogue record for this book is available from the British Library.

In respect to links in the book, the Publisher expressly notes that no illegal content was discernible on the linked sites at the time the links were created. The Publisher has no influence at all over the current and future design, content or authorship of the linked sites. For this reason the Publisher expressly disassociates itself from all content on linked sites that has been altered since the link was created and assumes no liability for such content.

Editorial direction for the English edition: Claudia Stäuble
Translation: Fabia Claris
Copyediting: Meredith Hays
Art direction: Sabine Houplain
Cover design: Hannah Feldmeier
Typesetting: Verlagsservice Dietmar Schmitz GmbH, Heimstetten
Production management: Friederike Schirge
Printing and binding: Gráficas Estella S.L.

Printed in Spain

ISBN 978-3-7913-8288-3

www.prestel.com